TALENT 2015

In your hands is the ninth Talent issue of Foam Magazine, entirely devoted to the remarkable work of emerging photography talents. Since 2006 *Foam Magazine* has published a special Talent issue annually, and in recent years it has grown to become one of the most important international platforms for young photographers.

We are extremely proud to report that many of the talented photographers featured in past Talent issues have developed into mature and valued members of the international photography community. To be fair, there are some of whom little if anything has been heard since. That is one of the risks inherent in the early identification and introduction of young talents: there can be no guarantee that the perceived potential will ever be realized.

Nevertheless we have every confidence that once again this issue contains the work of photographers who will turn out to be of lasting importance to the development of photography. Our track record is one important indication. Another is the fact that some of those featured here have already been able to stage exhibitions at major galleries and to find prominent publishers for their work.

Above all we are pleased to have discovered so many talented young people who have until now escaped the attention of their colleagues in the field. The fact that our annual Talent Call brings in the work of such a large number of unknown photographers from all over the world (this year we received 1,208 submissions from 67 countries) lends an extra dimension to the annual Talent issue. There are clearly some truly extraordinary talents operating under the radar or just outside our field of vision. We believe it is an essential part of our task to bring them into view.

This magazine is not our only means of doing so. Every year the work collected in the Talent issue is shown in an exhibition that travels the world. This year the Talent exhibition can again be seen during Paris Photo in November at the Atelier Néerlandais in Paris, where we will also organize symposia about the importance of young talent and new developments within photography. In early 2016 the exhibition will move on to Brussels. And of course much attention will be paid to this Talent issue and the photographers included in it during Unseen, the international photography fair taking place in Amsterdam from 17 September, of which Foam is one of the initiators. It is there that this issue will be launched, and we hope that many of the photographers selected for it will attend the fair so that we can present them to you in an appropriate manner. It's an opportunity for you to get to know not just the work but its young and promising creators. You are more than welcome. See you at Unseen 2015!

Marloes Krijnen
Editor-in-Chief

REMA

TAL

RK-
ABLE
ENT

by Marcel Feil

According to most encyclopaedias 'talent' means a special gift, an innate aptitude. Talent is inextricably linked to a person who has a capacity at their disposal that's not merely a fact (you either have it or you don't) but immediately marks them out. Your particular gift makes you different from other people, it makes you a talent (in short, you either are or you aren't). That indissoluble connection between the property and the bearer of that property also means that in everyday conversation we talk about having a talent and about being a talent.

— Talent issue #39

We think an age limit of thirty-five makes sense, since by then most of the artists have left the academy behind them and generated a visual language of their own, yet they are still young enough to develop further, to carve out a path for themselves in the photographical profession and remain influential for a significant time to come. Having said that, there is clearly a difference between 'being talented' and 'being a talent' . Talent is unrelated to age, but anyone with a talent will generally be young, with outstanding skills or abilities in comparison to others.

— Talent issue #28

Talent is relative and always measured against the standards set by other people. The fact that many of the artists who sent in their work have not been chosen does not mean they don't have talent (or are not talents), it simply means that in our judgment others are greater talents. As well as relative, the verdict is to a great degree subjective. Other people might reach a different verdict, and no one should be surprised that heated discussions take place between the editors.

— Talent issue #39

Often the terms 'talent' and 'promise' are used nearly as synonyms. This corresponds to the metaphor of a diamond in the rough: the capacity, the potential is there, just as the confidence that this potential will reach maturity as long as the talent gets the right guidance. There is of course never any certainty that this will really happen, but a talent is in part determined by the confidence of those around him/her that it's worth the effort to invest in that talent.

—Talent issue #20

As editors we only see the final product of a specific creative process, namely the actual photos. We do not know whether the photographer created these with the kind of flair and natural ease by which we would become convinced of his or her talent. For what if the same work had been created after much plodding and toil, by someone who had to pull all the stops and study hard to achieve this result? Could we call that a talent? Does it matter how work has been created or is it only the final product that counts?

— Talent issue #20

Since the entire editorial team is professionally engaged with photography every day and sees and knows the work of countless extremely diverse photographers, and since we are often intensively occupied with both the history of photography and new trends and developments in the domain of visual culture, a framework emerges that is indispensable in reaching a reasonably measured and well-founded judgment.

— Talent issue #39

Related to the idea of promise for the future is an implicit judgment about the past and the tradition in which someone works. Someone is considered a talent in a specific field and within a specific discipline, and this talent is also measured in the light of a specific history and tradition. Is someone a talent if he or she attains an acknowledged level of quality and meets certain accepted standards? And therefore continues that tradition in an estimable way? Or is it up to the talented, in particular, to reinterpret and recharge it with new meaning?

— Talent issue #20

Our main aim is to produce an annual overview of work by young artists. It may point to developments, trends and themes, that are of particular importance to a new generation of artists who are likely, in due course, to have an impact on developments within the photographical field as a whole.

— Talent issue #28

To what extent does a photograph add something to that which already exists and to what degree are we touched by it because it is unfamiliar, provocative, challenging, or simply because we feel it has a certain something but cannot immediately say what it is? In short, we prefer photography that challenges what already exists rather than corroborating it.

— Talent issue #24

The work we looked at often moved completely naturally between one end of the photographic spectrum and the other, and much of it went beyond the boundaries of what we regard as photography, even today, calling those boundaries into question or extending them in some completely convincing way. If anything did become clear then it was the unrestrained freedom and creativity with which photographical images are currently made.

— Talent issue #36

Especially in a time when everyone is connected to everyone else via social media and the internet, and communication through images has expanded enormously, new developments are picked up extremely rapidly, hyped and made public property. Trends are picked up rapidly nowadays and by huge numbers of people, then translated into work that is usually a good deal less interesting. It's therefore important to sift the wheat from the chaff and identify the trendsetters.

— Talent issue #39

Certainly in a society driven by innovation, trends, hypes, images and economic considerations, a forced craving to keep presenting the newest and best is also often present in the art world. Fear of being too late and missing out, fear of being a trend follower instead of a trendsetter, means that young artists sometimes very quickly are labelled 'the next big thing' . With substantial risk. Some artists are as vulnerable as they are great.

— Talent issue #20

In an issue completely devoted to young talent and therefore to a new generation of image-makers, there is sometimes a tendency to concentrate solely on things that are new, different and experimental. Those characteristics are valuable too, but not purely for their own sake. What matters, after all, is what is being said, the content and therefore ultimately the relevance of the work.

— Talent issue #39

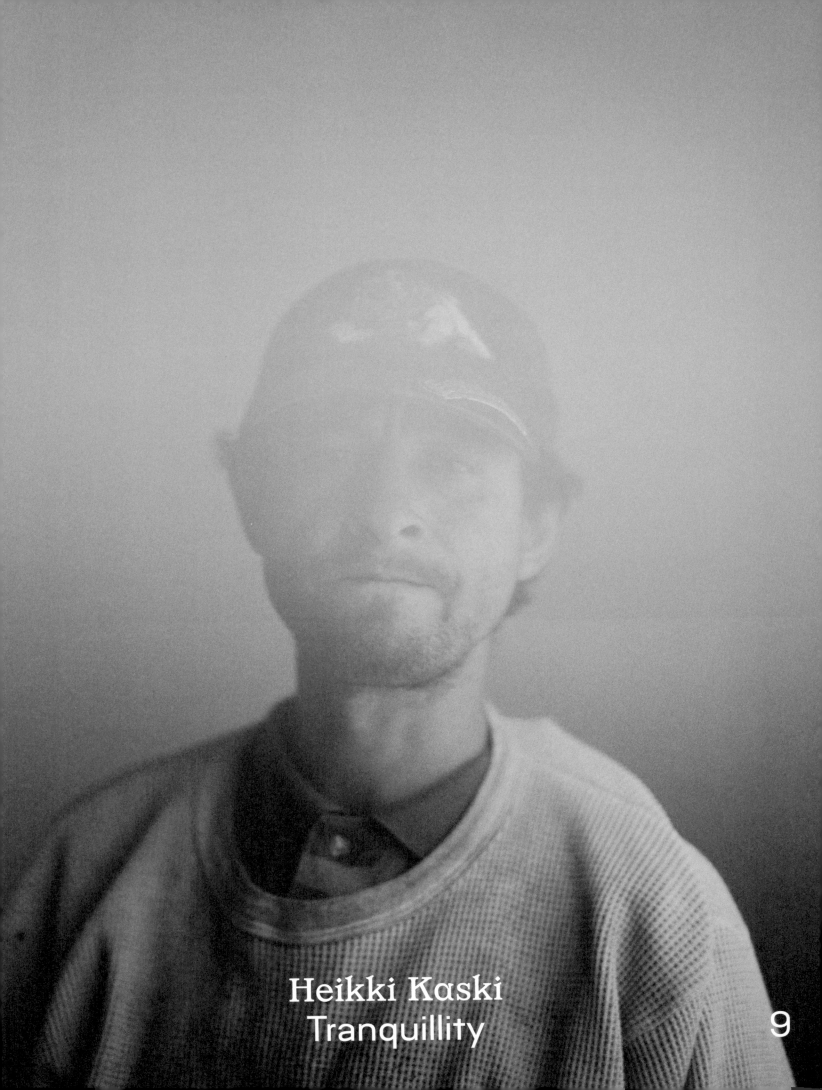

Heikki Kaski
Tranquillity

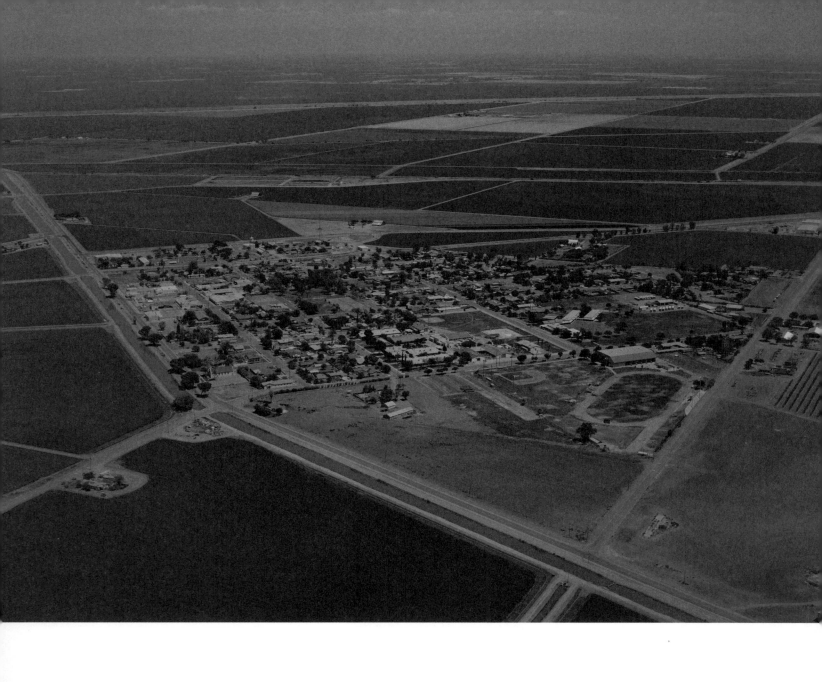

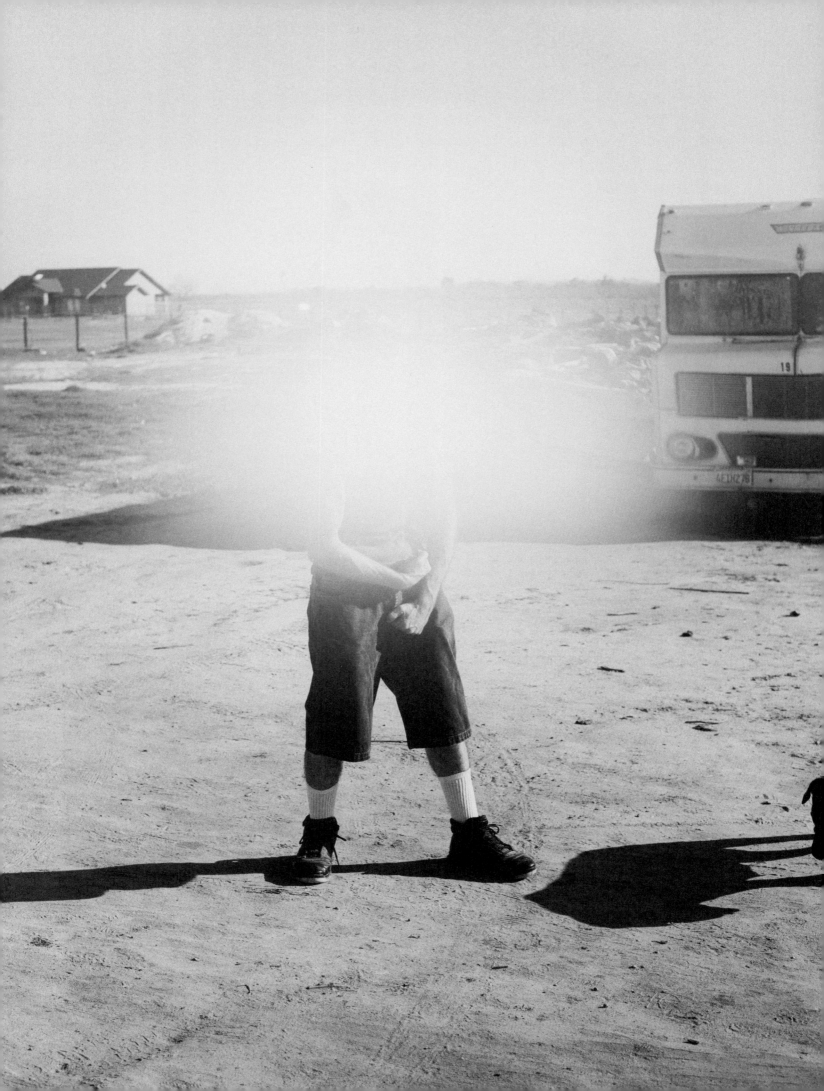

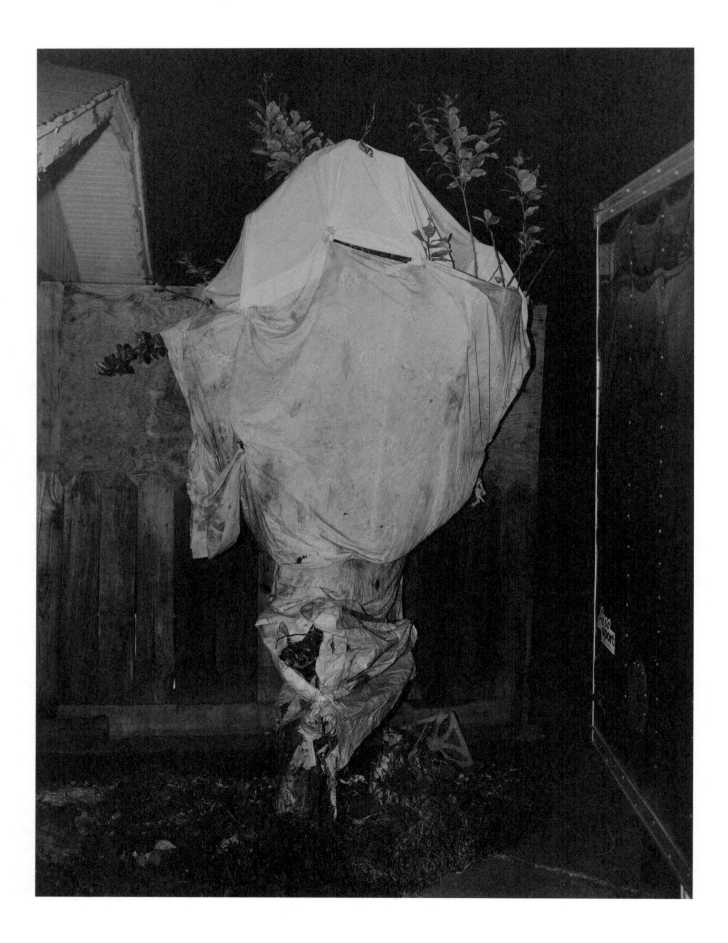

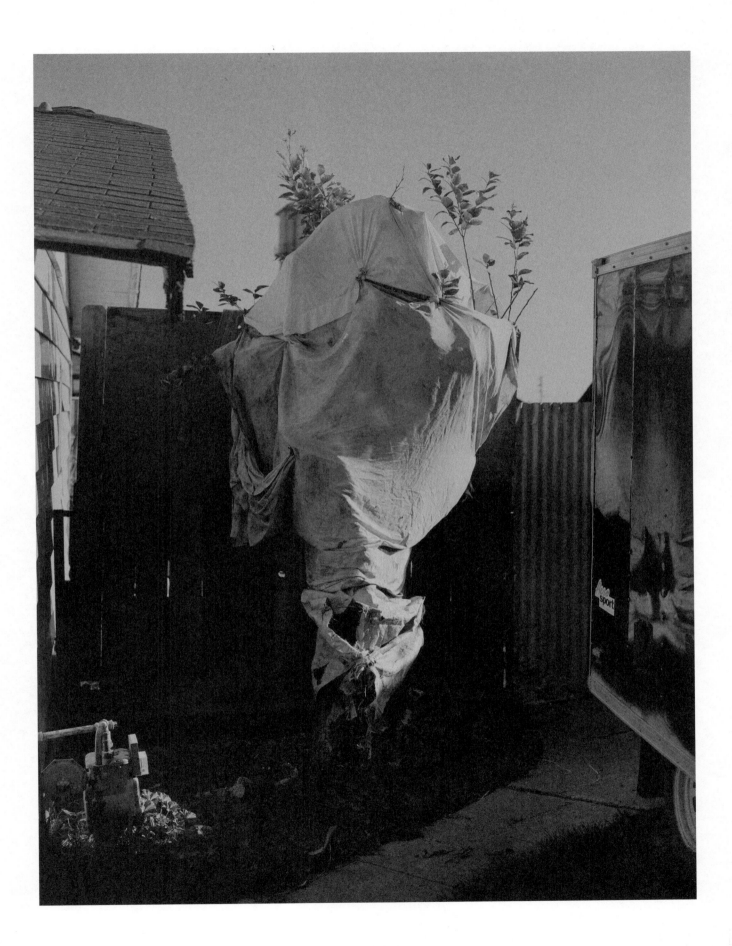

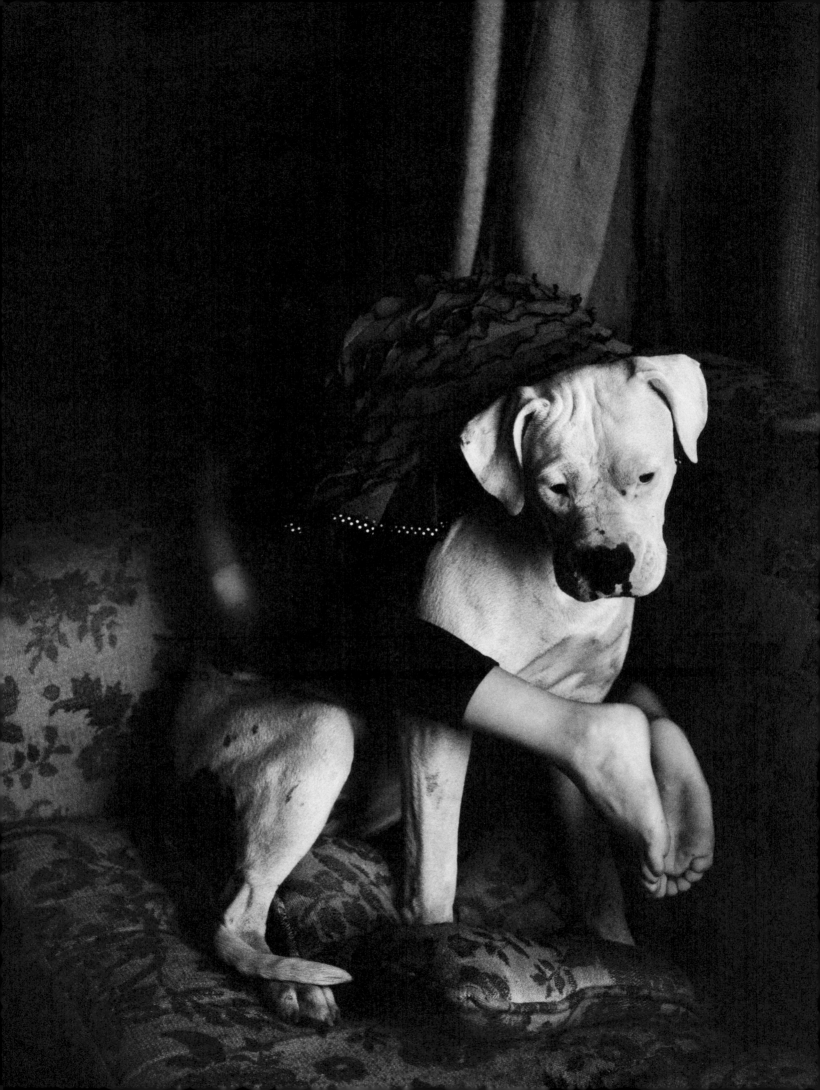

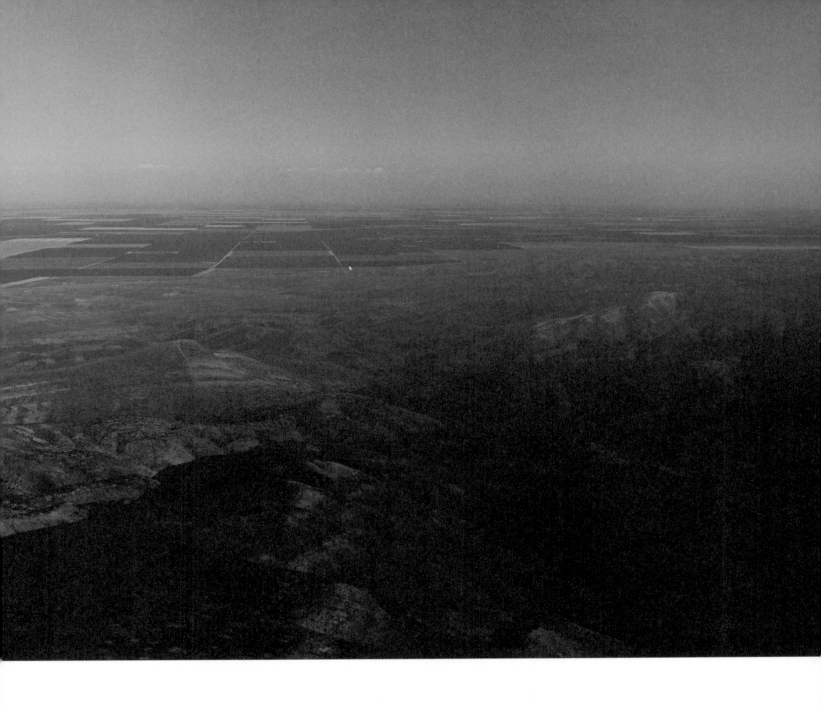

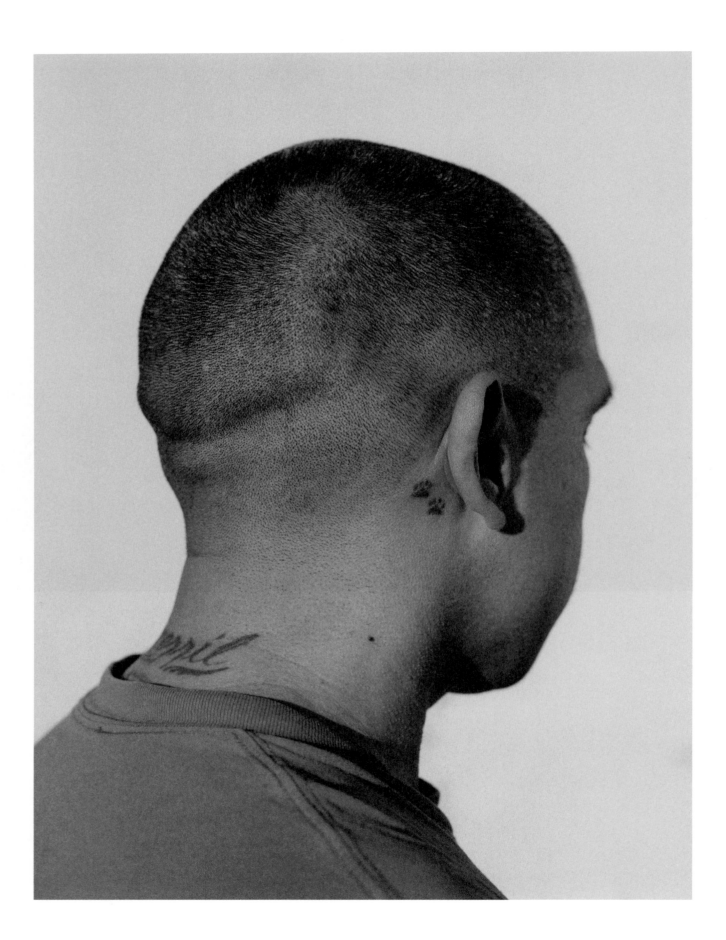

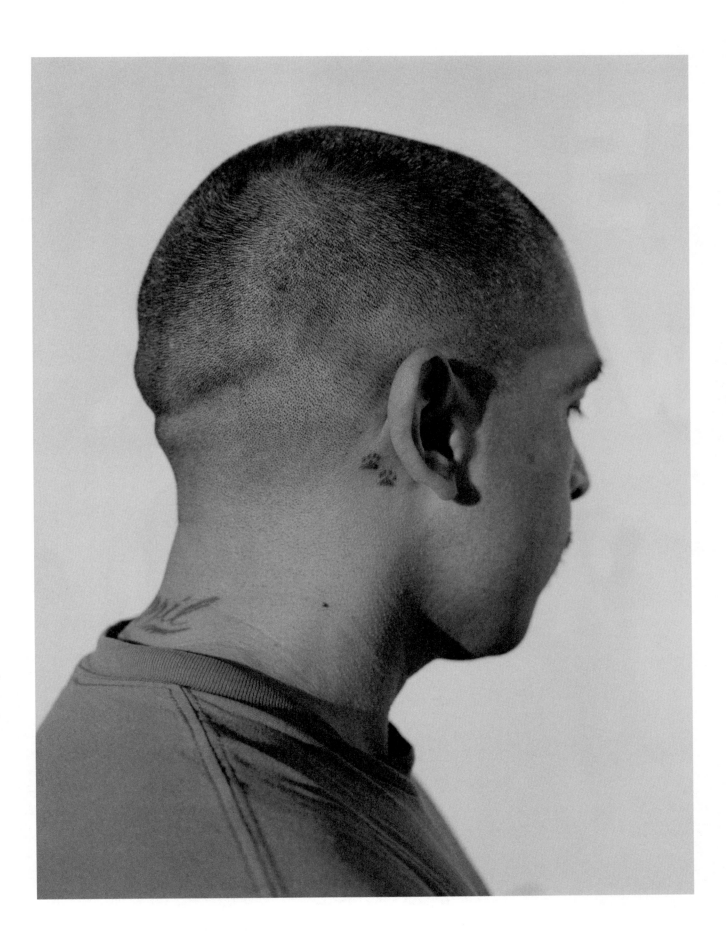

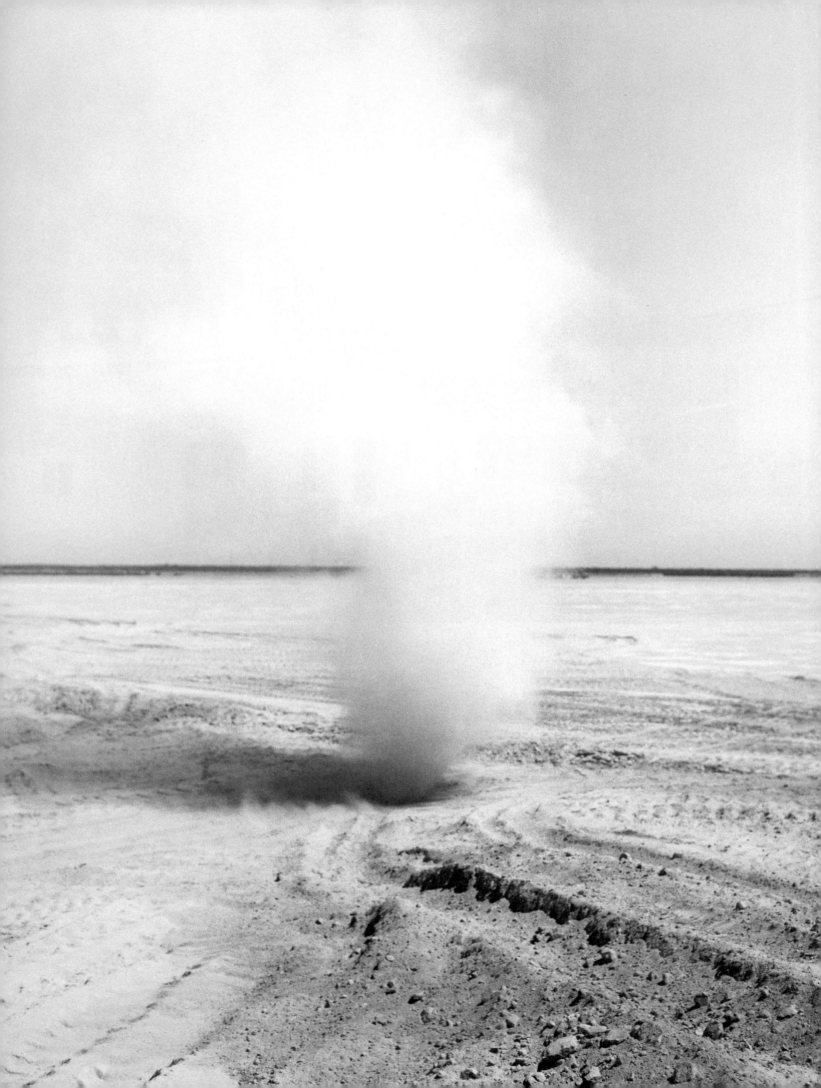

TOWARDS TRANQUILLITY

on **Heikki Kaski** p.9

by Russet Lederman

The American dream as evinced by a vast limitless horizon dotted with small towns and subdivisions whose names suggest the fulfilment of wealth, happiness and prosperity is both a familiar and foundational component of the American land-scape. Signage at various intervals along the massive U.S. Interstate Highway System announces towns such as Freedom, Maine; Eden, Montana; and Hope, Arkansas. Optimism and expectation, followed by a sense of missed opportunity seems inevitable upon approaching and then passing the exit ramp for one of these utopian-named towns. It is as if the car fills with each town's catchy civic jingle, 'There's a feeling in the air that you can't get anywhere, except in <insert town name here>.'[1] Drivers, who typically endure long stretches between highway exits, feel the pull of their car's wheels towards the potential of these *exceptional* communities that suggest the power of dreams fulfilled. It seems like they should be hard to ignore; but we do it all the time.

Heikki Kaski, a Finnish photographer, who lived intermittently in Los Angeles from 2012–2014, inevitably succumbed to the lure of one of California's many utopian-named communities. During the summer of 2012, on a long drive from Northern California to Los Angeles along the I-5 Freeway, he impulsively decided to visit the small central Cali-fornian town of Tranquillity. Encouraged by the town name's allusion to calm, serenity and a carefree life, as well as the act of randomly picking a place in the middle of nowhere, Kaski decided to take the I-5 exit ramp towards Tranquillity. What he found was quite different than what is suggested in the inflated real estate prose that typically champions towns and subdivisions with utopian names. Rather, Tranquillity is a sweltering dream unfulfilled, that sits along an irrigation ditch in the semi-arid Fresno County agricultural region. As the text accompanying Kaski's

photographs of Tranquillity describes it, 'A flat horizon surrounds Tranquillity in the Central Valley. Those some 800 people in and around these 12 streets, 4 churches, 2 grocery stores, 2 hardware stores, a car dealership, a post office, a library branch, a high school, Mom's drive-in or The Corner Bar may have seen me when not working on the fields stretching around: almonds, pistachios, migrated bees shaking the pollen.' For Kaski, there was more to Tranquillity than just a simple contradiction of a utopian name. There was something particular about the town and its inhabitants that drew him in; that he needed to explore. There was a quiet beauty and depth within its garbage-strewn lots, rundown buildings, weathered inhabitants and ravaged landscape – a coarse and trampled emptiness that also had much potential.

On his first night in Tranquillity, he pitched his tent in the backyard of The Corner Bar, getting a handwritten camping permit on the back of a slightly burnt, salvaged business card from the bar. Kaski took only a few photographs that night and then awoke to a scorching hot morning sun before heading back to Los Angeles. But as Kaski observes, 'There was something there: the landscape, the atmosphere, and the stillness. On a personal level, I wanted to return to Tranquillity to pursue that "something" through photography.' This urge resulted in a series of distinctly poetic images – first presented in book format – that reveal a raw beauty in the mundane and psychologically complex character of one small town in America's West.

Over the next year and a half, Kaski returned frequently to Tranquillity, pitching his tent behind the bar and directing the lens of his various cameras, including a hundred-year old large format, at anything and everything: from the cracked asphalt to decrepit barns to people to landscapes. Slowly, an editing process and documentary focus emerged as he began to talk to people and learn more about them and

Some
it takes d
to see the
with
of the A
dre

times
foreigner

beauty
n the ruins

merican
am.

Towards Tranquillity

their town's history. Despite his obvious outsider status in this largely white and Latino farming community, Kaski made many unlikely friends with individuals who went out of their way to help him both practically and socially: from providing housing to sharing intimate views of their private lives. These social interactions had a profound impact on Kaski's understanding of his photography and his documentary approach, allowing both to evolve within a fluid space that encouraged a continual process of re-evaluation and discovery. Kaski affirms, 'I'm neither interested in illustrating the paradoxes of documentary photography nor a political art conceived in the studio. Rather I am exploring a documentary practice that permits me to work with a real town, real landscape and real people. By exposing myself to the outside, I encounter more "radical" and layered material with the potential to discover photographs that were initially unforeseen to me. If somebody asks if Tranquillity is a real place, then I have at least partly succeeded.'

The book's sequencing is a carefully considered tapestry of ambiguous truths: claims are made and then refuted. As the first few pages ostensibly

suggest: there is a map, a landscape and a pair of portraits. But, are there really? Maybe it is partially a dream as suggested by the text that Kaski transcribed from a recorded conversation in Tranquillity and then chose to emboss on the book's dense black cover, '...But then I never knew what happened and nobody ever talked about it. So I just attributed it to a dream. Sometimes when you have dreams and you wake up and, you know, they're almost real. They feel like real.' This blur between the fictive and the real that strikes most American observers as ironic, is precisely the means by which Kaski is able to excavate a deeper truth. Sometimes it takes a foreigner to see the beauty within the ruins of the American dream. In Kaski's vision, the facts are presented: there is a map *that outlines the town of Tranquillity*, a landscape *which is obscured by a dust whirl or fallen branches*, and a pair of studio portraits *of the same tattooed man taken moments apart*. Truth is shifted and recalculated within his camera's lens. Similar to the broken down towns and arid desert of Wim Wenders' *Paris, Texas*, Kaski's Tranquillity is a collection of worn chairs, dried-up orange

peels and gnarled tree trunks that speak to a foreigner's view of America's continental scale and its ability to dwarf human frailty in its wake.

Unlike the New Topographics, Kaski's images of Tranquillity's tire-marred fields and prefab homes are not subtly ironic visions of a rotting American exceptionalism. Rather, their strength is a subjectivity that uncovers a disquieting beauty within the mundane, the discarded and the ravaged. Where others see no hope, Kaski sees potential. Distinguishing his book by what at first seems a disjointed opening cadence, Kaski cleverly interweaves a range of disparate and often repetitive images that include a breath-taking full-bleed black-and-white landscape reminiscent of an Emmett Gowin aerial view; portraits of hidden or blurred faces; trees wrapped in tarps that suggest the infamous hooded form of an Abu Ghraib prisoner; and neglected interior and outdoor spaces. Punctuating the sun-scorched and scarred landscapes that recur throughout the book are colour and black-and-white photographs of caged dogs, tattooed backs, a river baptism, a cluttered yard and a stained mattress. Faces are rarely shown. Whether hidden or blurred, they maintain a sense of ambiguity that serves to further illustrate the frequent questioning within Kaski's documentary approach. As he notes, 'Blurring faces is a violent act. The people portrayed in my *Tranquillity* images have no political power – their identities are unimportant and they are unrepresented—so I felt I might as well hide or blur their faces because their identity does not matter. I wanted to refuse the use =of portrait as a symbol. Throughout the book there is no information to be retrieved from behind the blur and in this context the portrait has lost its potentiality.'

But Kaski is ultimately an optimist, who searches for a deeper meaning in the mundane and the seemingly lost. In the middle of the smartly designed book

by Kaski, with typography by Dutch graphic designer Hans Gremmen, a visual and psychological reprieve is offered from the hardscrabble photographs that are the mainstay of *Tranquillity*. Sandwiched between orange pages marked by fragmentary texts from recorded dialogues, are repetitive images of a distant flock of birds shot upward against an immense and somewhat ominous blue sky. They are a moment of reflection that colours all that precede and follow them, confirming Kaski's role as a subjective documentarian who carefully unearths an ever-shifting reality in a man-altered landscape of forsaken dreams.

There are thousands of towns in America with utopian names and impoverished landscapes. Kaski could have landed anywhere in his search to escape the overwhelming hyperreality of Los Angeles. With no base knowledge of the American West—other than popular media references—Kaski threw a dart at a map of California and found Tranquillity, a town in the San Joaquin Valley 20 miles off the I-5 Freeway. Through the time-honoured ritual of the American road trip, Kaski set out in a car packed with camping gear. What he discovered within the desert of a monotonous Americana are shattered hopes that still retain the outline of their original potential. His detour via a random freeway exit ramp—sparked by a foreigner's *shocked* curiosity—ultimately exposes more than just the ambiguity in a town's utopian name. Through unsettlingly beautiful images of neglect and decay, Kaski addresses his documentary practice, its ability to accurately convey truth, and his right to use it. For Kaski, Tranquillity cannot be ignored. It is as much a real place, as a state of mind.

HEIKKI KASKI (b. 1987, Finland) studied photography at Lahti University of Applied Sciences, Finland, and Valand Academy, Sweden. His work has been exhibited throughout Europe, including at the Extensions Hagen residency program in Dala-Floda, Sweden, and at the Finnish Museum of Photography. *Tranquillity* won the Unseen Dummy Award in 2013, and was published by Lecturis the following year. He currently lives in Copenhagen. www.heikkikaski.com

RUSSET LEDERMAN (b. 1961, United States) is a media artist, writer and photobook collector who lives in New York City. She teaches media art theory and writing in the MFA Art Criticism & Writing program and MFA Computer Art department at the School of Visual Arts, New York. She regularly writes on photobooks for print and online journals, including the International Center of Photography's library blog. She is a co-organiser of the 10X10 Photobooks project and has received awards and grants from Prix Ars Electronica and the Smithsonian American Art Museum.

1 'Hello' city song by Frank Gari as discussed in 'No Place Like Home,' This American Life, 14 March 2014: podcast.

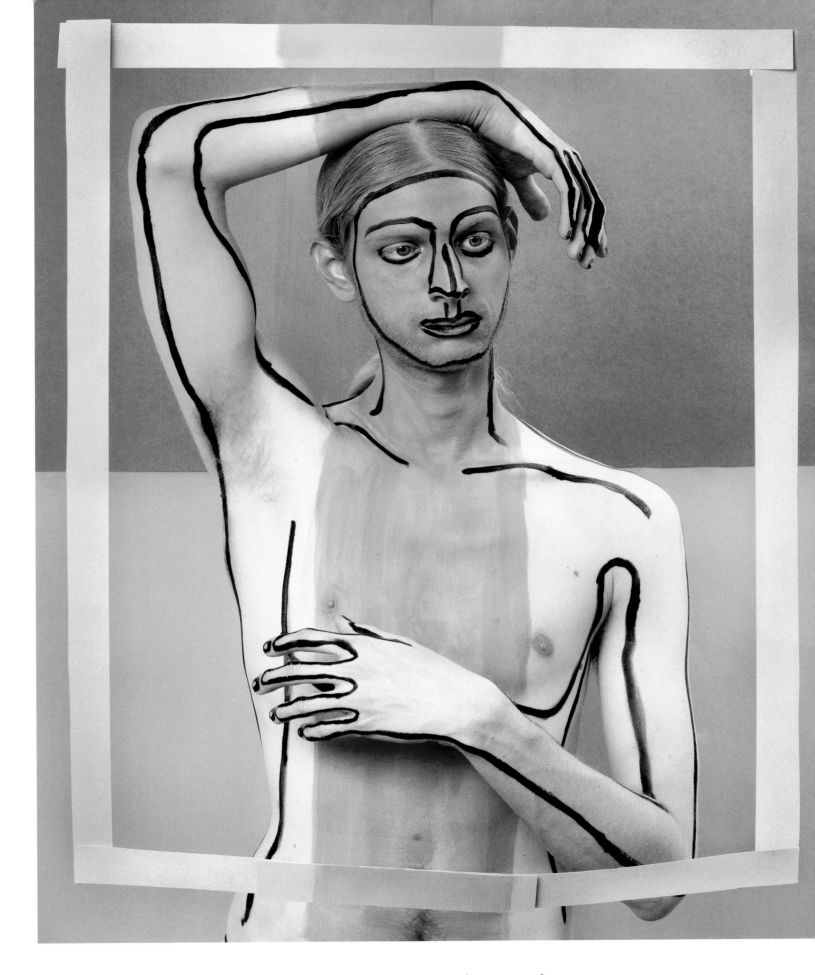

Manon Wertenbroek
Tandem

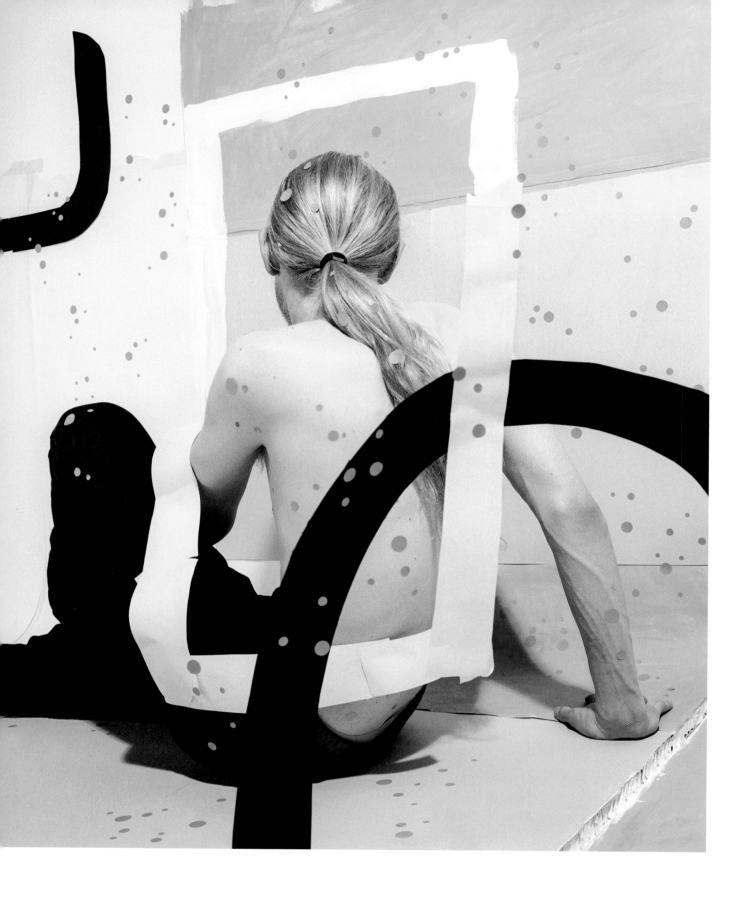

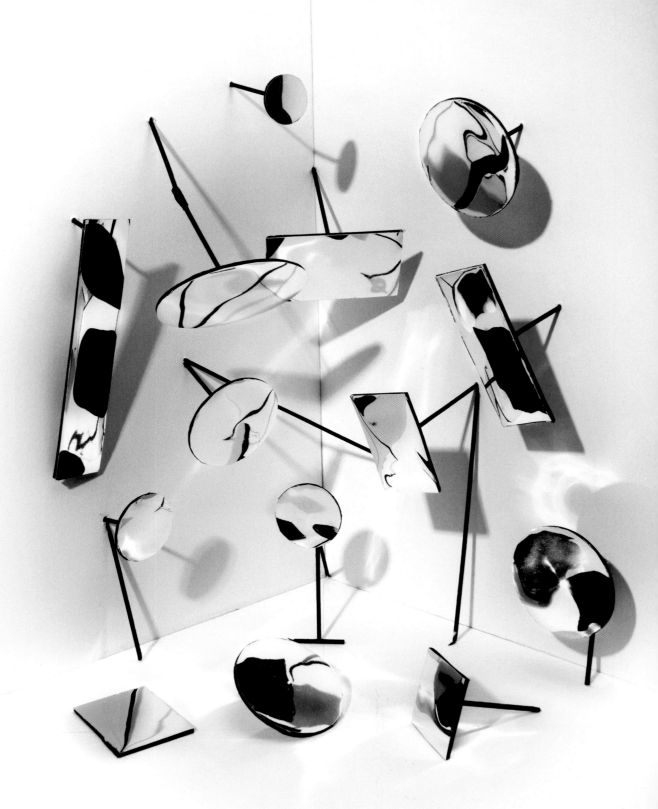

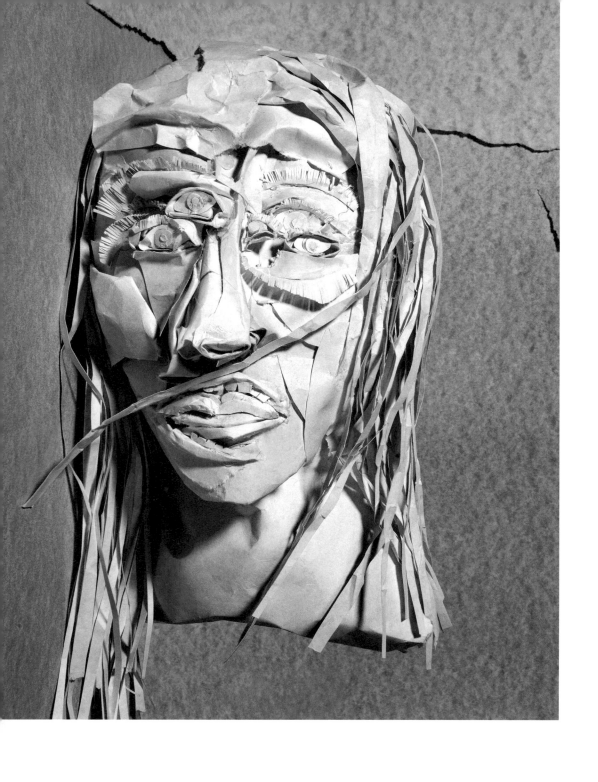

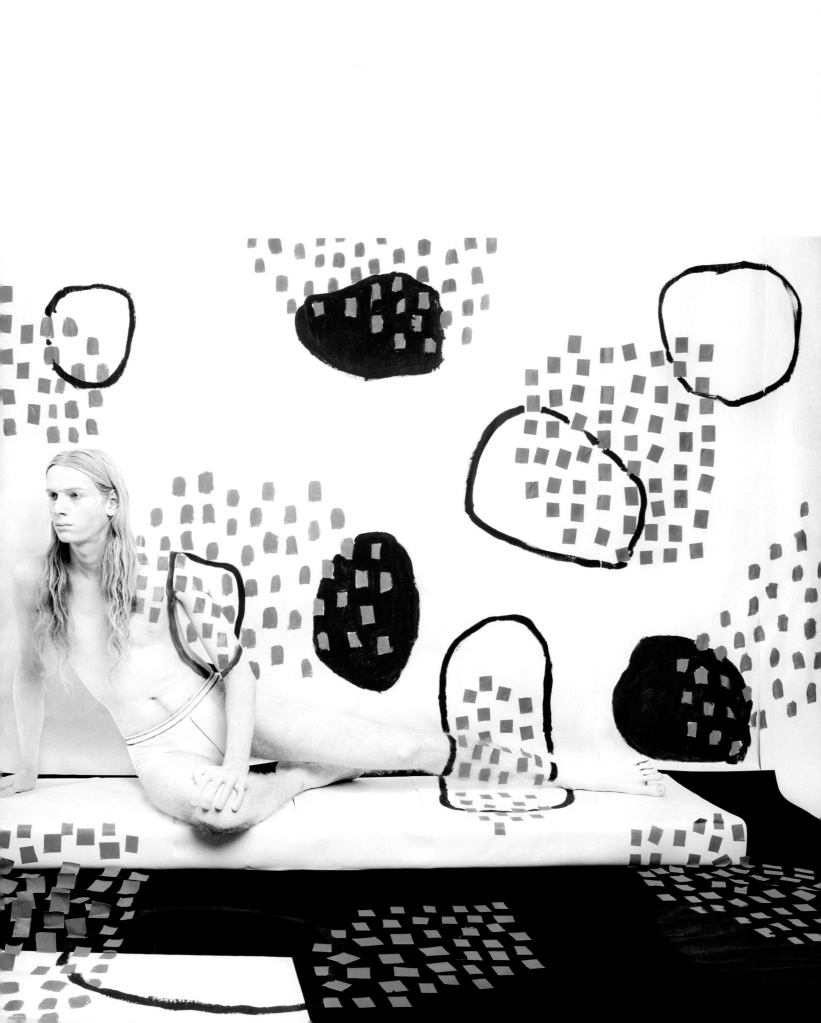

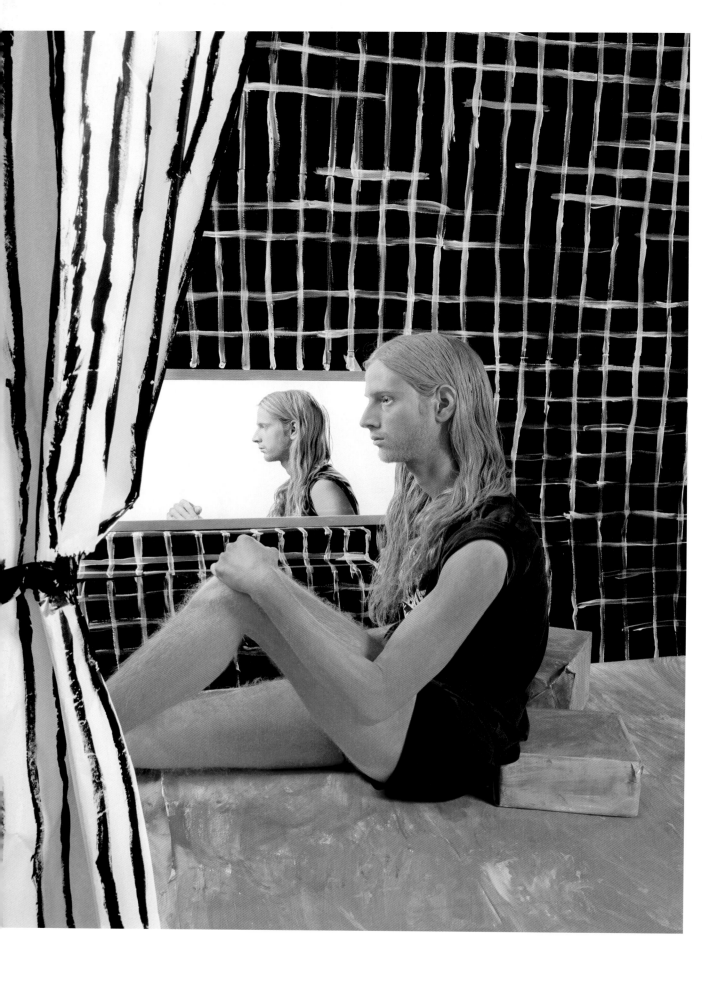

Constantin Schlachter
Une Trajectoire

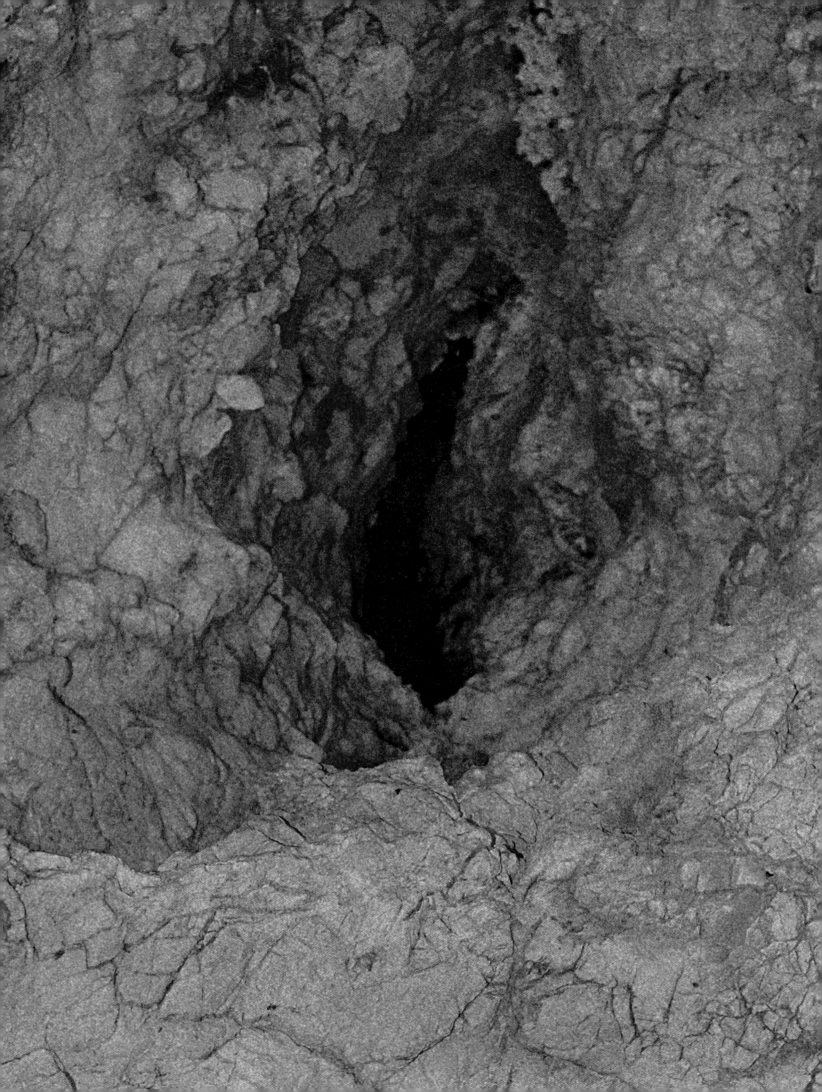

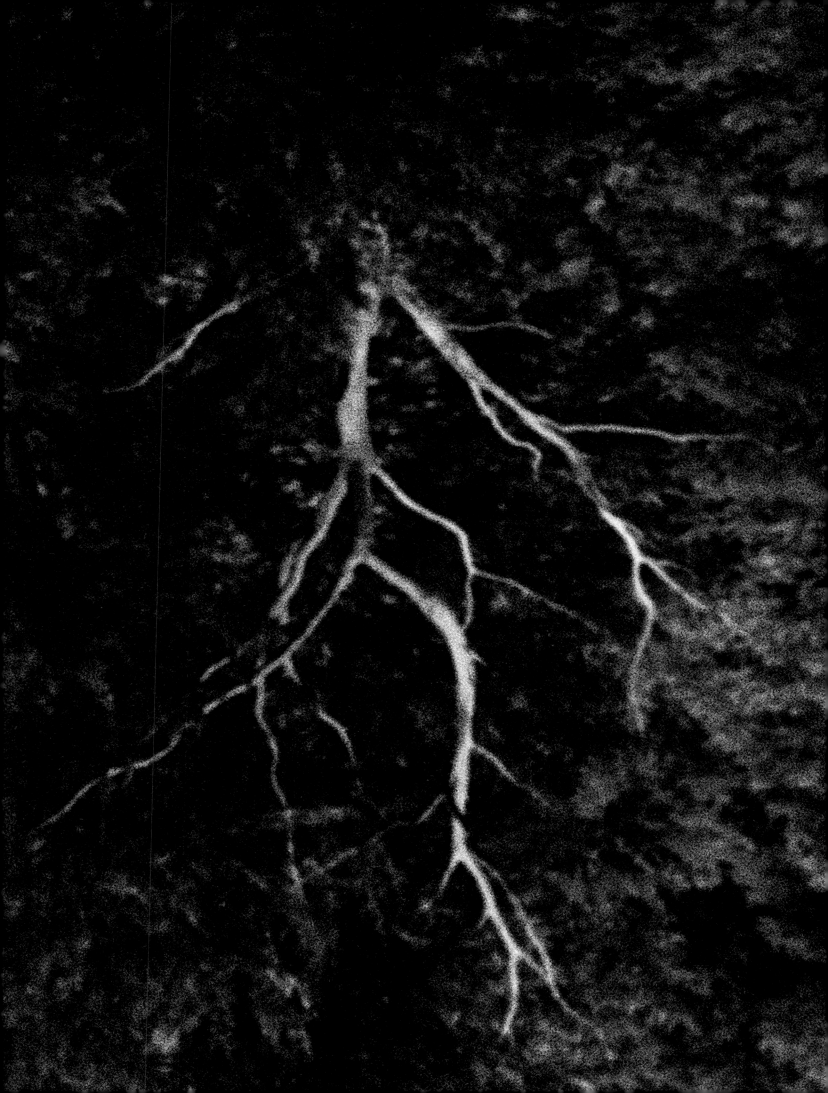

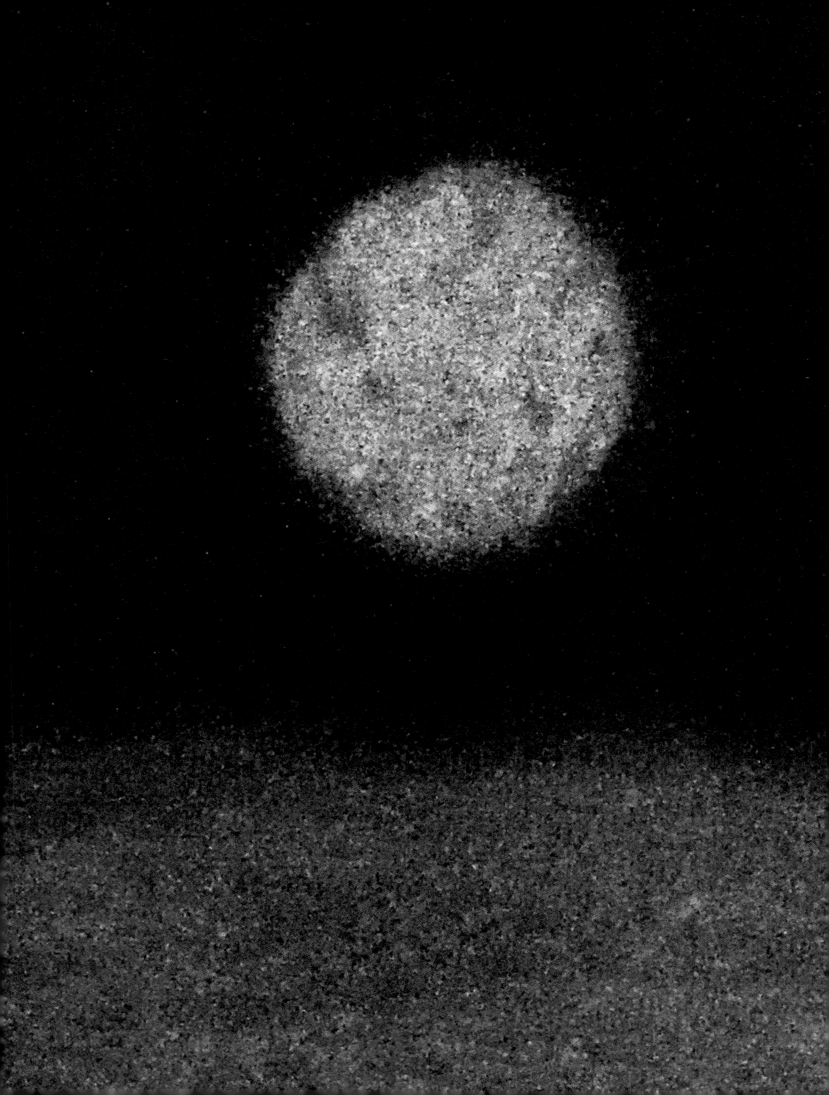

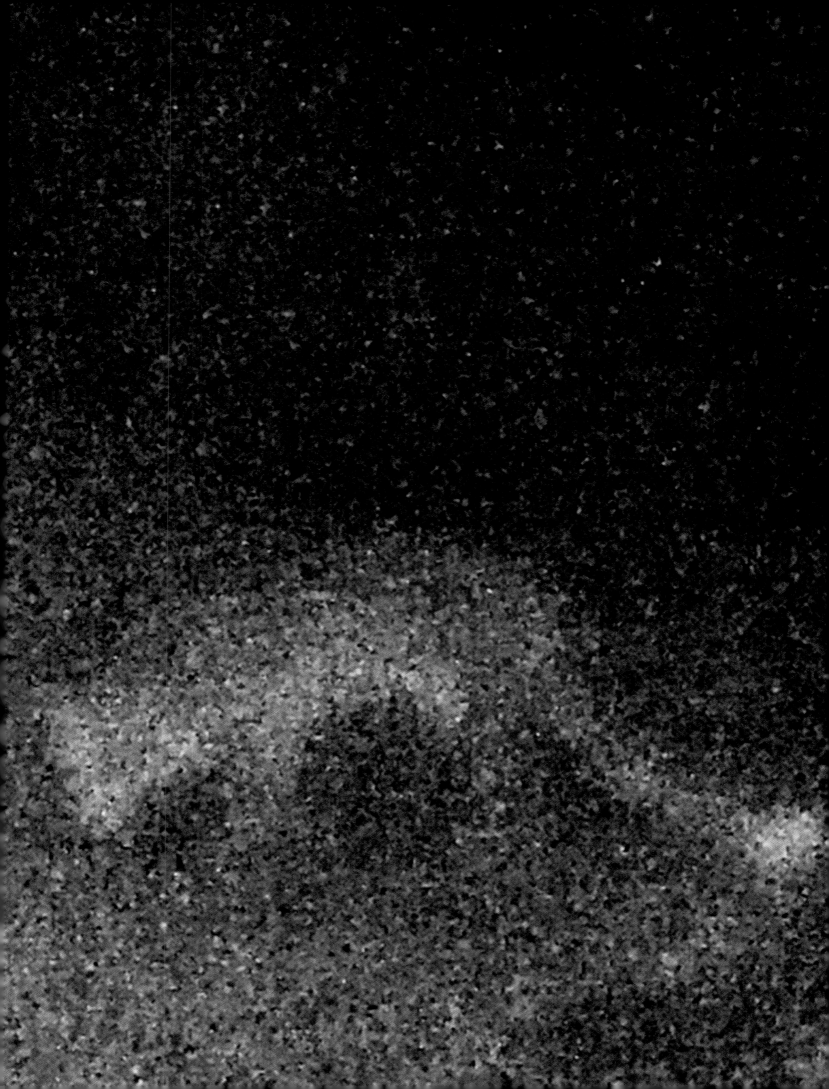

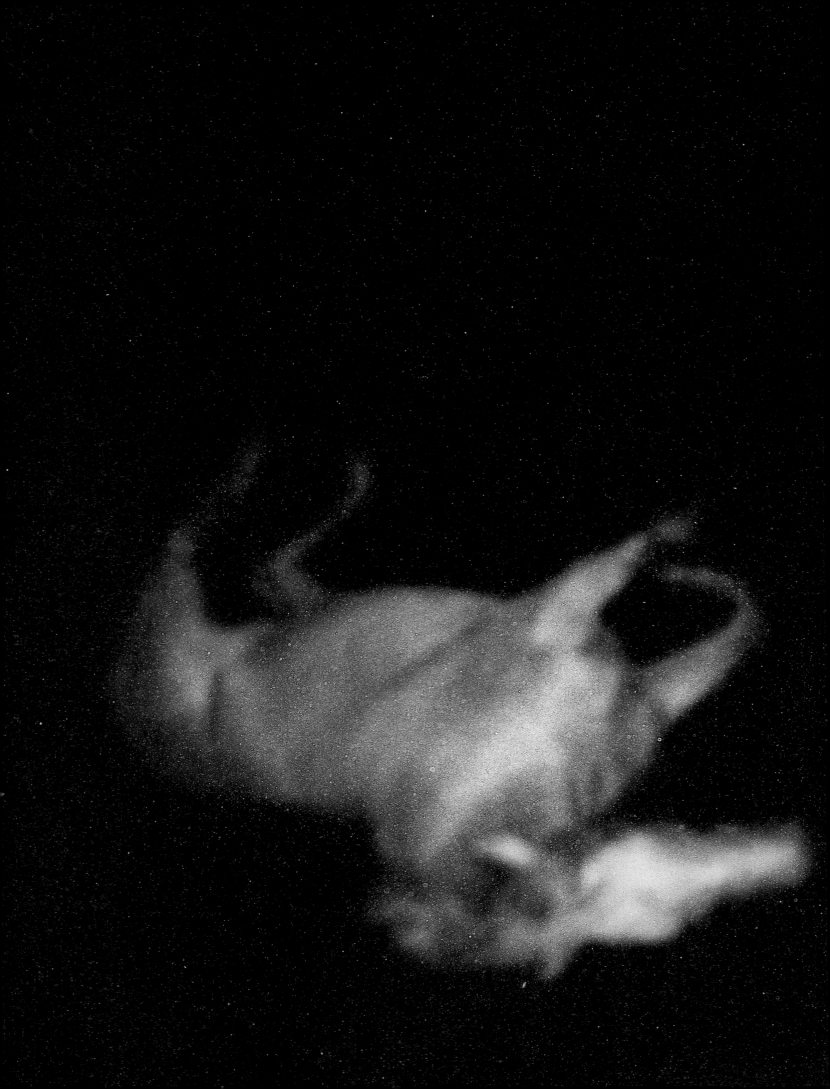

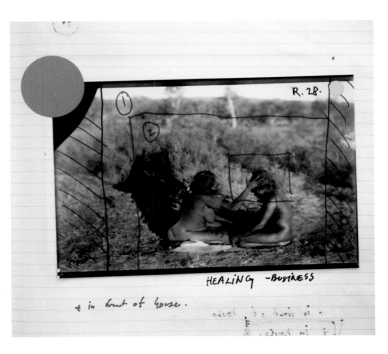

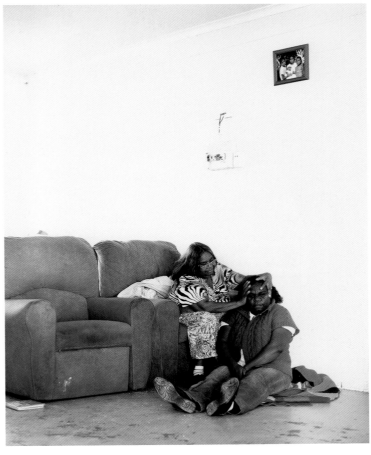

Christian Vium
The Wake

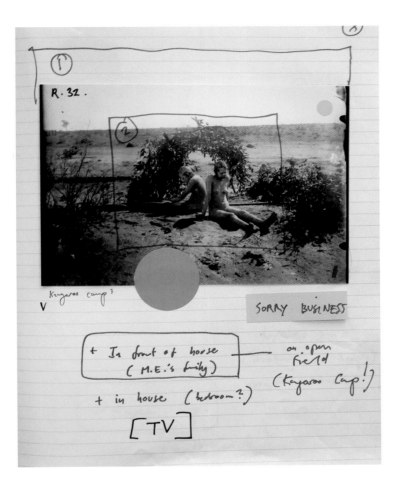

R. 32.

Kangaroo camp?

V

SORRY BUSINESS

+ In front of house
 (M.E.'s family)

on open
field
(Kangaroo Camp!)

+ in house (bedroom?)

[TV]

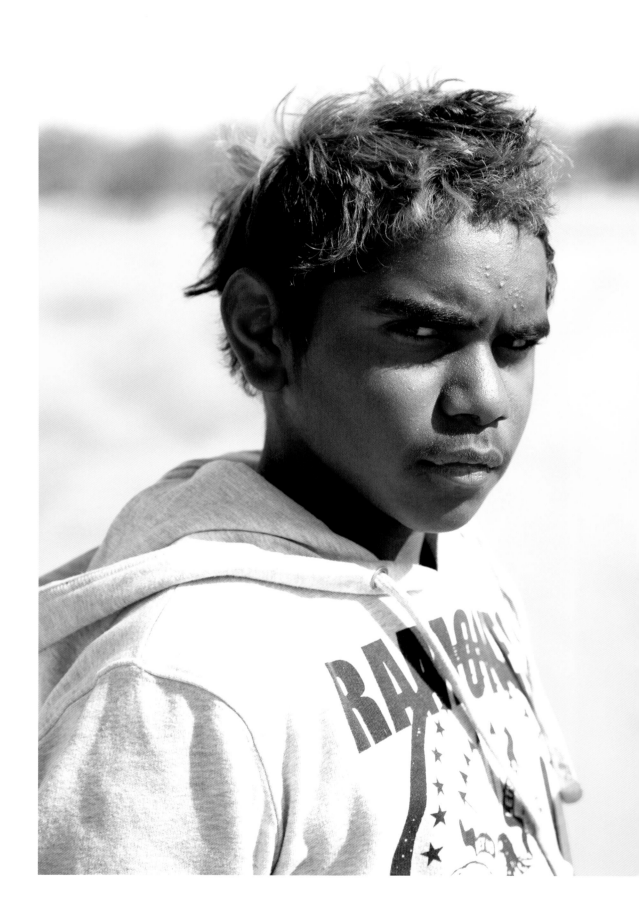

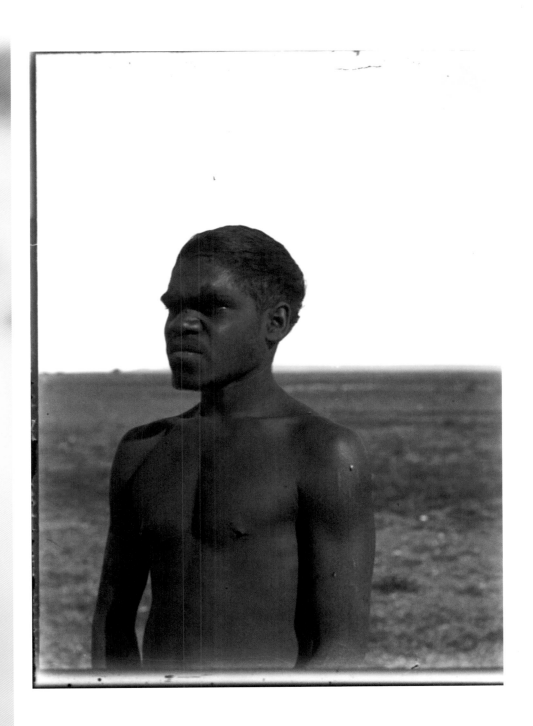

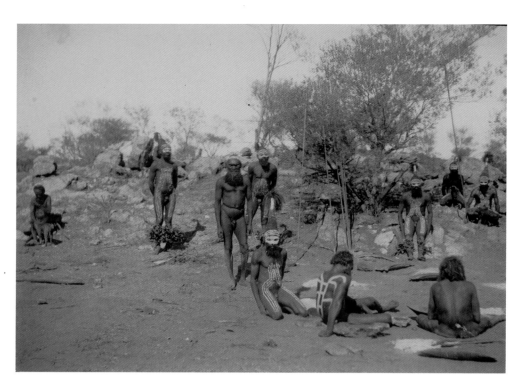

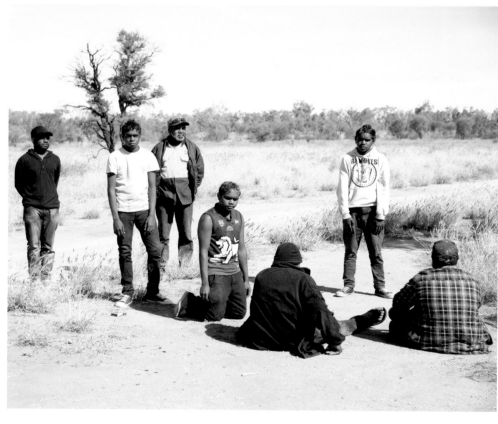

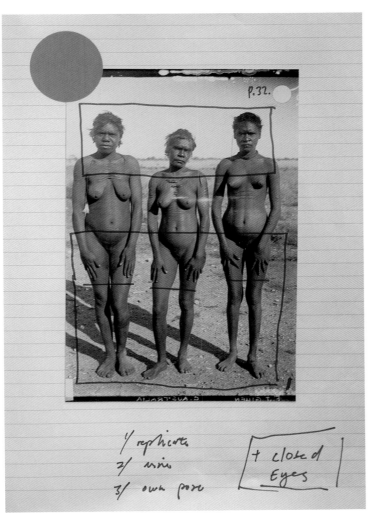

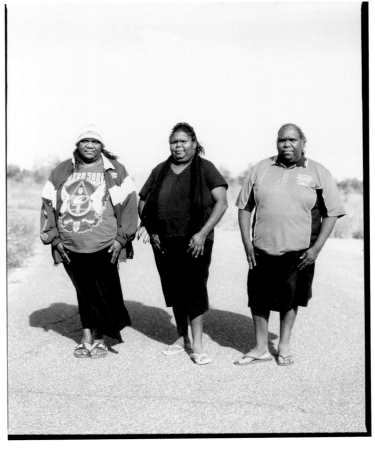

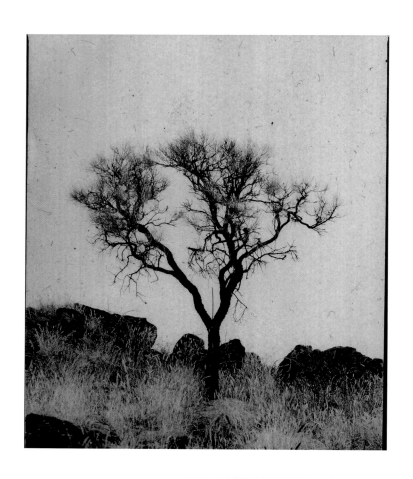

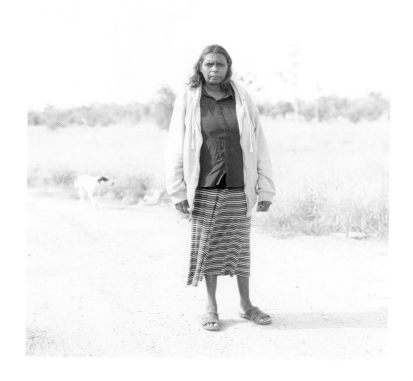

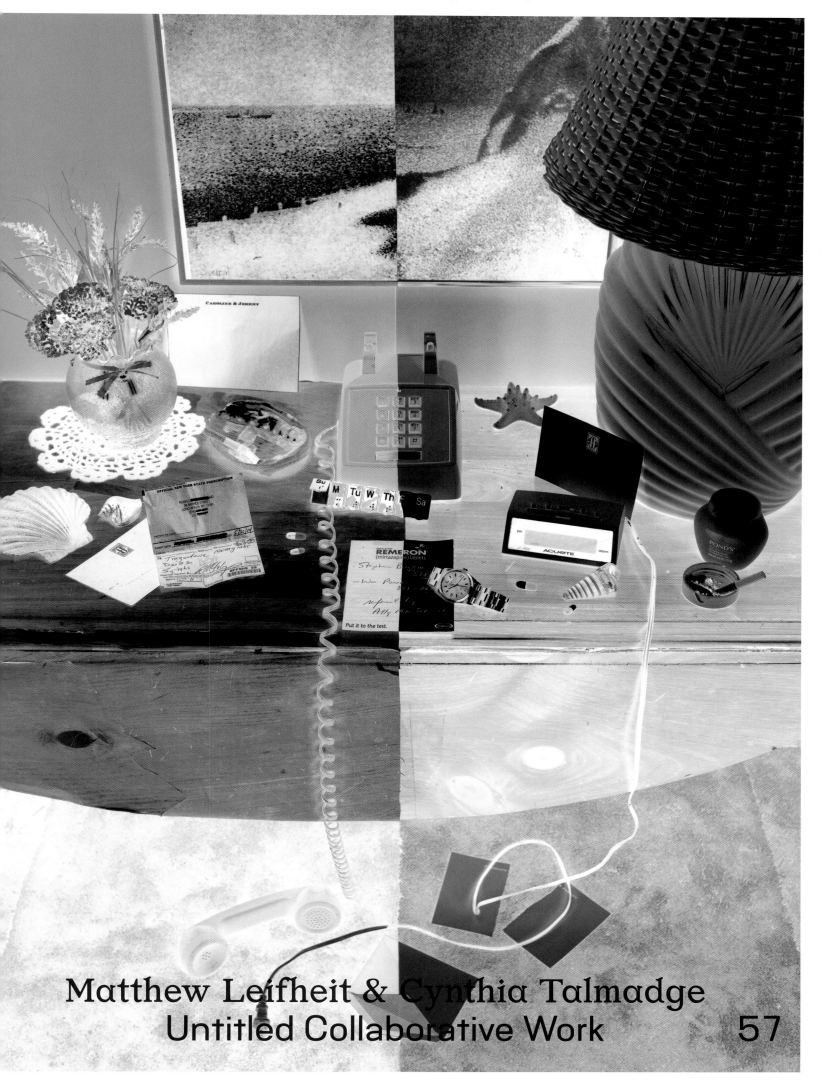

Matthew Leifheit & Cynthia Talmadge
Untitled Collaborative Work 57

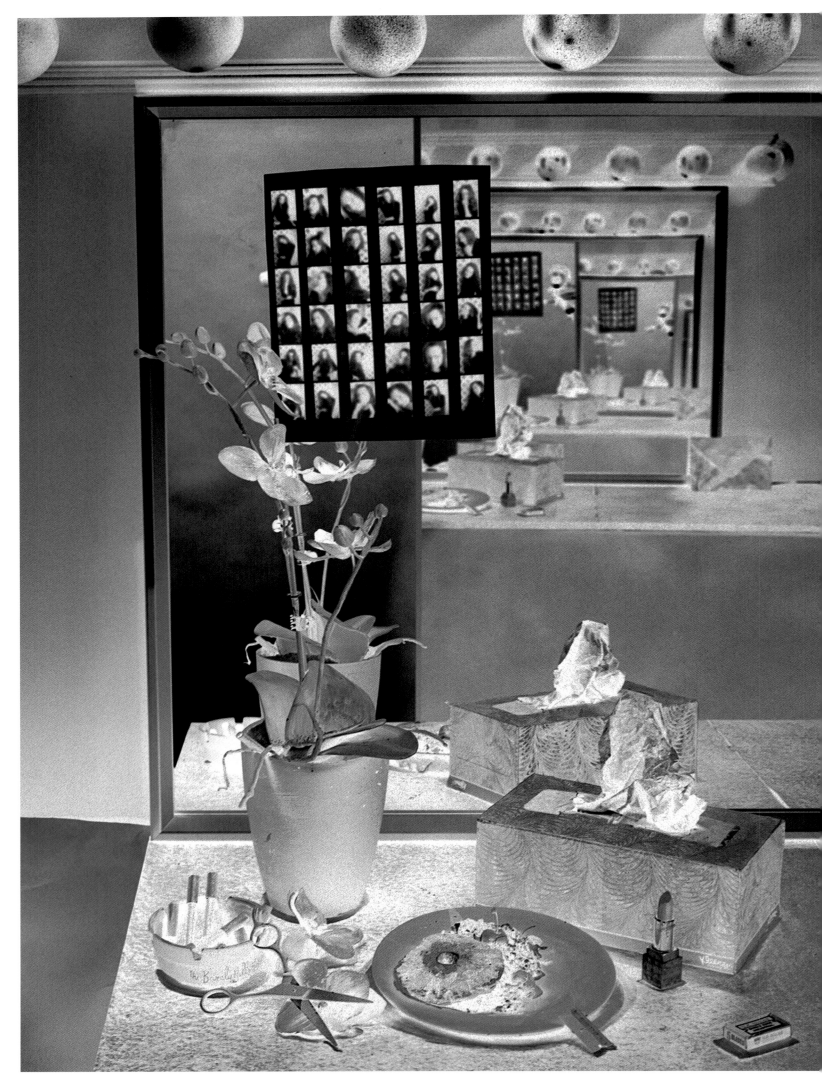

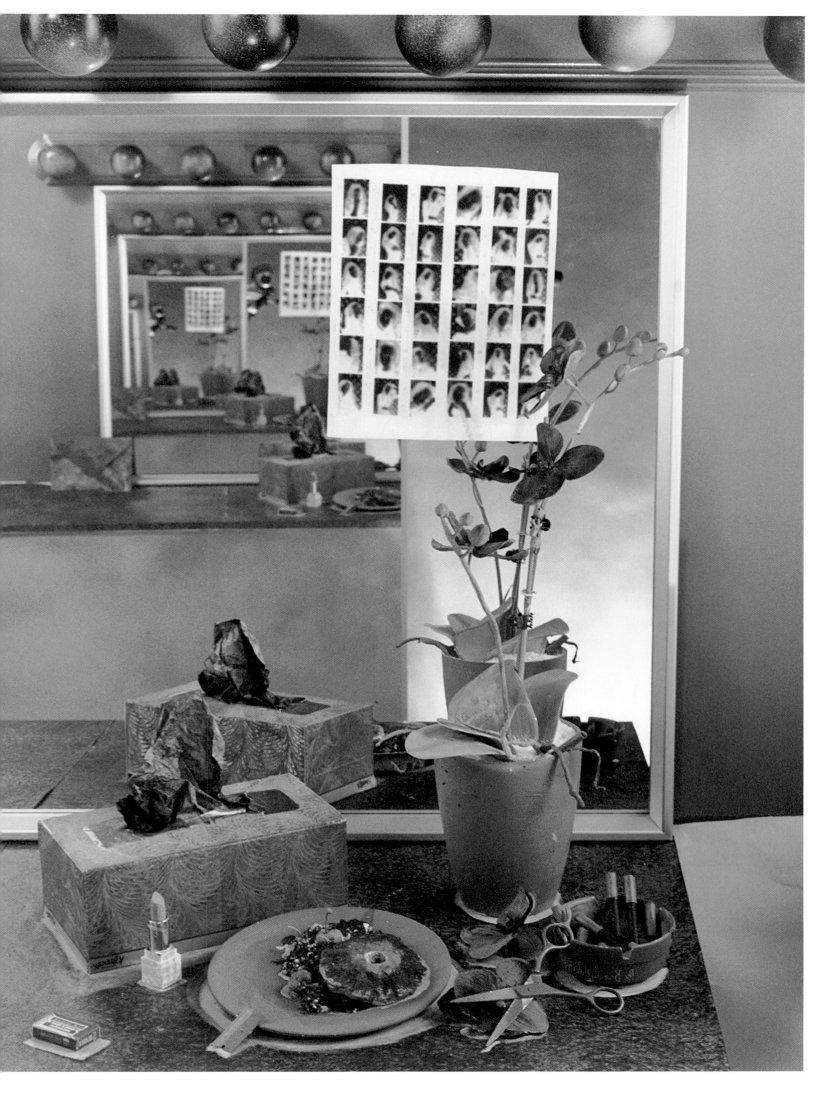

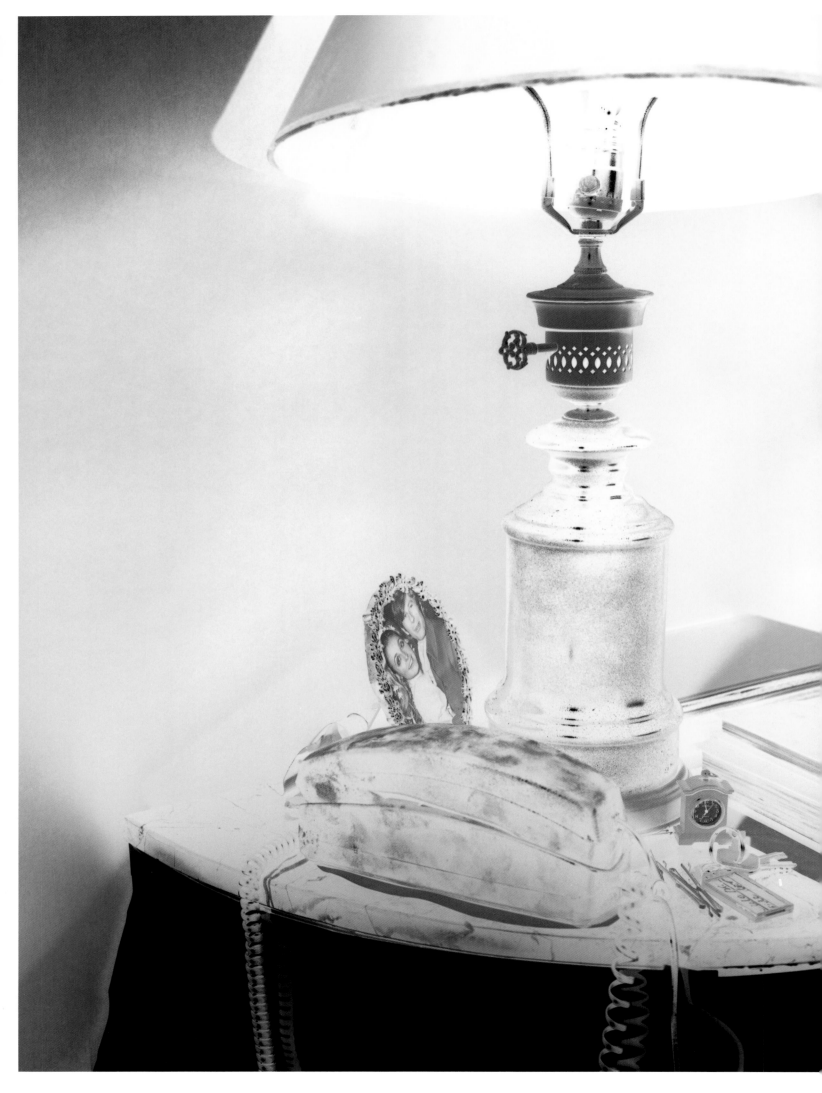

Finding a Form for Feelings

by Karin Bareman

A white frame floats in mid-air. A man looks through it, staring into the middle distance. His bodily contours are emphasized by big black lines. He is offset by an ochre and white background, a pink band ties everything together. Of all the pictures in the series *Tandem,* this one is perhaps the most intriguing. Whereas in the other images the model is still very much a human being, here he is very nearly transformed into a two-dimensional paper cut-out.

Manon Wertenbroek's route into photography is perhaps a little unusual. She started off her preparatory year at the art academy fully intending to study industrial design, as a result of her interest in objects, materials and forms. However, the required technical understanding of machinery proved frustrating. Photography provided her with a way to

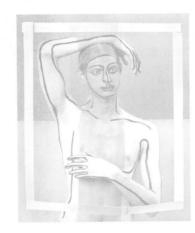

Manon Wertenbroek
p. 33

continue creating and designing objects. As Wertenbroek puts it: 'What I liked about [it] was the fact that I could have a frame. I could create objects, but at a certain point I was supposed to stop [working on them], because they had to go into the frame that I chose with the camera.' Even though her imagery reminds me of that by artists such as Daniel Gordon, Hannah Whitaker and Lucas Blalock, the artist considers expressionist

painting to be far more influential on her practice than the work of fellow practitioners.

It therefore comes as no surprise that the combination of material design and photography provides a way for Wertenbroek to process her emotions and experiences. She tries to give form to them, to make them tangible and visible. Her preferred materials are those that can be shaped easily and instinctively, ranging from clay to paper to pigments. She then carefully considers the objects she wants to create and how to arrange them in the final frame. The next step is to craft the actual objects. The production time for each picture can vary from hours to weeks, but on average she works three days on creating and lighting a set. Wertenbroek then generally spends an afternoon recording it. Capturing the scene as she has conceived of it in her mind's eye provides closure. In the artist's words: 'When I finish the photograph and print it, it finishes these feelings. It's like I turned a page. If I still had the sculpture I would feel like I am still having that feeling of something that I am searching for. With photography, it is a conclusion.' This need for closure also means that the elements of her images are never reused in other pictures. For the body of work featured here Wertenbroek collaborated with her brother as model. She

initiated this series, because she used to be very close to her sibling during her childhood. However, upon reaching adulthood they quickly grew apart. Teaming up with her brother was a way for Wertenbroek to process her emotions as well as an effort to reconnect. Moreover, as she states: '[As] I had been working on lots of projects with only objects, I wanted to go back to do something with portraits. I wanted to put something real into my sets, something that already existed.'

It was an intensive time. They spent three months creating the photographs. During the afternoon and the evening they could be found in the studio, with her brother modelling for several hours on end. Wertenbroek sees their time spent together as a cathartic performance: 'I wanted to find a way to express and digest these emotions and also to frame him in a certain way in order to keep him. To make an image of him that I wanted to have. It was almost a personal lie. I wanted to have my brother [back] so badly I was going to do this project and keep him in my images.' Wertenbroek feels that at a certain point they did become closer. Nonetheless, it remained very difficult to explain to her brother why she was doing this. And when the series came to an end, the distance returned. The artist is satisfied with the results though: 'It was a way to replace the weird memories by some new ones, some funny ones. Now I feel less disappointed about the fact that I am not that close to him, because at least we shared something new together after our childhood memories'

All images from the series *Tandem* © Manon Wertenbroek, courtesy of the artist

MANON WERTENBROEK (b. 1991, Switzerland) is a photographic artist who lives and works in Lausanne, Switzerland. In 2014 she obtained her BA in Visual Communication & Photography from ECAL. Her images have been published in *Yet Magazine*, *Else Magazine* and *Tank Magazine*, and have been exhibited at Festival Planche(s) Contact de Deauville in 2013. She works on personal projects and commissions, including for the Swiss Design Awards. A joint publication of photographs and poems by her combined with illustrations by Louisa Gagliardi is scheduled for release in autumn 2015. www.manonwertenbroek.com

KARIN BAREMAN (b. 1982, the Netherlands) is an independent writer and curator based in Amsterdam. She studied Anthropology and Visual Anthropology in Amsterdam and Manchester, focusing on the relationship between audiovisual culture and memories especially in relation to the former USSR. She has been awarded the Milton Rogovin Research Fellowship in 2015 from the Center for Creative Photography in Tucson, Arizona for her forthcoming research into Milton Rogovin's work on the mining industry in Appalachia. Her articles have been published in *Unseen Magazine*, *Of the Afternoon*, *Extra Magazine* and on American Suburb X and Potaatoo, amongst others. She previously worked as assistant curator at Foam.

The Photographic Wanderer

by Marco Bohr

Constantin
Schlachter
p. 41

In his photographic series *Une Trajectoire*, the French artist Constantin Schlachter focuses predominantly on subjects from the natural world such as rock formations or the night sky dotted with stars. Through a combination of photo manipulation and presenting the work in monochromatic colours, Schlachter makes his subjects look otherworldly—almost as if they were photographed on another planet altogether. Removed from their original context and situated within the darkness of this photographic series, the subjects depicted by Schlachter quickly take on the form of visual allegories. The otherworldliness in this work provokes the viewer to search for a meaning, looking for shapes in the rock formation or appreciating the passing of time in a long exposure of a nocturnal landscape.

The cave is one of the many recurring motifs in this body of work, bringing to mind Plato's *Allegory of the Cave*—amongst theorists and historians a frequently referenced philosophical debate about photography's presumed ability to depict the real. In Schlachter's work, however, the cave refers to something more primal or what the French philosopher Gaston Bachelard describes in his influential book *The Poetics of Spaces* as the ultimate form of shelter that can provide intimacy and comfort. The cave references the allegorical retreat to the womb, further emphasizing the fact that spaces are both physical as well as psychological.

The title of the work *Une Trajectoire* is a subtle reference to the journeys by itinerant monks from the Early Middle Ages who had no domicile or leadership. The so-called Gyrovagues—a French word derived from the Latin for 'circle' and 'wandering'—are Schlachter's inspiration for his own journeys into nature as a form of spiritual exploration of the inner mind. The emphasis in Schlachter's work is therefore not on religion, but rather it is on spirituality as *Une Trajectoire* to the imagination. These two aspects of a journey, both in the physical and a metaphysical sense, are signified by focusing on recognizable subjects yet Schlachter makes a conscious attempt to obscure these subjects via photographic manipulation.

Due to the heavy manipulation and obscuring of the subject, in Schlachter's work the viewer inadvertently participates in a type of visual experiment where some subjects can only be recognized by their shape. This type of *Gestalt* psychology is particularly apparent in images of animals such a fox, a goat or a horse. The purposefulness with which these animals punctuate the body of work is comparable to a fable, though the precise reason for their appearance remains unknown.

In my interview with the artist Schlachter broke his methodology down into a number of steps: first he photographs a subject following his own instincts and intuition. He then manipulates those images either while or after they were taken to blur the line between the real and the imagination. In the final instance Schlachter pays attention to how the images relate to each other within the context of the photographic series. The last point is rather important because the viewer is not necessarily asked to contemplate a single image, but rather, he is encouraged to consider the image within the body of work as a whole. Even if we only see a small selection of Schlachter's photographs, the sequencing of images and the notion of seriality relates to a type of storytelling more commonly found in experimental cinema, a subject Schlachter studied before he completed a photography course in Paris.

Schlachter's attempt to visually obfuscate the natural world can be related back to his upbringing. Raised in a small town called Altkirch in the Alsace Region, not far from the border with Germany and Switzerland, Schlachter grew up near thick forests, rolling hills and lush nature. The subjects we encounter in *Une Trajectoire* are mostly taken in that region of France. One of the few people in the photographs is the photographer's father. In that sense the word *Trajectory* also constitutes a journey into the past, though the manipulations allude to the fact that memories are never static and are instead prone to change. The work presented here could be considered a self-portrait of the artist: a *randonneur*, or hiker, traversing the landscape for indeterminate periods with few belongings on a journey into the past, or a journey into the imagination. Or both.

CONSTANTIN SCHLACHTER (b. 1992, France) is an artist based in Paris who works mainly with digital photography, manipulating his images through various digital and analogue processes. He studied Literature and Cinema at the Lycée Paul Valéry, Paris. In 2014 he obtained a Photography Diploma at Gobelins, l'école de l'image, also in Paris, receiving First Class Honours for his portfolio. In 2014, he exhibited an excerpt of his project *Une Trajectoire* at the collective exhibition *Fetart School Factory*. www.constantin-schlachter.com

MARCO BOHR (b. 1978, Germany) is a photographer, academic and writer on visual culture. Born and raised in Germany, studying photography in Canada, living in Japan, and continuing postgraduate studies in the UK, he hopes to bring an international perspective to the study of photography. He completed a Visiting Fellowship at the Australian National University before his appointment as lecturer in Visual Communication at Loughborough University. His writings appear regularly on visualcultureblog.com, a platform for photography and visual culture.

Talent

Sorry Business

by Jörg Colberg

Christian Vium
p. 49

Much like writing, taking photographs is not a completely innocent business. Despite the medium's relative youth, photography has played an important role in some of mankind's worst self-inflicted tragedies, whether they were societal and/or cultural (and thus playing out over larger periods of time) or more violent. To photograph inevitably is connected to being in a position of power, and that photographic power has often been connected to other types of power. European explorers and anthropologists who trekked across other continents and brought back photographs from the colonies of cultures deemed inferior—and often depicted accordingly. Photographers played a large role in ideas of cataloguing people on the basis of obscenely misguided pseudo-scientific principles, some of which, in a seemingly more innocent manner, are still in play today.

Several important questions arise. How can the medium's toxic elements in its history]be properly acknowledged and processed? And given these toxic elements, what are the ways in which the medium can re-engage with some of the subjects it previously dealt with without re-violating their rights?

An awareness of some of photography's most important challenges that arise from its past (or even ongoing present) misuse has entered public consciousness, particularly the depiction of women in the media. Other, equally important issues have yet to emerge into the mainstream, the idea of The Other being one of them.

Between 1875 and 1912, anthropologists Frank Gillen and Baldwin Spencer created what was to become an influential catalogue of Aboriginal life in Central Australia. In the resulting photographs, the idea of The Other plays out in its most basic form, which probably also is most easily understandable: a marginalized culture was being photographed. In mid-2014, anthropologist and photographer Christian Vium went to Central Australia, aware that his own photographic work to date contained traces of 'what I have come to understand as stereotypical and problematic in its institutionalized view on The Other'. This, he understood, would be a reason for concern. 'Perhaps, in spite of my good intentions, I was merely reproducing a problematic way of representing The Other that is deeply engrained in anthropological discipline as well

as the entire history of the western world.' But how to solve the conundrum?

Vium's main ambition for the project, of which *The Wake* is but one part and ongoing, 'is to facilitate a temporal dialogue between past and present across cultures, which may, somehow, point toward the future.' It is important to realize that to photograph is not to be engaged in dialogue *per se*. To get to a dialogue, the power dynamic inherent in the medium has to be broken. To that end, Vium made collaboration with his subjects an integral part of his work. 'In my point of view, photography is about this: dialogue and collaboration, and my current work oscillates around three practical pivots: archive research, visual repatriation and photographic re-enactments. Working in close collaboration with local people, many of whom are descendants of those depicted in the original photographs is crucial to this endeavour. Their readings, analysis and performances constitute the nexus of cultural critique.' Consequently, the photographs from the archive are not being discarded, but are instead acknowledged for what they are. 'The original photographs become a point of departure for dialogues and encounters that become social events often drawing an audience, as a form of semi-improvised theatre plays.' Much of the work ended up focused on the depiction of mourning practices, commonly referred to by Aboriginal Australians as 'sorry business'. Given their shorter life expectancy the prevalence of such practices probably should not be surprising. Mourning became a central metaphor for the challenges facing Aboriginal Australians today.

'I'd like to think,' writes Vium, 'I make photographs with people, as opposed to taking photographs of them.' And this he ties to such ideas as Werner Herzog's notion of *ecstatic truth,* or *Verfremdung* (defamiliarization) as defined by Viktor Shklovsky and Bertolt Brecht. At the core lies the idea that, 'as Jeff Wall has put it, "it is more interesting to look at the picture as a representation than to look at the event as an event".' This is intended to bridge the gulf between two cultures, one of which forced the other to live in abject poverty, its rights denied and went on to write the script for how the other culture was to be seen. To bridge the gulf photography's most basic assumptions and rules need to be broken or subverted, as anything else might just end up being a re-staging of earlier injustices, despite any number of good intentions.

Engagement with this work will require some effort on part of the viewer, but as-likely-someone from a very privileged background, being willing and able to engage with the legacy of his or her culture is the least one can expect.

CHRISTIAN VIUM (b. 1980, Denmark) is a photographer, filmmaker and anthropologist, primarily working on long-term personal projects anchored in participatory observation and in-depth collaboration. Investigating the intersection between documentary, art and the social sciences, he has worked with a wide variety of professionals, from film directors, journalists, photographers to anthropologists, historians and artists. Works have been shown at exhibitions and screenings in Athens, Austin, Berlin, Cape Town, Copenhagen, Geneva, London, Moscow, New York, Norderlicht, Stockholm and Taiwan. He is currently employed as a Post Doctoral Research Fellow in visual anthropology, as part of the research project *Camera as Cultural Critique* at Aarhus University. www.christianvium.com

JÖRG COLBERG (b. 1968, Germany) is a writer, photographer, and educator. Since its inception in 2002, his website Conscientious has become one of the most widely read and influential blogs dedicated to contemporary fine-art photography. In addition to publishing writing online, his articles/essays have been published in photography and design magazines and in photographers' monographs. He is also a Professor for Photography at Hartford Art School.

Talent

Emotional Relics, the Copy, and Constant Effigies

by Brad Feuerhelm

The famed philosopher and cultural anthropologist Claude Levi-Strauss constructed an oeuvre of written works that considered the connectivity between society, ritual, myth, and symbol. His work was concerned with how the human mind fashions a structural analysis to the mythmaking of an image and how a society thus understands itself. His interests in the cultural law of a society reflect that the individual did not create understanding by its pattern of personal cognizance. He was particularly concerned with the creation of the historical society and how such societies used symbols, languages, perception, and myth—building tradition, ranging from ritual adaptation of material function to its representation within societies at large.

Within the tradition of myth-making analysis and the ontological processes of sacred ritual, we begin to understand the camera's importance within methods of representation, and that of the photograph itself, as well as the subconscious inventions of a pathos created around the photographic image as a

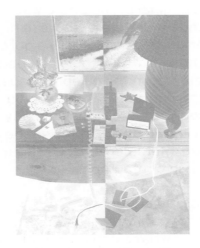

Matthew Leifheit &
Cynthia Talmadge
p. 57

physical object. That is to say, we empathize with the representation of a photographic image in emotional terms as a stand-in for memory, and that of an emotional relic or effigy transposing our emotional condition onto that of a physical object of representation. The importance of this function-as-object, underlines a subsequent cultural attachment to what is represented within the photograph and how its implications are registered by historical analysis and collective structures of emotion and language.

In the works of Mathew Leifheit and Cynthia Talmadge, we look at the fabricated photograph and its methods of presence and absence through the use of the negative and positive print, further enabled by the medium of Talmadge's painting. The use of the negative image next to the positive creates a division between how our methods of optical perception understand the positive's inverse, largely its negative. The schism here is created in optical and metaphorical terms and considers what Hillel Schwartz has termed the 'culture of the copy'. All manner

of horrific pathologies are exacerbated within their doubling. The metaphorical Siamese twin, the polycephalic dysmorphic head, and its cultural associations with a horror that is close to the original body, becomes an errant discourse with the understanding of the familiar yet estranged copy.

Further to this, the use of the positive/negative diptych within the work, a new question of methodology of perception arises when we consider the use of the familiar in terms of the patterns of twentieth-century phenomenology of fame, particularly fame and tragedy as seen in the still-life image of Sharon Tate's bloody phone
on her bedside table, next to a micro-relic within, the photograph of her and Roman Polanski on their wedding day. The image enables our collective understanding of her murder and that of her unborn child in 1969 by Charles Manson's followers as that of an effigy of whose inquest resonates an understanding not only of that of the effigy, but that of our own place within the hierarchies of social group surrounding historical infamy and tragedy. The negative and positive images produce a catalyst for our understanding of that which is negative in an image at its positive base into what we may cultivate from our perception of its inverse, the negative. It is as if to suggest an

unburdening of collective trauma through the uncanny cognition of what the inverse could be, if not given a positive status within our cultural associations of its image. Speaking on the work itself, the artists have made certain that they understand the position of its place within their tableau.
'We were originally drawn to a police photo of Sharon Tate's bedside table from the morning after her murder for its staged quality—it's a utilitarian photo but it's also too perfect, almost what we imagine a set decorator would present as this scene. The original police photo was found on Pinterest, so we're not even sure that's actually a police photo in truth... People seemed interested in the celebrity aspect of the picture, that they could recognize a story they already had knowledge of in the image. We're interested in ideas about truth in photography.'

This is to suggest that the authors are very aware of the idea of what a copy can project in a photograph, and the pathos that it implies on a cultural level. To take a photograph that could be spurious, but to employ its use to create an effigy of which cultural symbols of mourning and fame meet at an intersection is to elevate the document to a level of mass psychological warfare from which the audience, within the context of seeing both the negative and positive images, are forced to subconsciously understand and project these systems of traumas on the photographic object, for whose social order and permutations may become affected to that of mythological status through psychological programming in artistic practice, the circumstances of which are to consciously accept the per-

ceived object as calculably disharmonious to collective pathologies of loss, trauma, and fame.

All images from the series *Untitled Collaborative Work* © Matthew Leifheit and Cynthia Talmadge, courtesy of the artists

MATTHEW LEIFHEIT (b. 1988, United States) is a Brooklyn-based photographer, curator, and writer. In addition to being photo editor of *VICE Magazine*, he self-publishes *MATTE*, a journal of emerging photography sold by Printed Matter, Inc. and MoMA PS1.
www.matthewleifheit.com

Cynthia Talmadge (b. 1989, United States) attended The Rhode Island School of Design at various points between 2005 and 2011. She has been featured in recent group exhibitions in NY and LA, including shows at Monya Rowe Gallery, Petrella's Imports, and Pioneer Works. Her work has featured on HyperAllergic, #FFFFWalls, the Opening Ceremony blog, and VICE. She is also the founder of the cult Cynthia Talmadge for KAΘ clothing line and an interior design consultant to health care providers CRC Health Group/Sierra Tucson. She lives and works in New York.

BRAD FEUERHELM (b. 1977, United States) is a photographer, photography collector, curator, dealer, and writer on photography. He has published several books on his collection and has exhibited his collection of photography widely. In 2012 he published his first book with Self Publish, Be Happy and in 2013 he published his second book *TV Casualty* on the Kennedy assassination and popular screen culture with Archive of Modern Conflict. He has contributed his writings and collection to *Granta, British Journal of Photography, Photography & Culture, Dazed & Confused* and *Art Review*. He is also a director and managing editor for American Suburb X.

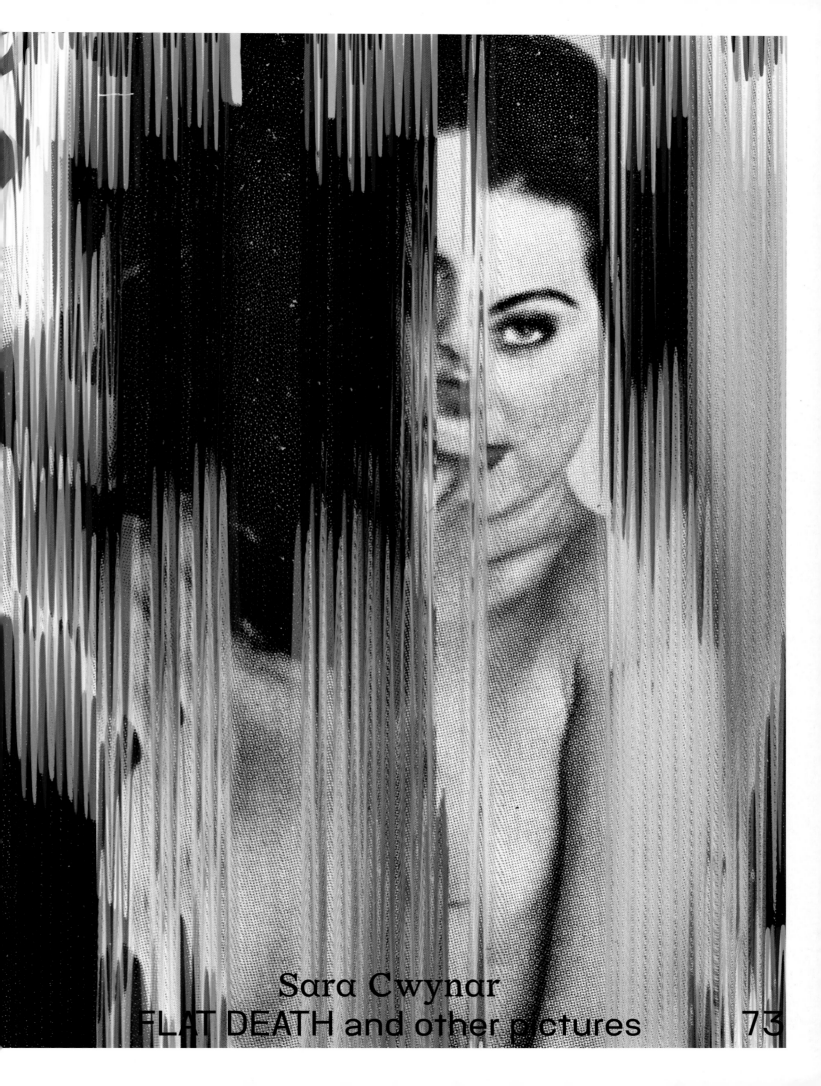

Sara Cwynar
FLAT DEATH and other pictures

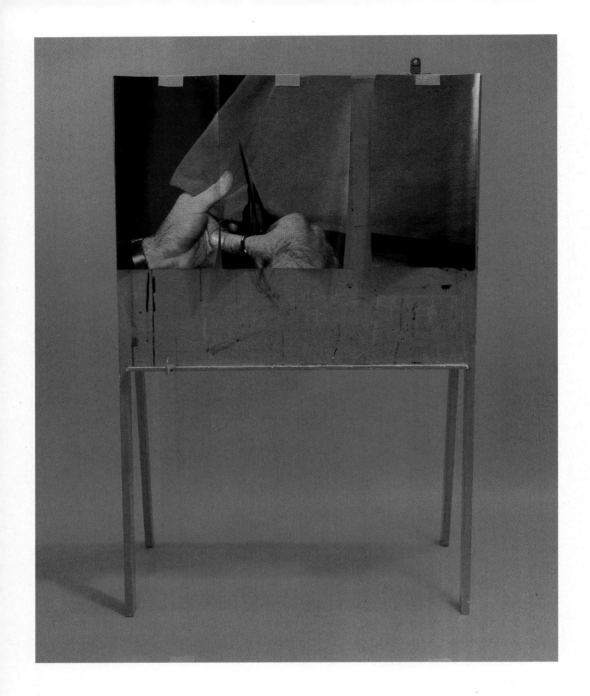

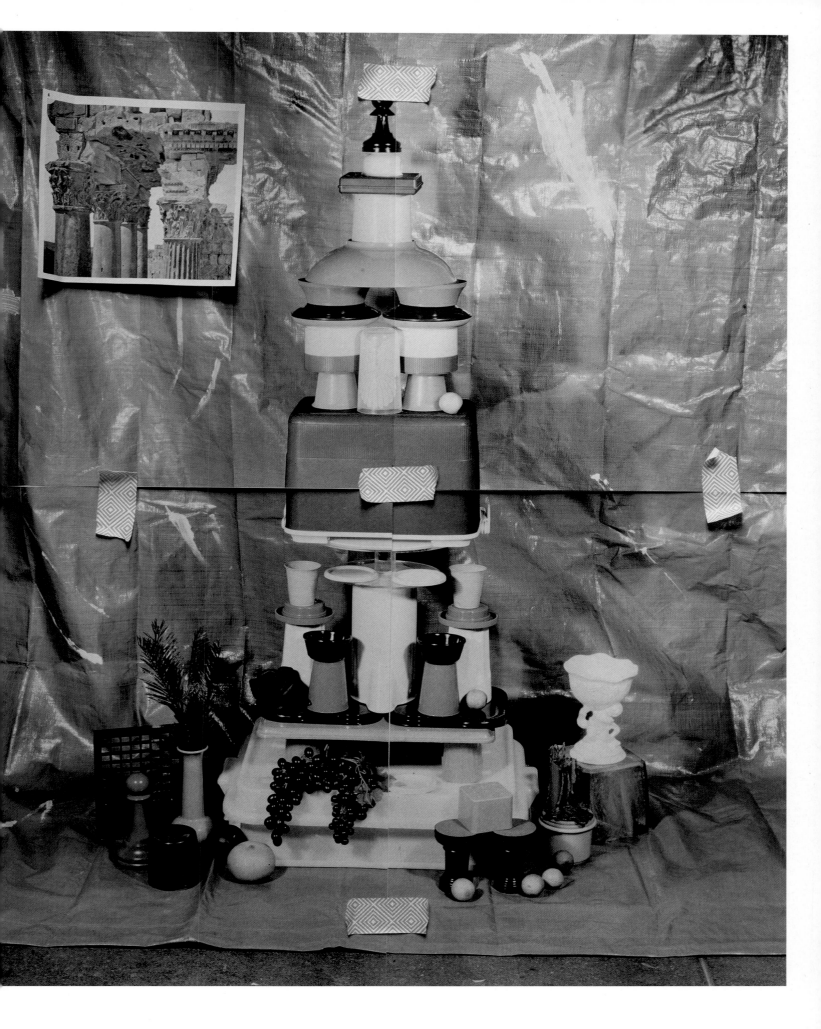

No. 64 CONS. H. 8 ¼″ W. 24″ D. 16 ½″

No. 66 WIRE H. 20½" W. 24" D. 11¾"

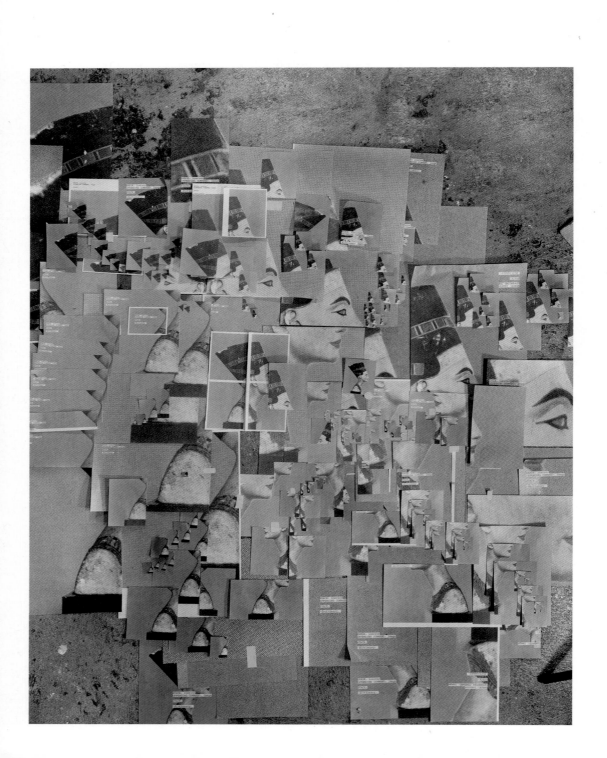

BETWEEN KITSCH AND THE HYPERREAL

on Sara Cwynar p.73

by Claudia Küssel

Sara Cwynar's practice moves between photography, installations and collage and starts with obsessively collecting and ordering visual materials. Saving, taking and re-composing images is a cathartic means of satisfying a constant impulse to collect and to create a tangible record of her experience, grasping a small piece of the world and reconstituting it according to her own terms. The resulting archive is composed of images saved over years of her own photo-taking, from encyclopaedias, flea markets, as well as objects she encounters. In this process of accumulation and the resulting collection, she is interested in the ways in which we understand the world through pictures: how we view ourselves and our history through a shared image-based archive built from cultural fantasies and photographic tropes. A key characteristic of her method is the investigative attitude she applies to the photographic image and its representation, with photography itself as the most important subject.

Cwynar is one of the striking voices of a new generation of visual artists working in photography with a special interest in the aesthetics of analogue procedures. Her attitudes are very much defined by the internet era and how our concept of the world is influenced by commercial and promotional photography. Artists like Matt Lipps, Lucas Blalock and Kate Steciw all share a special interest in the specific qualities of both analogue and digital photography while working in traditional genres and forms. They use found images, from printed sources and the internet. They cut, rearrange and compose, add, layer, manipulate, and play with the tension between the two- and three

dimensional. They combine hybrid approaches so that the process is just about as important as the end result.

Although Photoshop is used for specific effects, its traces can be noticed in the final work. Instead of using the tool to conceal, Cwynar finds ways to make it reveal or emphasize the process. 'Most often, the way I work is through sourcing printed material from various magazines, books or encyclopaedias. I then scan these images into digital files and blow them up much larger than the originals, printing them out as laser prints and re-tiling them back into the original picture. I will also sometimes improperly scan found printed matter to mark an analogue print with digital noise, mixing old images with contemporary imaging technologies. I then rebuild the images in different ways using a combination of contemporary and older, discarded materials. I re-photograph the construction in the studio and print it back out as a photograph, making a new still-life image out of a found one. It is a circular process: beginning with a photograph and flattening it back into a new version after much intervention and manipulation. The pictures go through several rounds of digital and analogue photo processes before I have a final.'[1]

Although there's an obvious sympathy for the vintage feel of photography from the sixties and seventies in Cwynar's works, that is only a first impression: 'As nostalgic and analogue as my work is, it's often responding to the internet—I'm not just fetishizing these images, but responding to the way we experience images now. You look at my photographs, and you read it in an instant as you do with everything, and then hopefully you realize, "Oh, wait, it's not quite that"—maybe you could think about everything you're looking at a little bit more, maybe you notice some of the objects as things you own or relate to, or you could have the process thrown into question.'[2]

With a background in graphic design, Cwynar has a special sense for the visual qualities of an image and how to manipulate it. In her earlier works she focused on common images, par-

She's cons
life of pho
over

especially at
time of a
the m

dering the
tographs
ime,
his
hange for
edium.

ticularly outdated advertising still-lifes. For the series *Color Studies 1-6* (2012) she followed the formula of the commercial still life to systematically organize everything in her studio. She used colour scale (a visually immediate category) to arrange her materials into surreal versions of conventional consumer still-life photographs and taxonomies of single-image types formed into collages. This piece pulls from many images she has saved of outdated product shots in which something that was historically desirable and forward-looking becomes absurd with the passage of time.

However, most of her three-dimensional practice finds place to stage a picture within the studio. She's interested in raising tension by adding real objects to her presentation as she did for the exhibition *Everything in the Studio (Destroyed)*. On a wallpaper she presented an image of a culmination of objects she collected and installed in one of the corners of her studio. After taking a picture, she destroyed the installation and got rid of the objects. For her presentation she re-installed a wide range of objects onto it, creating a monumental tableaux of banal objects, fruit and plants, mirroring the original situation and causing optical confusion between the image and the real props at the same time.

Her fascination for ordinary objects is rooted in literature and theory: 'I refer often to Milan Kundera's concept of kitsch which he defines in

The Unbearable Lightness of Being as the familiar images we look at in order to ignore all that is not aesthetically appealing about life (examples are national and religious motifs, monuments, idealized nature, advertising imagery, symbols of progress). These images make up much of the common archive.' She expanded upon this concept of kitsch in relation to pictures in her second publication *Kitsch Encyclopedia* (2014), a book that compiles texts by Kundera, Roland Barthes and Jean Baudrillard alongside her own writing and collected photographs to draw out the ways in which images are used in the construction of a collective consciousness in a world that is layered with kitsch.

Baudrillard's *Simulacra and Simulations* (1981) is an important reference, especially for his definition of kitsch as a manifestation of the hyperreal, as simulations of the world that have started to matter more than the reality they represent. 'In my works I am trying to foreground the fact that images change without us and that they often obscure their status as constructions, seeming like pres-

entations of reality even when they are highly manipulated. I am trying to make pictures that show their falseness on their surface. I'm interested in how pictures accumulate, morph, endure, get away from us and become something different to what was originally intended. I try to highlight these changes—how images warp with the passing of time and changing trends and with a divorce from original context. It is not just form that changes as images move through space but also function, value, and use.' The ongoing series *Accidental Archives* works through photography's inherently archival nature—how it turns everything into a document with some authority,

being 'a central reason I often choose photography as my medium'—and plays with that expectation. The series involves making stranger versions of familiar images, and finding examples of pre-existing archives waiting to be photographed. Her recent works are still based on found images, but she has shifted from the genre of still-life to the representation

of portraiture in photography. The tactile aspects of the image have an important presence, especially in the manner she treats both the represented skin of the human body, painted skin or skin of sculpture, as opposed to the surface of the paper. 'I liked how it negates the space in the actual photographed environment (like a constant reminder that this is a photograph with a surface) and how the texture interacts with the flesh in the photographs.' One of her most recent works starts from a small image of Nefertiti she found in an encyclopaedia: 'The original photograph in the picture has a slightly different colour. It's right in the middle with a dot on it. I scanned the picture and then printed it out over and over again on a laser printer. Sometimes it would stall and make this error message (you can read it in the picture, "error: operator offending command: image stack dictionary") and it would stop printing when the error happened. So I had all these different fragmented pictures of her face and then I rebuilt her image out of them. I also was thinking about an office or a screen and having too many windows open on a computer screen at work, but using this faded picture of a highly valued object.'

Cwynar comments playfully on the fundamentals of photography and its tradition of composition, genre and aesthetics by constructing her own personal archive as a method of intervening in the larger archive, which is out of her control. She's considering the life of photographs over time, especially at this time of change for the medium. As systematically as she works with ordering the world through images and objects, she's exploring how our idea of the world is defined through pictures over time, how dreams and desires are created—between kitsch and the hyperreal.

SARA CWYNAR (b. 1985, Canada) is a New York based artist working in photography, installation and book-making. In 2013 she held her first museum show at Foam with the exhibition Everything in the Studio (Destroyed). She is currently finishing her post-graduate position at Yale School of Art. She is represented by Foxy Production, New York, and Cooper Cole Gallery, Toronto.
www.saracwynar.com

CLAUDIA KÜSSEL (b. 1975, the Netherlands) has been a curator at Foam Museum since 2012. She's an art historian and graduated from Leiden University. She has previously worked as a freelance curator and for the Exhibition Department of the Nederlands Fotomuseum, Rotterdam. She edited Handbook to the Stars, by Peter Puklus, and is a regular contributor to the Foam blog and Foam Magazine amongst others. She lives and works between Haarlem and Amsterdam.

1 Abeles, Michele, et al. 'Recording Images: A Round-Table Interview Curated by Lauren Cornell with Michele Abeles, Sara Cwynar, Jon Rafman & Travess Smalley.' Mousse, 43. Apr. 2014: 238-252.
2 Linton, Jackie. 'The Recurring Sara Cwynar.' Interview Magazine. 4 April. 2014. Web

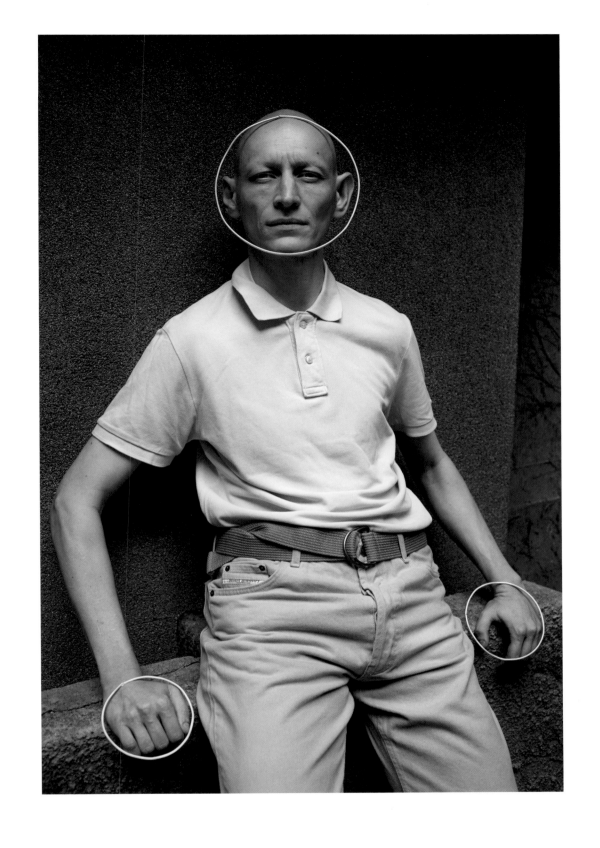

Márton Perlaki
Bird Bald Book Bubble
Bucket Brick Potato

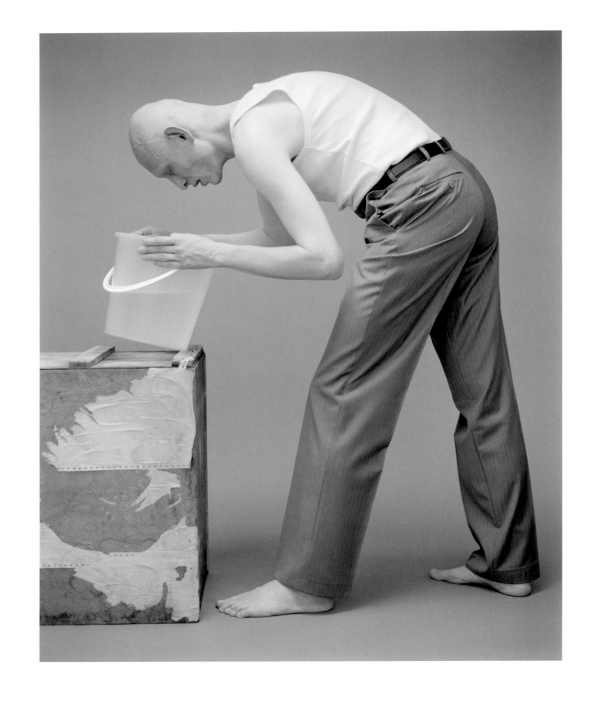

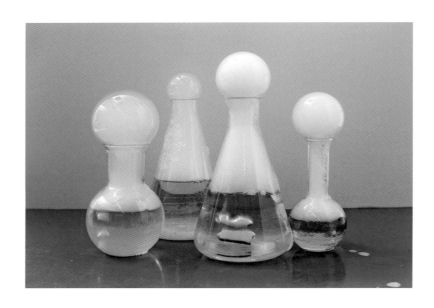

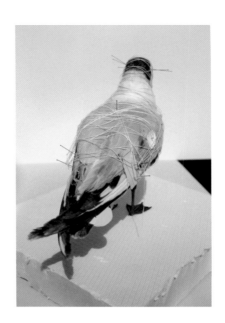

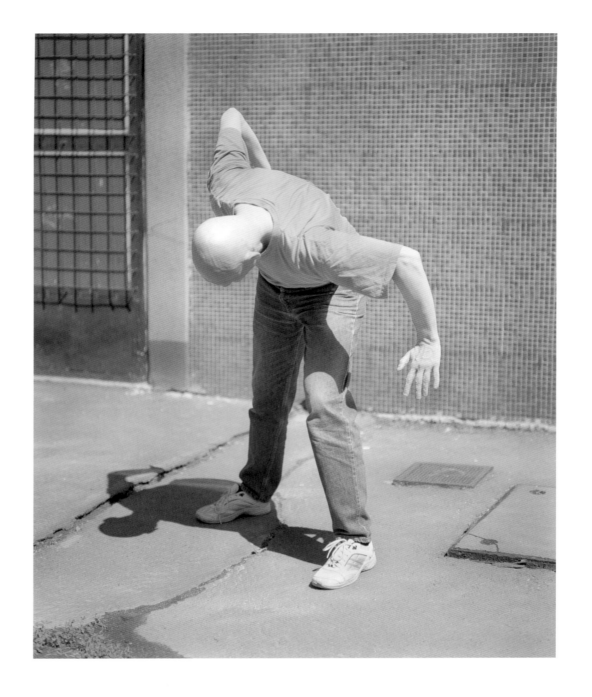

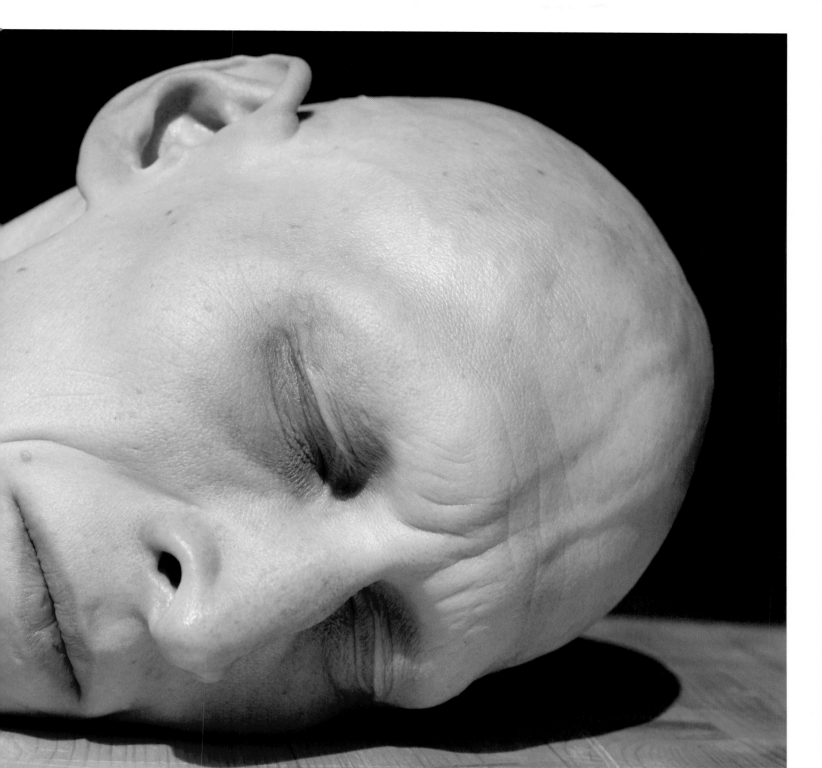

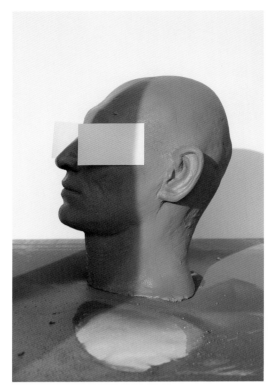
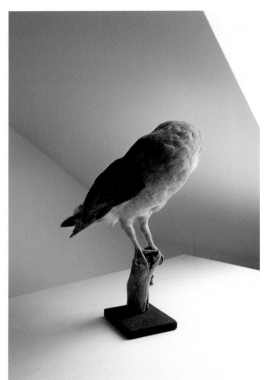
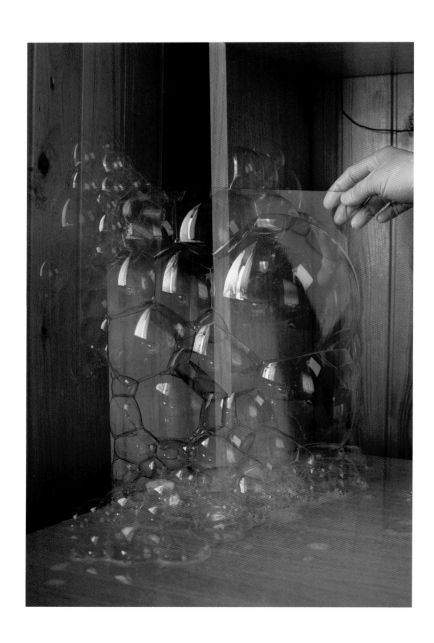

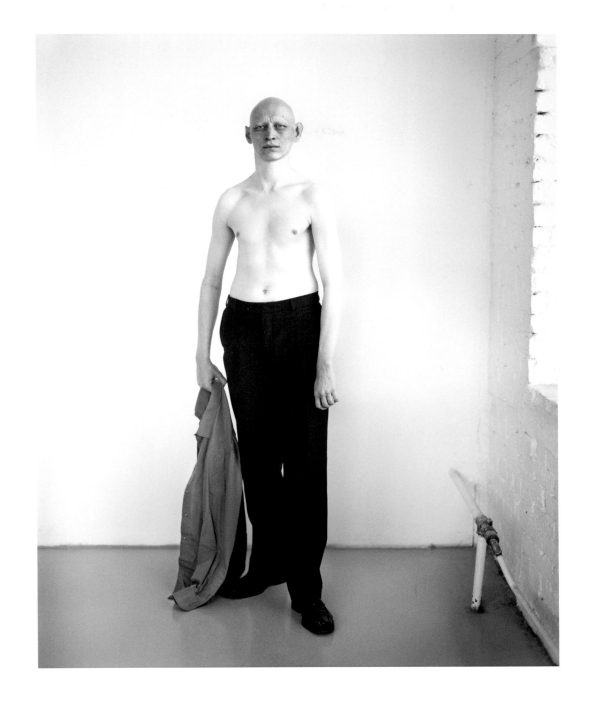

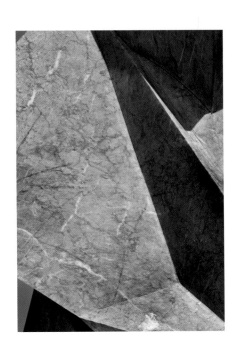

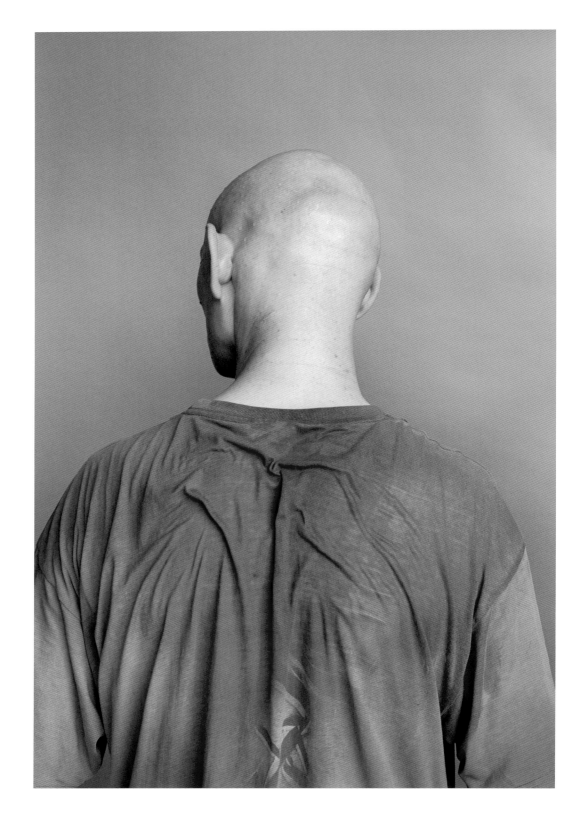

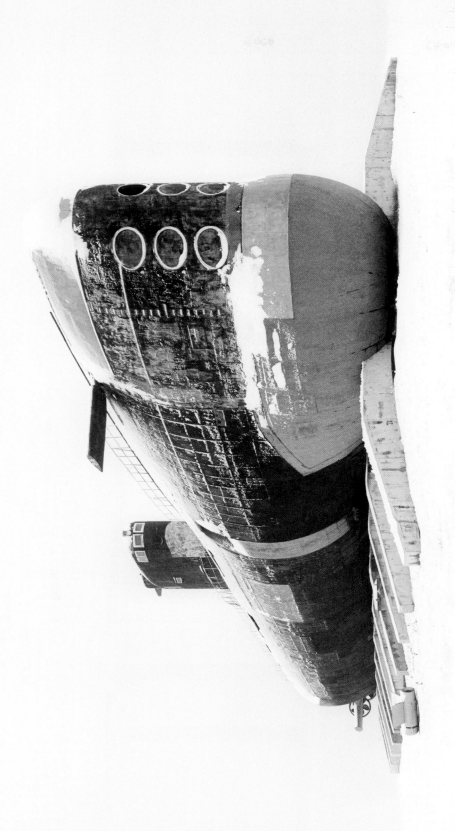

Danila Tkachenko
Restricted Areas

107

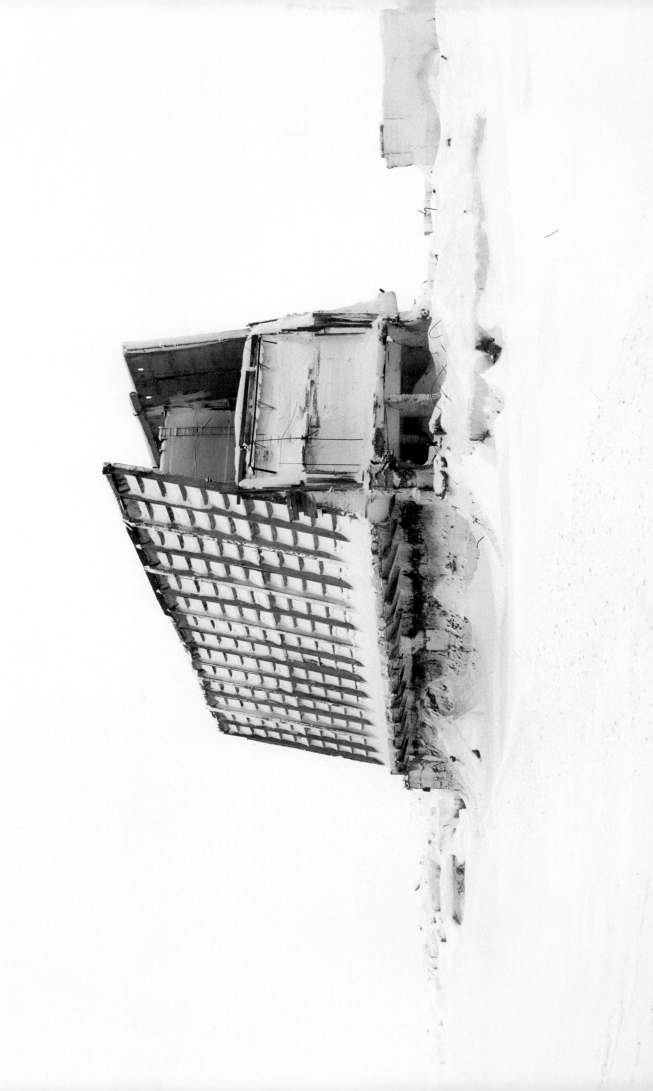

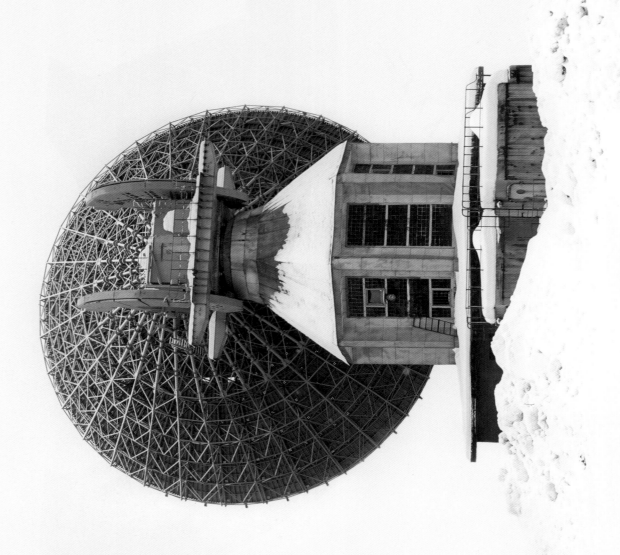

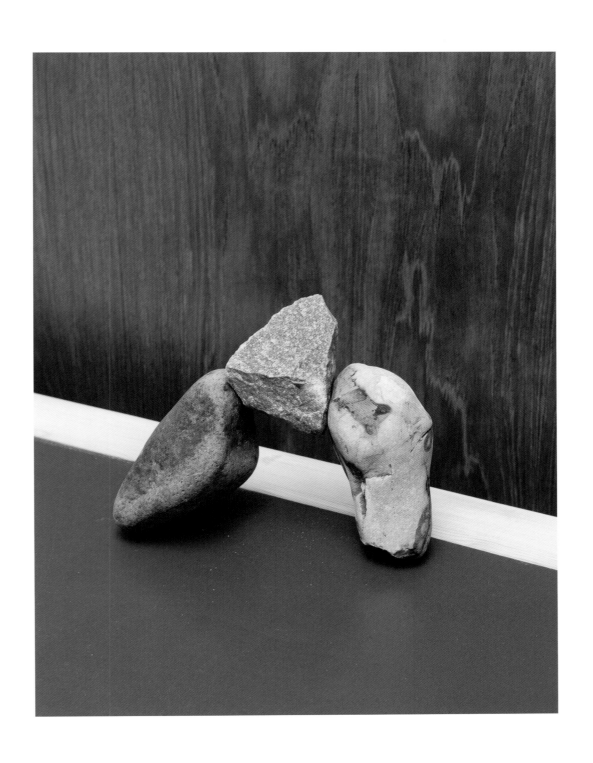

Johan Rosenmunthe
Tectonic

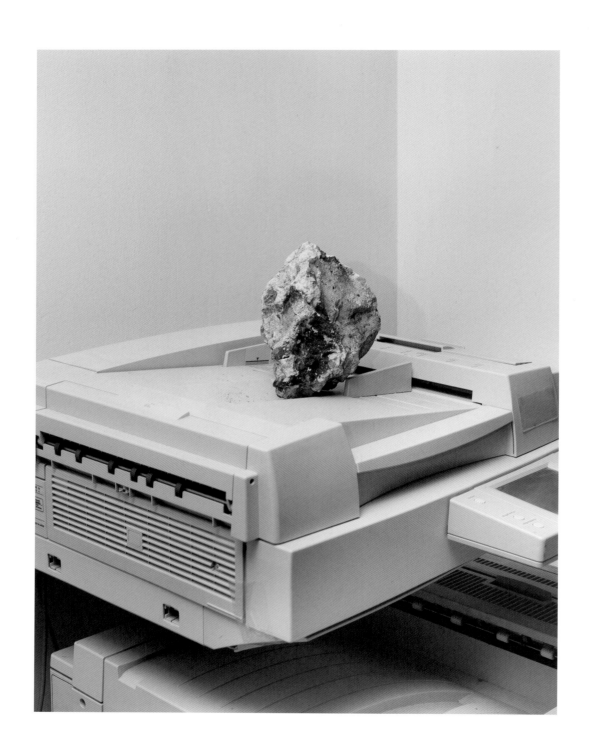

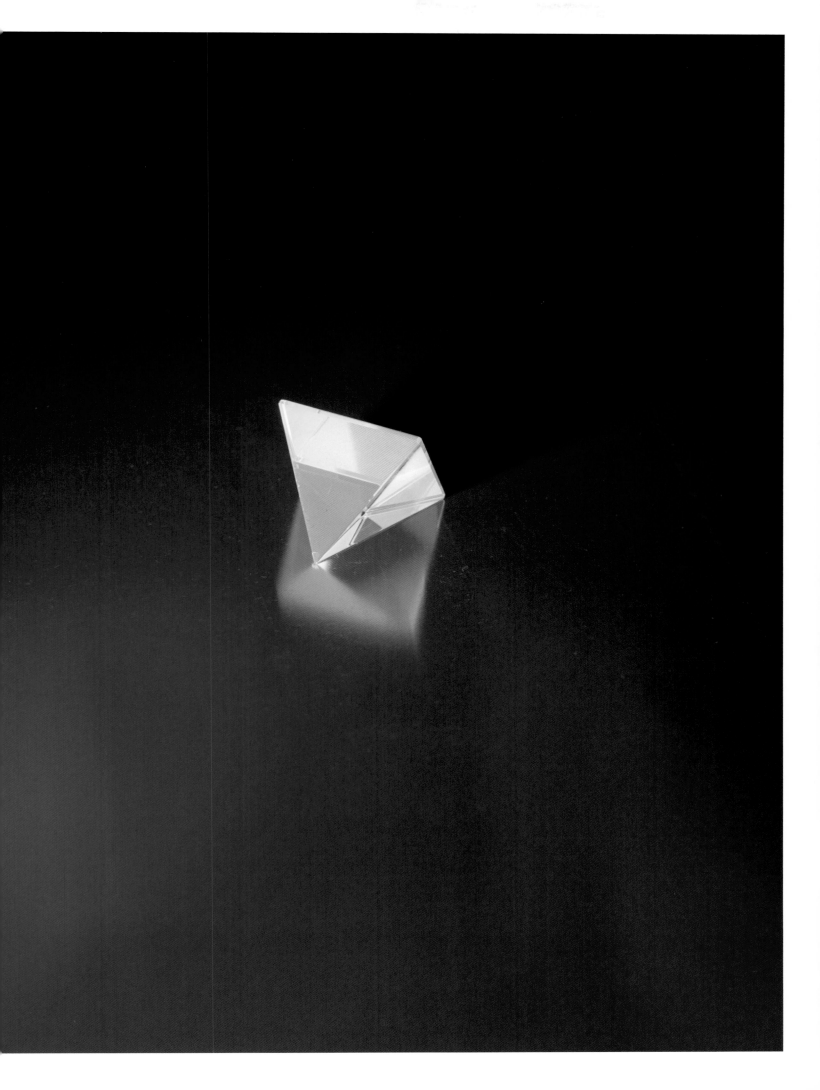

Guo Peng
Untitled

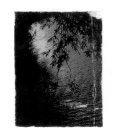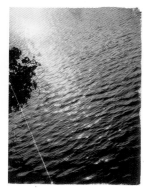

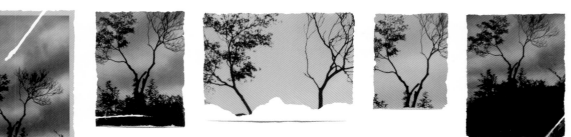

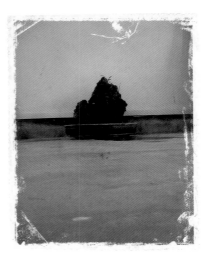

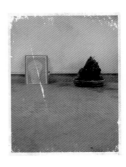
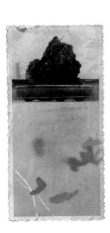
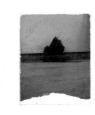

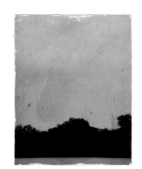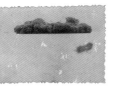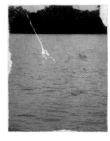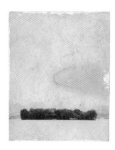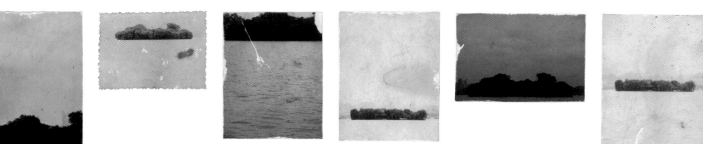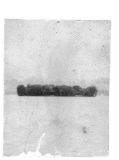

Mind Games

by Tim Clark

'A picture has the ability to mislead the mind, opening a door to alternative narratives that exist within the viewer's subconscious,' says Hungarian artist Márton Perlaki. 'I wish to access these moments of subjectivity and navigate the viewer towards a game of associations.'

His ongoing series *Bird Bald Book Bubble Brick Potato* presents a rich array of seductive and zany imagery, drawing principally on two main photographic genres—still life and portraiture. Perlaki's process involves carefully planning and creating unique arrangements, wherein he makes everyday objects and scenarios undergo an absurdist upheaval. Some images show a macabre-looking man as he strikes equally unusual poses or exhibits various states of uneasiness; some show stuffed birds wrapped in string, their eyes pierced with needles; while others reveal constellations of bubbles emerging delicately from laboratory apparatus. These are but a few examples of the jarring mix of themes and photographs that chafe on our mind, ultimately summoning the idea that discontinuity and dislocation can be powerful strategies to break down audience identification in order to defy viewer expectations.

'I was always drawn towards variety in a series and never really interested in linear storytelling,' he says. 'I find it important to make the viewer participate and invite them to make connections between seemingly unrelated images. Everyone can create their own personal narrative which seems like a fun process to me.'

Providing both senseless and factual situations, Perlaki conjures up what could be considered visual poems or private performances, yet records only one remote moment, such is the nature of photographic capture. On the surface of things, his photographs are relatively simple and innocent—childish even—but the results are equal parts capricious and witty, menacing and eerie.

Above all, it is the human element that finds its way into the imagery via the portraits that is key to both heightening and complicating the sense of disquiet. This obviously relates to Perlaki's specific choice of model, Elemer, who despite his outward impression, is in fact a 'happy family man and a teacher living and working in Szolnok, Hungary'. What is evinced here is the notion that the reflection of reality reveals nothing about reality. The photograph of Elemer tells us nothing about the individual. As Bertolt Brecht famously remarked: 'Photography is the possibility of a reproduction that masks the context... So something must be built up, something artificial, something posed.'

Perlaki's work shares a kinship with this sense of photography

Márton Perlaki
p. 97

setting out to experiment and instruct, typified by such photographic constructions: 'My idea was to use one character throughout the series and I was struggling to find the right fit when I accidentally came across a photograph of him while I was browsing on Facebook. Elemer's peculiar appearance in these staged moments adds a mystical

quality to the series. He is simultaneously sculptural and enigmatic, which for me was a perfect combination for the series.'

The relationship between content and context within the frame as well as between the images is the lynchpin of a great photograph, according to Perlaki. In accumulative effect, his images can contradict or complement one another in a critical or reflexive way similar to Brecht's insistence on the built up. Their particular sequencing and repetition across the series demonstrate that viewers are not meant to understand these pictures as images illustrative of Elemer but something more suggestive, where the focus is restless and multiple. And as a sitter, Elemer becomes just another one of the photographer's props within Perlaki's playful subterfuge of the conventions of editorial and commercial photography.

'I am very interested in the transformational aspect of photography,' Perlaki says. 'How clashing contexts or remote moments combined can create new, unexpected paths of interpretation. Seemingly meaningless situations can gain baffling, often grotesque connotations in my work.'

Harking back to the impetus for the project, Perlaki explains: 'The whole project started as a stream of ideas. The trigger was a series of cards that companies used to include in packs of cigarettes. They were actually called "cigarette cards", in the first half of the century. The cards would display useful household tips. On first glance the images look silly and nonsensical but when you flip them over and read the corresponding text the pictograms suddenly make sense.'

As we do one final shuffle of his imagery and survey the causal connections between them, we stray further into realms beyond reality—an imagining of diversion and trickery. 'I like pictures that trigger my mind and evoke mixed, often bipolar feelings,' he concludes. 'Photography for me is a great tool for projecting my feelings, often subconsciously, into a picture.'

All images from the series Bird *Bald Book Bubble Bucket Brick Potato* © Márton Perlaki, courtesy of the artist, with thanks to Andrea Kozma and Elemér Szatmári

MÁRTON PERLAKI (b. 1982, Hungary) attended Bálint György Press Academy (with a major in photojournalism) and Budapest University of Theatre and Film Studies, where he graduated with a Master's in cinematography in 2011. He co-founded *The Room Magazine* in 2004 where he worked as a photo editor until 2015. His editorials have been featured in *T Magazine*, *Time Magazine*, *Wallpaper**, *Muse*, *M le Monde*, *Holiday Magazine* and numerous other international publications. He currently lives and works in New York. www.martonperlaki.com

TIM CLARK (b. 1981, United Kingdom) is the newly-appointed associate curator at Media Space at The Science Museum, London. Exhibitions he has worked on include *Julia Margaret Cameron: Influence and Intimacy* and *Gathered Leaves: Photographs by Alec Soth*. He is also the founder, editor and publisher of *1000 Words*. His writing on photography has appeared in *The Sunday Times*, *The Telegraph*, *Time Lightbox*, *The British Journal of Photography* and *Next Level* as well as in numerous exhibition catalogues. Recent independent curatorial projects include *20/20 Vision* at Christophe Guye Gallery, Zurich and *Rebecoming* at Flowers Gallery, London.

Unplaces

by Lewis Bush

Danila Tkachenko
p. 107

For *Restricted Areas*, the photographer Danila Tkachenko travelled across the former Soviet Union and its satellite states, seeking locations that were once closely linked to scientific and industrial research and innovation. For the people involved in operating these sites, they were not only about material gain or strategic advance. They were also ideologically imbued, tied closely to the idea that the Soviet Union and its allies were involved in creating a better future. That brave new world failed to materialise and as Tkachenko notes in his accompanying statement, the places that sought to bring it into being are now mostly abandoned. With the failure of the Soviet project these sites 'have lost their significance, along with their utopian ideology which is now obsolete.'

His photographs of these locations reveal scientific campuses, industrial sites, military complexes and discarded hardware, starkly isolated against the uniform white of snow.

Utopian is an unlikely but appropriate description for these places. Many of the locations shown form part of secret cities, conurbations which once fulfilled some important industrial or military function in the Soviet Union. These cities were long closed to outsiders and often did not even appear on official maps until after the Soviet Union's collapse in 1991. The Greek word οὐ, the root of the neologism utopia, implies nowhereness and the impossibility |of finding or visiting such places. Now that these once secret cities have become open,

mapped and visible, any thoughts of their being a utopia-in-progress has dissolved. What we find instead are bleak, desolate wastelands, where disintegrating hulks lie amidst an imperceptible landscape, with few reference points to orientation or scale.

As well as dissolving the idea of the Soviet Union as utopia, these sites also hint at one of the great contradictions of modern science. That for all the claims to the contrary, scientific research is often profoundly political, shaped by a particular world view, and occurring more often than not with the aspiration of making specific ideologies concrete. The positivist scientific tradition of which these sites are the decaying wreckage reflects a very particular view of the world, one where material resources are infinite, empirical observation is the key to understanding, and that knowledge is believed to be largely benign. Yet as the Cold War well demonstrated, the technologies that result from scientific research are as often as likely to lead us to states of dystopia, of oppression and shortfalls of knowledge, as they are to states of utopia, freedom and education. The splitting of the atom and the age it ushered in became much more about the threat of nuclear destruction

than it did the far more positive application of this research. Likewise for all the promises made of the democratic potential of the camera, it has more often been a tool of oppression, targeting, and destruction, than one of liberation.

Some of Tkachenko's photographs do hint at a more positive vision of an unrealised future. Like an interplanetary communication dish, built in anticipation of an imminent colonisation of other worlds which never materialised. Similarly the squat, saucer like shape of the Bulgarian communist party headquarters resembles something preparing to launch itself into a bold future, even now as it sits on its mountaintop perch in a state of dereliction and decay. And yet even these structures, with their rather more benign aspirations than military rocket motors or experimental lasers, are still foreboding things. In many ways these photographs speak to Western stereotypes about Russia, and play to our hunger to view ruins, and particularly those of the Soviet Union. The source of the need that Tkachenko's photographs briefly gratify seems to stem in part from a dissonance that has lingered unresolved for the quarter of a century since the Soviet Union collapsed. A sense of

astonishment that what Ronald Reagan famously termed the 'evil empire' turned out, in the moment of reckoning, to be little more than a house of cards. For generations who grew up in the shadow of nuclear annihilation, it is strange to find through photographs such as these that the source of that threatened obliteration is today little more than a land of rusting steel and crumbling concrete.

Musing on the ominous presence of the abandoned bunkers of the Second World War, the novelist J.G. Ballard compared them to the Pyramids of Giza, describing the fortifications as 'the leavings of a race of warrior scientists, obsessed with geometry and death'. There is a powerful sense of archaeology in Tkachenko's photographs also, of turning over the ruins of an extinct and inexplicable species. These remains are unintended

memorials to *Homo Soveticus*, or Soviet man. A few of these monuments, like the radiation of Chelyabinsk-40 or the ruins of the Chernobyl reactor— itself encased in the modern equivalent of an Egyptian sarcophagus—will persist here, long after the Pyramids of Giza have been reduced to dust.

All images from the series *Restricted Areas* © Danila Tkachenko, courtesy of the artist

DANILA TKACHENKO (b. 1989, Russia) is a visual artist working with documentary photography. After graduating from the Moscow School of Photojournalism in 2010 he was invited to work as a press photographer for the *Evening Moscow* newspaper. He then entered The Rodchenko Art School in 2011, and whilst there realised the need to work exclusively on artistic-leaning photo projects. He finished working on *Restricted Areas* in 2015, going on to receive, amongst others, the European Publishers Award for Photography and a grant from the Emerging Photographer Fund. www.danilatkachenko.com

LEWIS BUSH (b. 1988, London) studied history at the University of Warwick, and worked in public health before gaining a master's degree in documentary photography from the London College of Communication. He has since gone on to teach photography there and at other institutions in the United Kingdom. At the same time he develops his own personal photography practice which is concerned with the ways that power is created and exercised in society. He also writes extensively on the medium's history and its contemporary use for a range of print and web titles, and on his blog, Disphotic.

Stones and the Alchemy of Photography

by Kim Knoppers

Johan Rosenmunthe
p. 113

Browsing through *Tectonic*, the seductive, shiny blue book by Danish artist Johan Rosenmunthe, is a confusing experience, like wandering through a contemporary version of an art/science/ natural history museum in which objects and images of contrasting kinds are displayed together. Picture the Teylers Museum, the oldest

museum in the Netherlands, founded in 1874, where scientific instruments, minerals, fossils and art objects have been collected as part of an attempt to gain a firmer grip on the world. The lunar microscope, for example, which uses sunlight to magnify things invisible to the naked eye and project them. Or the series of models that French abbot René Just Haüy made at the turn of the nineteenth century, to represent the almost infinite number of different forms that crystals can take. Several of his models can still be seen in the old glass cases, in between the minerals, fossils and rocks. As a visitor you have a sense of being able to touch the past. All those fascinating objects seem to have souls of their own. 'Ever since childhood I've had a fascination for stones and objects that I feel are sacred. I was always collecting things, dismantling machines, finding the most essential part and walking around with it in my pocket. I almost worshipped that perfect object, which contained the spirit of whatever I'd taken apart. As a small child I collected stones and polished them with special

tools. That interest has remained with me throughout life.'

'In my work I'm interested in the point at which two tracks cross. One track is materials, their transformation and our understanding of them over time. An example might be the stones that I used for *Matter*, my exhibition at New Shelter Plan in 2014. They are totally normal beach stones but they were in the possession of the Church of Scientology in Copenhagen for many years, which donated them to me without telling me what they'd been used for. That history is now held inside the stone. It gives the stone a unique aura, a unique past and a unique energy. The changing histories and energies that materials can have as a result of human involvement with them is one of the tracks I pursue. My fascination for photography came from an interest in the camera

as a technical tool and in the whole technical set-up that surrounds photography: what happens in the darkroom? What kind of technical processes are going on in there? That's what drew me in. That's the other track: my interest in the physics of photography.'

The title of *Tectonic* refers to the entirety of processes, movements and distortions that take place in the solid surface of the earth's crust. Tectonics and the natural forces involved in it transform the countless minerals found on earth from one kind of material to another. That's actually much like what occurred in early photography, that alchemical process that went on in the first darkrooms. In his book Rosenmunthe ingeniously brings the two tracks together: his research into minerals and their cultural significance in our society, and the physics and alchemy of photography.

At the intersection of these two tracks we come upon the spirituality that resides both in those minerals and in photography. It's reinforced in the book with fragments of text by nineteenth-century writer Mary Anne Atwood. Her father, who was researching the history of spirituality, prompted her to write *A Suggestive Inquiry into the Hermetic Mystery With a Dissertation on the More Celebrated of the Alchemical Philosophers*. Shocked to find that it revealed too many of the hermetic secrets, he burned almost the entire print run. The hermetic texts of Late Antiquity attempt to initiate man into the hidden reality that exists behind the visible world. They have had a huge influence on the Western esoteric tradition.

Atwood was in close touch with the Theosophical Society, founded in 1875 by a Russian woman called Helena Blavatsky who attempted to prove the existence of another world by objective, scientific means, thereby avoiding accusations of trickery or fraud. Her relatively rational form of spiritualism was of great importance to the twentieth century pioneers of abstract art. Both Piet Mondrian and Wassily Kandinsky were interested in grasping a dimension beyond visible reality. The influence of spirituality on modern art was for a long time ignored by critics and art historians. It was not until the 1980s that a meaningful connection between esoteric and spiritualist sources and modern abstract art was fully recognized. Currently a revival of spirituality in contemporary art seems to be going on and Rosenmunthe's *Tectonic* can be considered part of this revival. Unlike the great masters of modern art, he is not interested in depicting a pure, cosmic reality. *Tectonic* is serious, but at the same time it contains a hint of irony. The technically perfect photographs form a sharp contrast to the sometimes rather slapdash experiments he has performed and depicted. It's up to the viewer to make connections between the photographs, but the carefully chosen titles sometimes offer clues. 'My interest in art came from wanting to send mixed messages. I want to communicate something that is not easily decipherable or understandable. I want some mystery.'

All images from the series *Tectonic* © Johan Rosenmunthe, courtesy of the artist

JOHAN ROSENMUNTHE (b.1982, Denmark) is based in Copenhagen, and was educated at the Danish School of Art Photography after receiving a BA in Human Science from Roskilde University. He is co-founder of the curatorial collective and publishing house Lodret Vandret, exhibition space New Shelter Plan and art book festival One Thousand Books. His work has been exhibited internationally, including at C/O Berlin, Tate Modern and the Museum of Contemporary Art Santa Barbara, all in 2015. *Tectonic* is available as a monograph through SPBH Editions. www.rosenmunthe.com

KIM KNOPPERS (b. 1976, the Netherlands) has been a curator at Foam Museum since 2011. She studied art history at the University of Amsterdam. She was previously curator at De Beyerd Center of Contemporary Art and has also worked as a freelance curator. She has curated group exhibitions including *Remind* (2003), *Exotics* (2008) *Snow is White* (2010, together with Joris Jansen) and *Re-Search* (2012), and solo exhibitions by WassinkLundgren, Onorato & Krebs, Jan Hoek, Lorenzo Vitturi, Jan Rosseel, JH Engström, Geert Goiris and Broomberg & Chanarin amongst others.

The Nostalgia Effect

by Federica Chiocchetti

Guo Peng
p. 123

Guo Peng is a Chinese artist based in Beijing who graduated from the sculpture department at Yunnan Arts University. His work reflects his promiscuous range of interests in photography, video, installation and painting. For him photography is an ideology converter, as it transforms the photographed object's material properties into ideological and consciousness

properties, that he carries with him. 'There are some moments in your life that touch you so deeply that you want to seize them and keep their memory.' In his series he photographed objects, such as books, stones, clocks, lights, but also elements of landscape and shadows. People are almost non-existent in his images; objects give him a higher sense of security and inner peace. When he started developing and printing his photoworks he realized that he wasn't satisfied with selecting and producing only one image per object. He also felt the need to spend more time with his photographs. So he printed his photographs in many different sizes, although mainly small, showing the same object or scenery from various angles and perspectives, and started always to carry them in his bag. 'I wanted to scrutinize and play with them as I wished. They were my companions and, over time, began to naturally gain little scratches, tears and damage.' Just like when you carry your relatives' photos in your wallet and look at them occasionally, at times intentionally, at other times they simply pop up while you are desperately searching for something else. They are there, exposed to time and space, and they will inevitably accumulate the ravages of both, like any other

object. 'I shall thank photography for giving me this fascinating opportunity to explore my relationship with objects.' And his photographs become indeed tangible specimens of subjective realities, as highlighted by Chinese art expert Monica Dematté.

The level of intervention he applies to the prints is something of a mystery. Whether he leaves them to show signs of natural deterioration or he actually accelerates their fragility, they achieve a poetic though humble status. Their simplicity encourages the viewer to engage with them on a more personal level and their serial multiplicity appeals to the collective imagination of the many viewpoints from where we can observe what surrounds us, revealing the subtle, at times almost schizophrenic, dynamics of our gaze. At a deeper level I believe they create a somewhat artificial yet harmonious nostalgic effect both in the artist and in the viewer.

In a conversation with his friend, artist Luo Fei, the latter points out how Peng seems to be interested in showing photography's ability to get closer to eternity by displaying fragility and increasing the age of his photographs. 'By using

smallness to overcome largeness, and stillness to defeat movement, I want to see the world in a grain of sand, heaven in a flower, and get back to what is known as Zen wisdom.' Peng's focus on objects is not dictated by an interest in material goods, but in the way they coordinate with the world, which he calls coordinating with aesthetics, claims Luo Fei. Perhaps coordinating with nostalgia too.

Milan Kundera, in his masterpiece *Ignorance*, writes about nostalgia looking back at its etymology: 'The Greek word for "return" is *nostos*. Algos means "suffering." So nostalgia is the suffering caused by an unappeased yearning to return.' I believe an irrepressible yearning to return, which suddenly reveals the existence of the past, the power of the past, permeates Peng's imagery.

He wishes to return to a state of simplicity, to restrain life to a basic level, and think more about how to savour the solitude of dealing with one's own past and memory, which is clearly reflected in the very act of looking back at his photographs that he carries with him. We can access our past only through memory. And memory is narrative: filtered, at times blurred or fragmented and always subjective.

It seems that seizing moments with photography alone is not appeasing for him; perhaps lurking behind his photo-ageing practice there is the unconscious desire to produce, and consume himself, the artifice of enhanced nostalgia in the very act of looking at his photographs. Unlike more patently fictional photographs, the artificiality of Peng's images is so subtle and embedded in the process rather than the subjects that it feels almost whispered. What is the effect on us, the viewers, once we learn that these seemingly old, dreamland photographs are somewhat virtual? Are we willing to suspend our disbelief? Is there any disbelief to suspend?

All images from the series *Untitled* © Guo Peng, courtesy of the artist

GUO PENG (b. 1982, China) graduated from the sculpture department of Yunnan Arts University in 2006. He has exhibited extensively within China, including the solo exhibitions *I come from where I come from* at Tai Project, Kunming, *Standstill* at OFOTO Gallery, Shanghai, and *As body and shadow* at Jiali Gallery, Beijing. He has also exhibited in Norway, Spain and Sweden. He lives and works between Nanjing and Kunming. www.guopeng.org

FEDERICA CHIOCCHETTI (b. 1983, Italy) is a London-based writer, photography critic, editor and curator. She is the founding director of the photo-literary platform Photocaptionist. Currently working on her PhD in photography and fictions at the University of Westminster, she is the 2015 Art Fund Curatorial Fellow (Photographs) at the V&A, working on the exhibition *P.H. Emerson: Presented by the Author*. Recent projects include the exhibition and book *Amore e Piombo*, co-edited with Roger Hargreaves for AMC books, and winner of the Kraszna Krausz 2015 Best Photography Book Award. She curates the endframe of the *British Journal of Photography* and has been appointed curator of the next Photo50 exhibition within the London Art Fair.

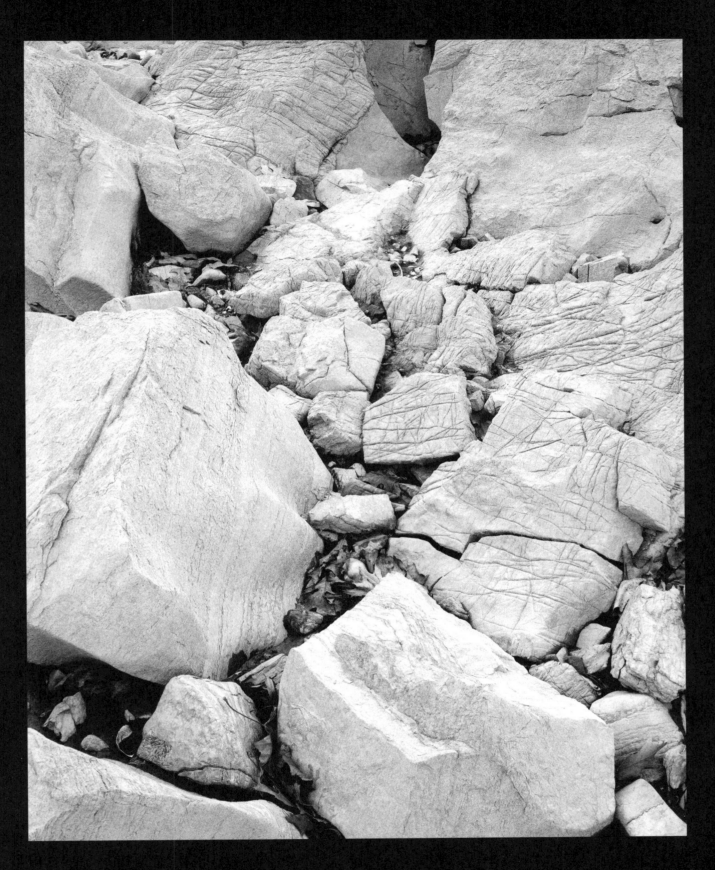

Justin James Reed
In Heaven the Darkness
is Quite Beautiful

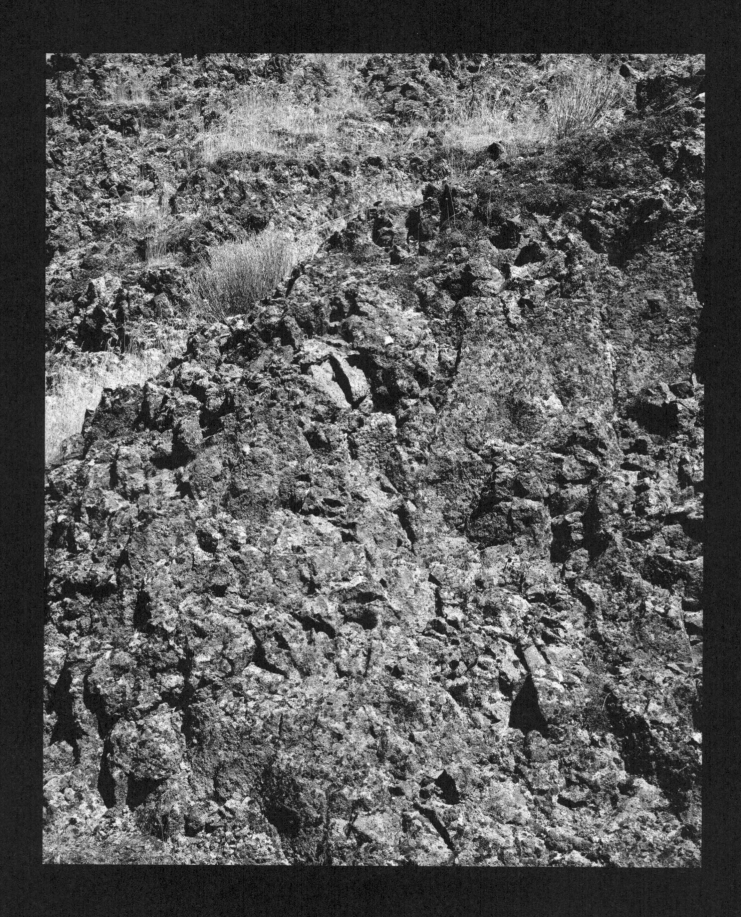

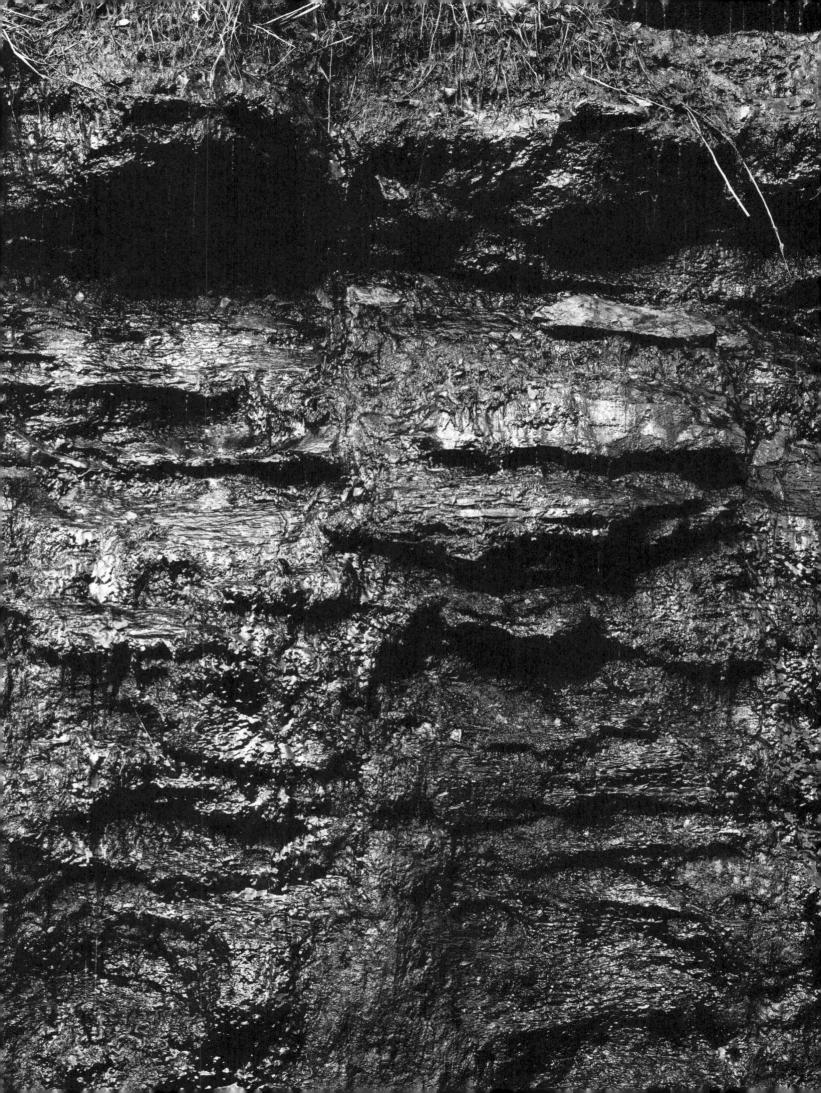

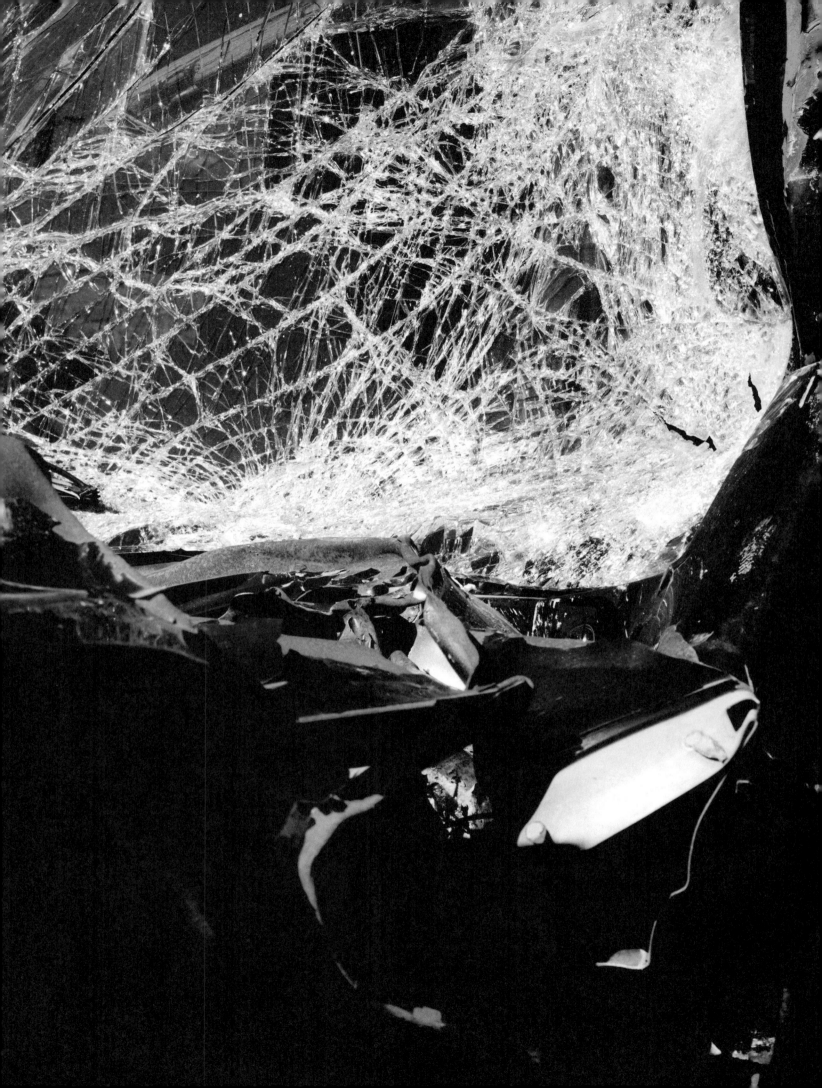

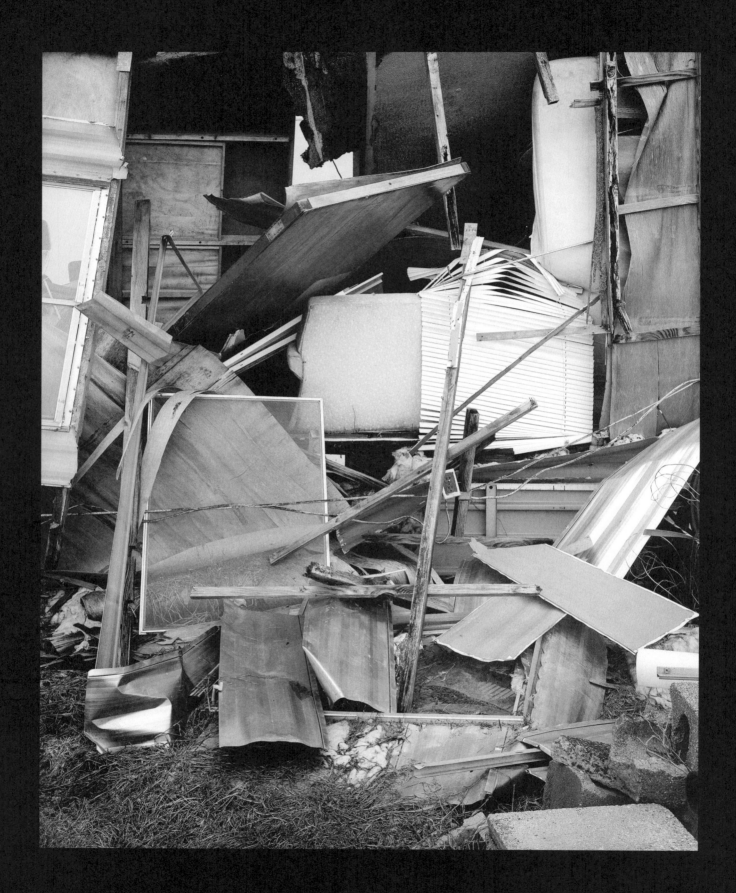

BEAUTY IN DARKNESS

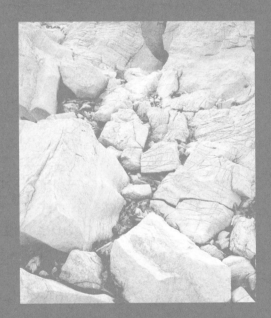

on Justin James Reed p.137

by Gemma Padley

At a glance, Justin James Reed's images could be etchings or charcoal drawings on paper—such is the density of tone and craftsmanship on display. The depth of the scenes presented to us, and the intricate detail of the surfaces he explores are meticulously rendered through Reed's large format camera, while the densely packed, frame-filling compositions become almost hypnotic, even stifling.

Difficult to tear your eyes away from, Reed's are the kind of images that give more away the longer you look—small details missed on a first glance gradually make themselves known as details do when eyes adjust to sudden darkness. Yet paradoxically, the subjects in Reed's images seem to retract further into the frame and fold in on themselves the longer you gaze. These

are photographs that mischievously (and purposefully) defy explanation and wriggle away from categorisation. For even though we mostly recognise the subjects shown to us—weather-worn and aged tree trunks, rough-sided rocks, and gnarled branches—the images sit beyond easy comprehension.

Keen to avoid creating images that are purely representational, Reed, who is based in Richmond, Virginia, USA, explains how his work has gradually taken a turn towards the abstract. He cites two pivotal texts that have 'helped me to move on my practice': *Seeing Is Forgetting the Name of the Thing One Sees* by Lawrence Weschler —a book about LA artist Robert Irwin, and *The Edge of Vision: The Rise of Abstraction in Photography* by Lyle Rexer—a history of photography and abstraction, both of which 'helped me to reconsider how a photograph could function', he says. 'I started to make this work a few years out of grad school—in 2009/10. At the time, people were interpreting my images in a far more representational sense than I wanted—the idea that the picture depicts something in the world and makes a commentary on that thing. But

I was interested in creating something that was more of a sculptural object— that could interrupt the viewing experience. You would be looking at something highly representational, but at the same time wouldn't necessarily decode anything from that representation. [I wanted] my images to be more "in-between", more abstract.'

For *In heaven the darkness is quite beautiful*, the title of which is inspired by David Lynch's film *Eraserhead*, it was less about having a fixed idea or a strong concept when embarking on the project, and more about going out and carefully observing what was around him, says Reed. He had begun the work while living in Philadelphia, and continued to make images for it after moving to the small town of Abingdon in south-western Virginia, where he had accepted a teaching post. Describing his new home as 'an off-the-grid place in the middle of nowhere', Reed lived in an old farm-house by a lake, and made most of the work here. Drawn to what he refers to as the 'altered landscape', he would go out, often at night, and ponder the metaphorical meanings of darkness, he says. 'You'll notice there is a lot of black

The ha
look
more tem

to r
touch the
of the

der one
, the
oting it is

ach out and
surfaces
mages.

in the pictures, a lot of contrast, which is to do with the materiality of photography but also to do with darkness as negative space. So it was about giving [negative space] meaning, letting it be something… It was less about trying to make a commentary than… seeing what was aesthetically possible. Creating images that have their own meaning—that speak for themselves, but aren't about something specific as such. The picture is meant to point back to itself.'

Reed explains that he was interested in 'not only making the strongest images I could, but ones that relied on the fundamental tools of photography—which were, in mind at that moment, large format photography and a reduction of form… How could I have someone look at a photograph and not think about

what it's depicting and more about it as a sculptural object? How do you induce that viewing experience? That was what interested me.'

While both colour, and black-and-white are important in his practice, the black-and-white images especially embody Reed's fascination with abstraction. 'I like the idea of thinking about black-and-white as being immediately abstract in its essence,' he says. 'A reduction into tonality of how we see.'

We can see his interest in form and shape at work acutely in the image of tar in a parking lot. Striking swirls of black tar stand out against a grainy grey background—the areas of light and dark carefully balanced in a delicate equilibrium, providing a tension that is central to the image's make-up.

While he considers himself to be a landscape photographer in many ways – 'I'm taking pictures that are in the realm of landscape photography'—Reed recognises that his is an unconventional approach. The absence of a horizon line for one throws the viewer off course, he says. But by shooting subjects at relative close range and using a small aperture to increase the depth of field, Reed flattens space and casts every element on an equal plane in a kind of democratisation of the landscape. Not a scrap of the photographic frame is wasted. 'Photography creates such a sense of reality, but it is a heightened reality – so much so that the images become hyper-real,' he says. 'I'm using what the camera allows me to do to create these super-sharp, detailed pictures, and then concentrating on this closed space. All of this "ups" the level of depiction, but it doesn't say something specific. Rather, this is a highly aesthetic investigation not only of photography, but of the world.'

His are images that create or sculpt space, rather than take something from space, says Reed. 'While making the work, I kept thinking, how can I push my skills and sculpt with the camera?' Indeed, the camera is just one of the tools Reed uses to make his work; previous works have seen him use glass, installation, projection, UV ink, and film. He uses whichever material best suits what he wants to articulate. 'Materially speaking, my practice, I hope, is fairly diverse, but it all stems from this 'photographic logic', which comes out of that world of trace, of residue, of impression—things that I think of in terms of photography. And even though I have these 'projects', my work runs together; I think of it as one body of work.'

The images are also an exploration of the surface of photography, 'something we don't always think about, because, essentially, a photograph is flat,' adds Reed. 'But it's ink on paper – it does have a surface. My painter friends think so much about surface, about the paint on the canvas, and this got me thinking, how can I inject this into photography? And I do think a lot of this work is about surface.' Indeed, in many of the images texture comes to the fore, becoming almost a character in its own right: cracks in rocks, roughly textured tree trunks and bristly branches seem to break through the smooth surface of the photograph. The harder one looks, the more tempting it is to reach out and touch the surfaces of the images. But while it would be wrong to directly compare Reed's work to painting, and it is not his intention to emulate painterly techniques, he admits: 'I'd hate to [liken the images to] Jackson Pollock's work or something, but... there's definitely an influence there [from painting].'

When I ask what themes he explores in the work, Reed hesitates, uncomfortable with the question. To say that the images in this series ruminate on nature and destruction is to be too specific, he says. 'There isn't a subject *per se*, but if you look at the body of work as a whole, you'll see a lot of destroyed things—a building that has collapsed, for example. The images are meant to be a little difficult in some respects—I don't want the viewer to soak them up. I want him or her to have to engage, to really look at them.'

As highly conceived and constructed as the images may appear, ultimately Reed prefers to 'go where the work takes me. I try not to think too much, but instead follow my instincts, and keep an open mind.' He goes through periods of 'intense investigation and looking', he says, which interplay with moments of intense creativity. 'You just have to make the work that you make and try to be as honest as possible,' he adds. 'It's either going to find an audience or it isn't. Accolades and shows come and go, but you're around for a while and you realise there's an ebb and flow to the art world. The most important thing to me is my friends and community, and talking to artists—to be excited about work, and to keep being excited.'

All images from the series *In heaven the darkness is quite beautiful* © Justin James Reed, courtesy of the artist

JUSTIN JAMES REED (b. 1980, United States) is based in Richmond, Virginia. His work and artists' books have been exhibited widely, including at Higher Pictures (New York), Carroll and Sons (Boston), Arnhem Mode Biennale (Arnhem), Depot II Gallery (Sydney), Lille DSV (Copenhagen), and the Maison d'art Bernard Anthonioz (Nogent-sur-Marne). His work is held in numerous collections, most notably the Library of Congress, Yale University Art Gallery, The New York Public Library, and MoMA Library. He is a member of the international collective, Piece of Cake, co-publisher at Brooklyn based Horses Think Press, and an Assistant Professor at Virginia Commonwealth University, School of the Arts. www.justinjamesreed.com

GEMMA PADLEY (b. 1984, United Kingdom) is a freelance journalist and editor who specialises in writing about photography. From 2012 to 2014, she worked at the *British Journal of Photography* as their senior reporter, and she currently works for them on a freelance basis as projects editor, as well as being a contributing writer. She has also written for *Photoworks*, *The Telegraph*, *Huck*, *Photomonitor*, *Nowness*, *LensCulture*, *1000 Words*, *IMA Magazine*, amongst others. And recently founded the blog Too Many TasteMakers, an online platform that focuses on showcasing new talent and photography news.

Sjoerd Knibbeler

Current Studies

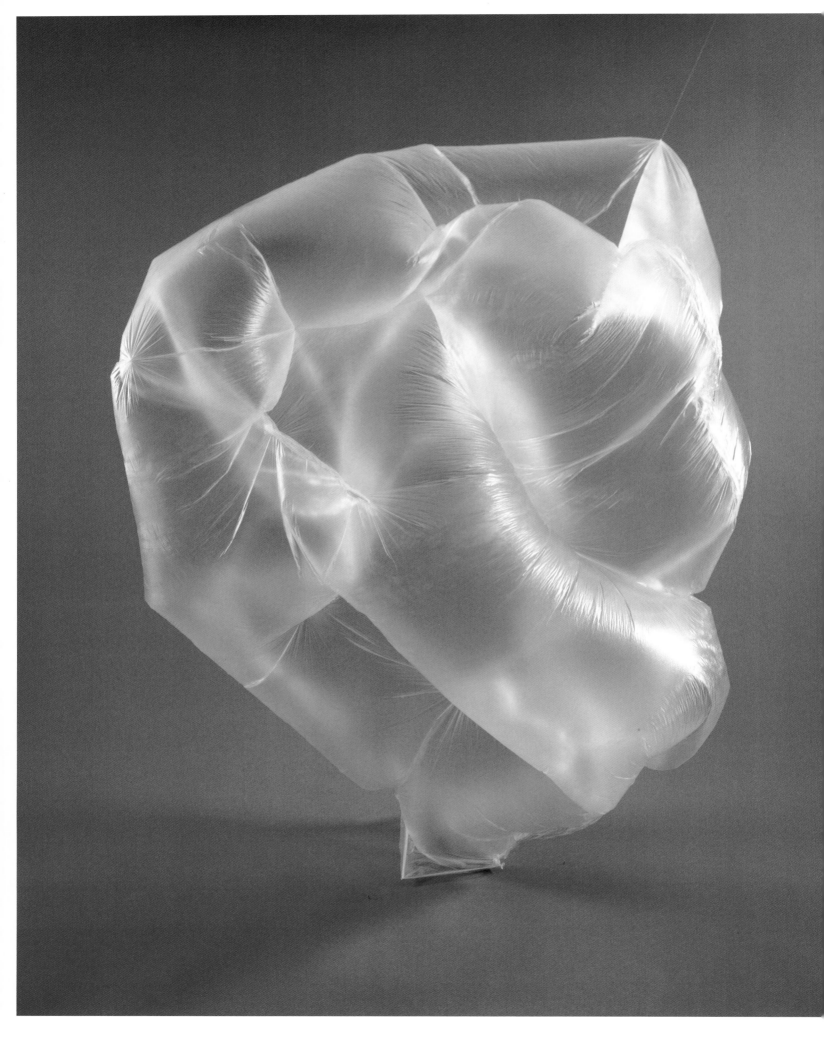

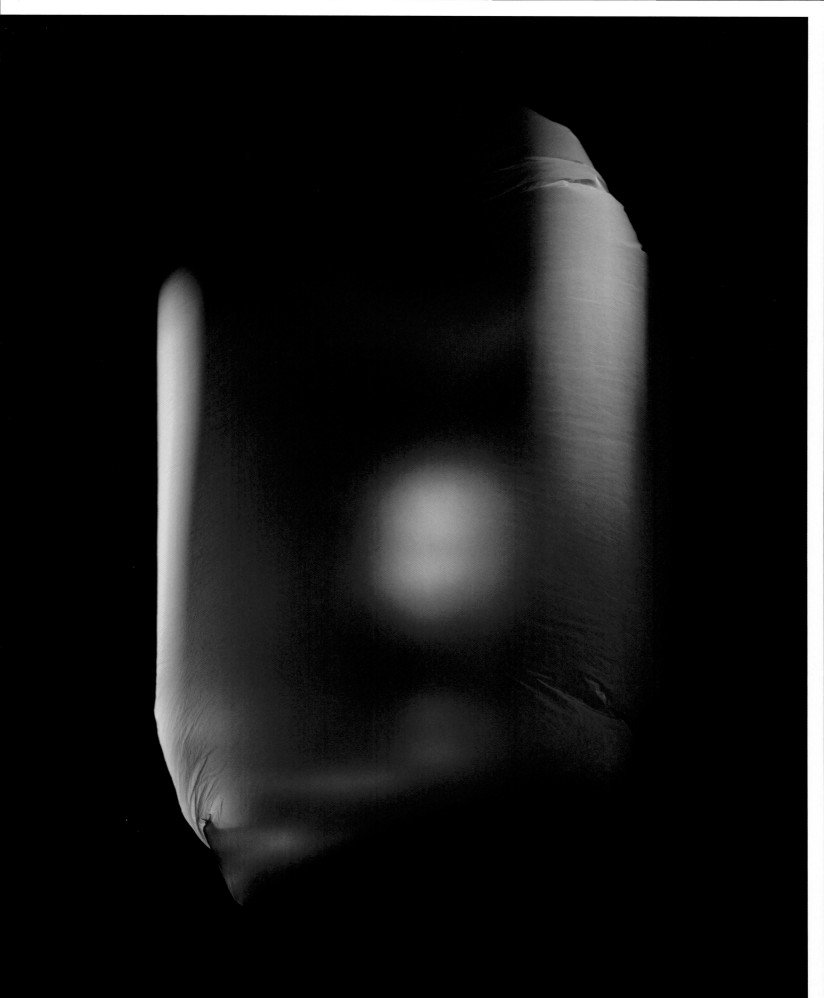

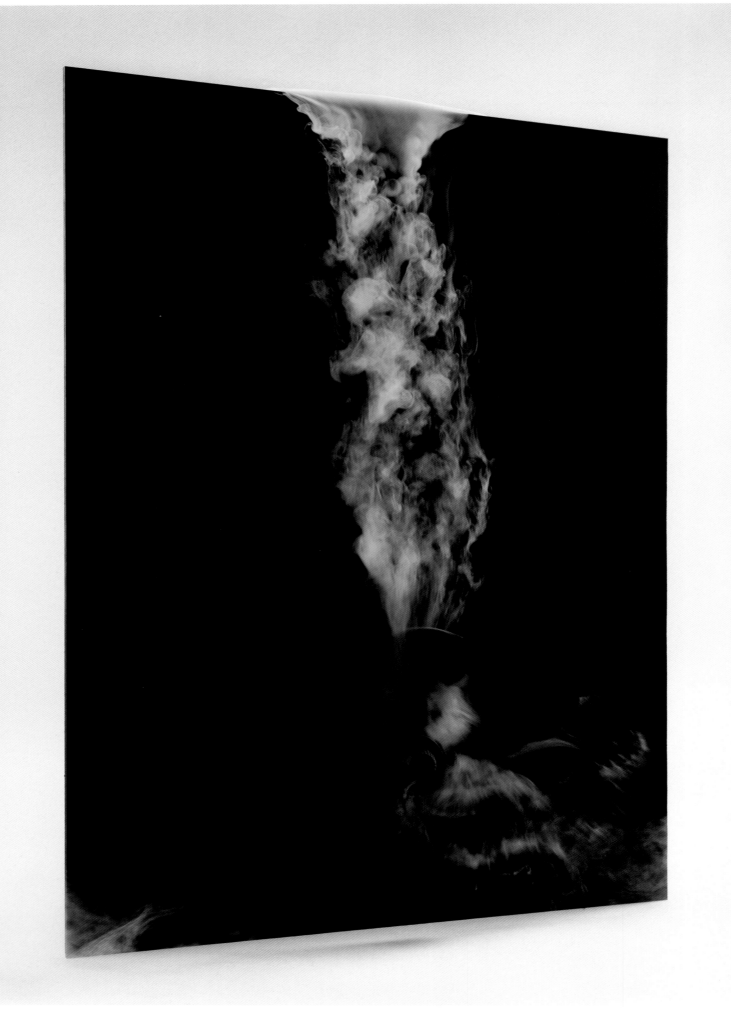

Naohiro Utagawa
Images

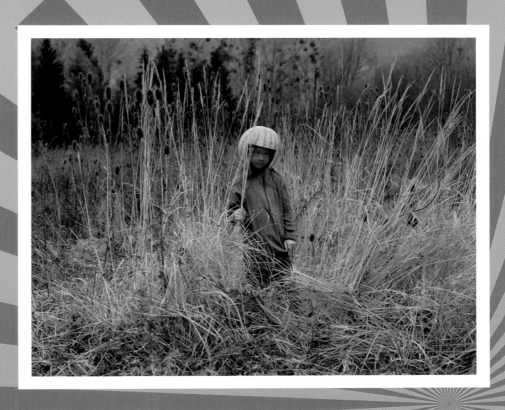

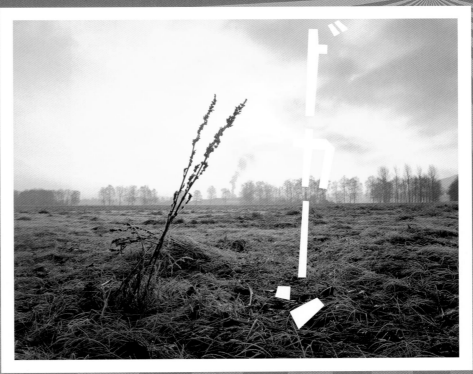

David Favrod
Hikari

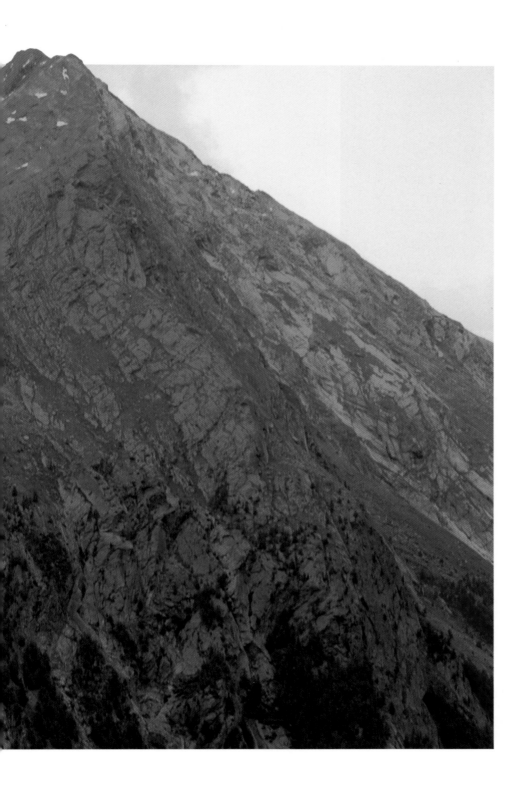

Image ©2012 TerraMetrics.

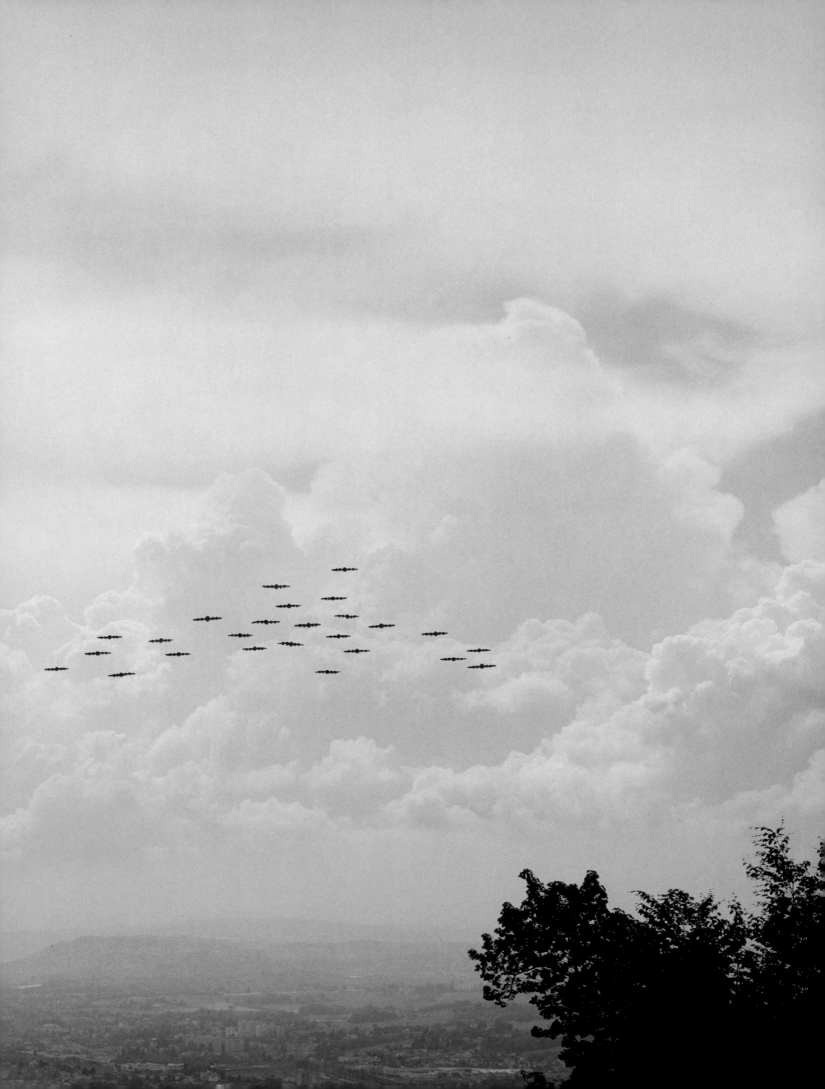

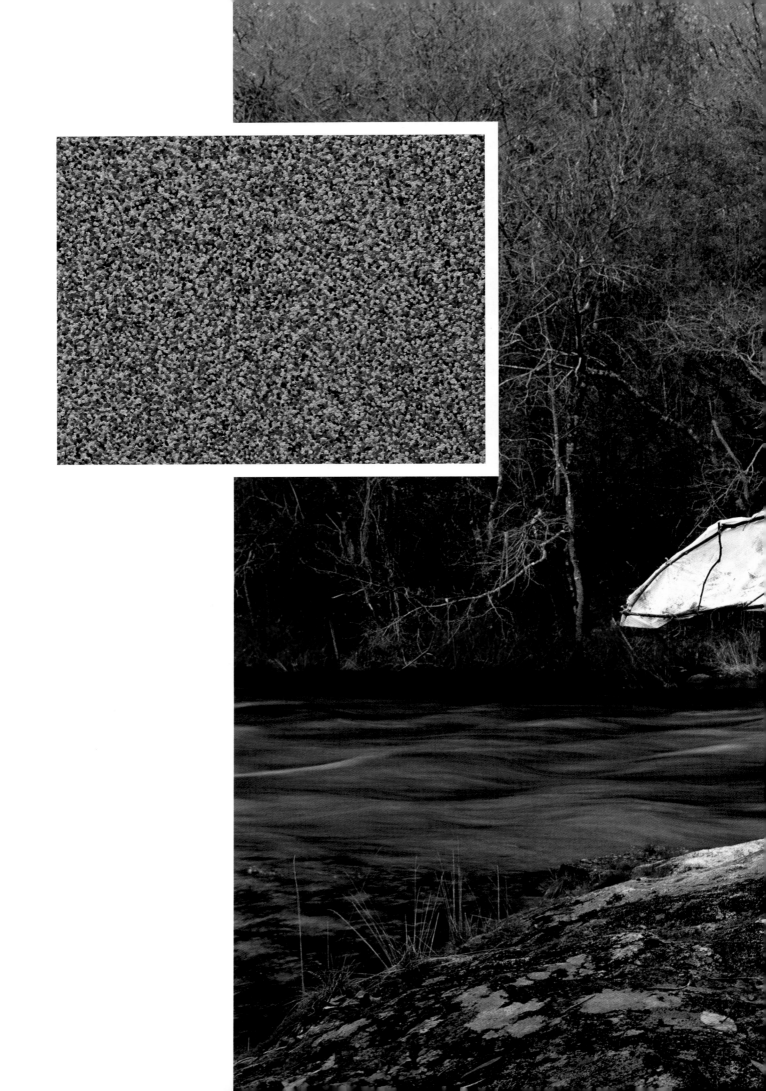

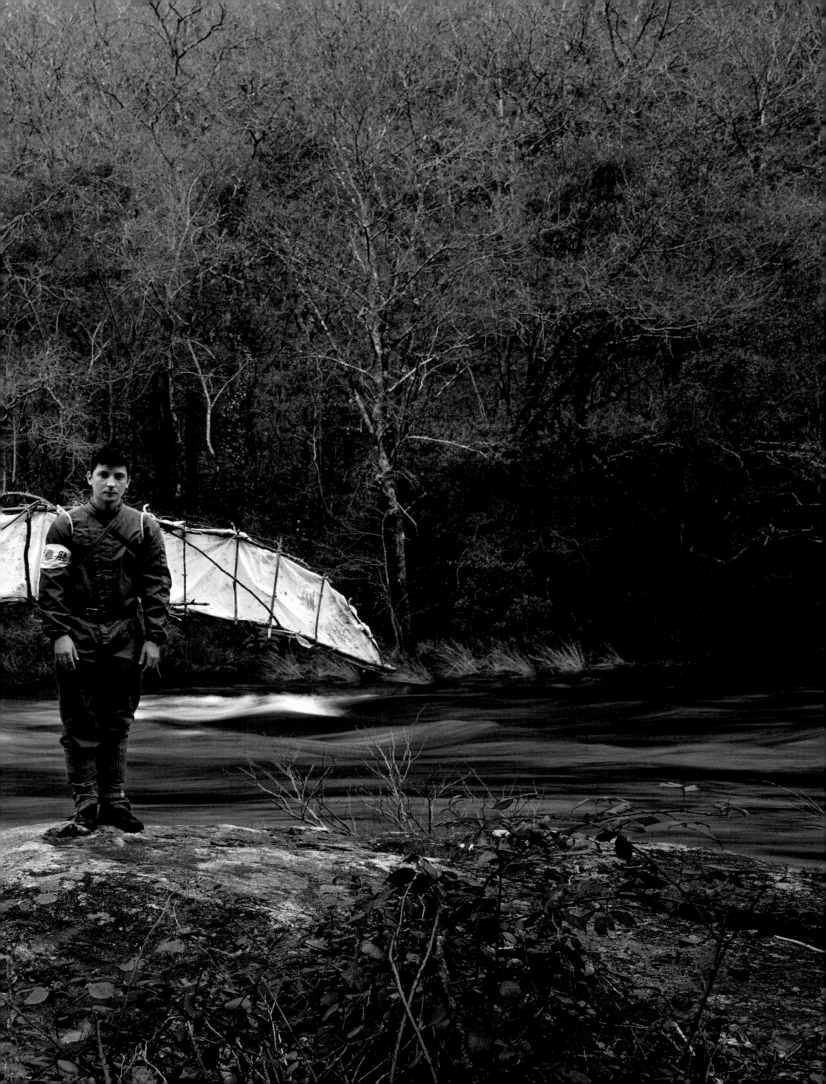

Zone de forte chute de p
Zone de faible chute de
Dommages et radiation

Zones affectées par la "Pluie noire".

Dans les heures qui suivirent l'explosion de "Little Boy", une pluie noire s'est mise à tomber sur la ville.
La pluie était noire car elle était mêlée de cendres provenant des résidus calcinés par l'explosion.
Les survivants l'ont bue pour se réhydrater sans savoir qu'elle était contaminée.
Toutes les personnes qui y furent exposées développèrent des symptômes similaires à ceux exposées
directement à l'explosion de la bombe atomique.

Image © 2014 DigitalGlobe
Image © 2014 TerraMetrics
© 2014 Cnes/Spot Image

Alessandro Calabrese
A Failed Entertainment

187

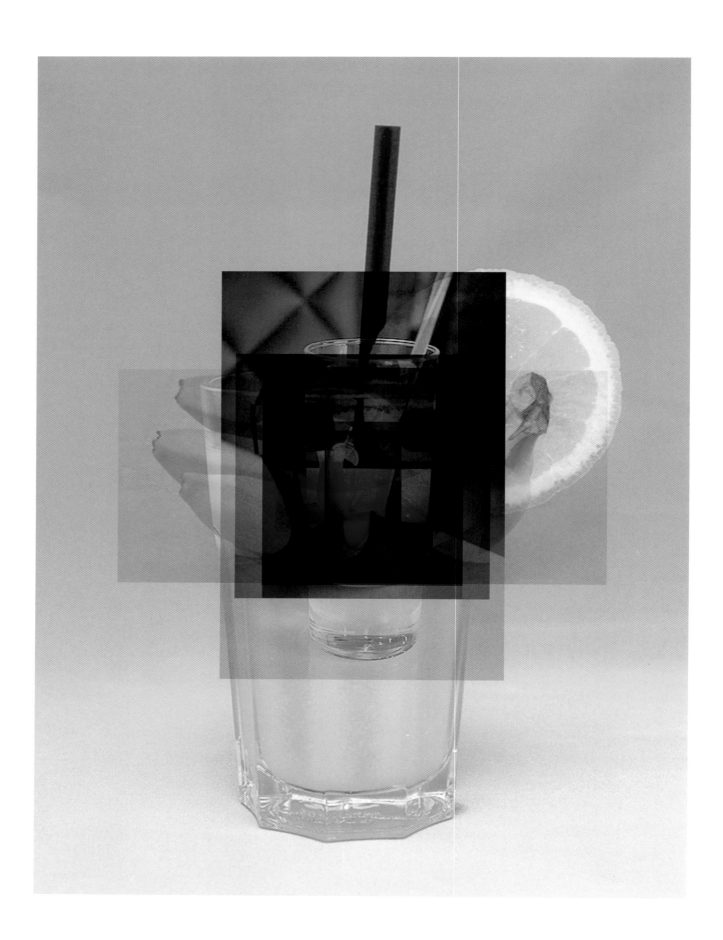

A World That Follows Its Own Logic

by Jörg Colberg

'I am interested in creating a world that follows its own logic,' writes Sjoerd Knibbeler, 'and in which the associative process is key.' It would be straightforward to argue that all photography operates along those lines, but photography being the most 'mechanical' form of art usually makes the viewer believe that the world on view is hers or his, even when it patently is not. A good artist will use that difference between the photograph and the world it is taken from and amplify it in such a way that it will become almost discernible, but really just almost. Venture a little too far and the construct 'photograph' will become apparent: the viewer will stop believing. She or he will instead doubt the picture and not what it depicts.

That mechanism is employed to great effect in *Current Studies*. 'The assemblage of the sets featured in my works serves to conduct, capture or obstruct the current of air that flows through or around it. What excites me is to find and capture a balance between the visible reference and the invisible subject.' In an obvious sense, air is unphotographable. Yet at the same time, we are familiar with its presence, given we not only breathe it, we

Sjoerd Knibbeler
p. 161

also experience it acting upon ourselves or on things on a windy day.

Any of the materials used by the artist in the studio can act as references to something that is invisible – the current of air. A resulting photograph becomes a reference to another reference. The challenge is to make the viewer perceive the photograph as a depiction of what is referenced this way, instead of what it is, a photograph. According to Knibbeler, the process of photographing centres on what he describes as an image's presence: 'It is a trial-and-error process from which an image should result that has a presence rather than a reference, since I believe that that presence might be the most adequate way for me to visualize what I cannot see.' We could say that it is the photograph's presence that makes us look beyond what it is in the literal sense, a piece of paper or the appearance of an image on a screen.

The making of *Current Studies* includes both performative and experimental aspects. Or should we say that an experiment really is a performance with both planned and unplanned aspects, the former being

the set-up, the latter being the possible outcomes? The former scientist in me could wrap his head around this idea, and it is close to how Knibbeler describes part of the process: 'Building the set then also becomes "setting the stage" in anticipation for this short moment when I am presented with the unexpected. The discoveries most often pose new questions, which in turn lead to new experiments, which is how the series evolves with each new work.' The fact that we see this work as art and not as something scientific in part arises from the strict distinction between the arts and sciences we have come to accept. Says the artist, 'I draw inspiration from scientific work and methods to create the images I make. But they remain to be images that have their value in the field of the arts.' Fair enough.

Exhibition spaces allow Knibbeler to drive his methodology a bit further, to use the physical space to create 'a world that follows its own logic, yet is not hermetic, but appeals to the imagination.' Of course juxtapositions of images are unavoidable in an actual three dimensional space. But there are more options: 'In a spatial context, there is – quite literally – room for making connections between works with different qualities. For instance, the static visual experience of a *Current Study* can be enhanced by a moving image. Or the Perspex, which I used for *Current Study #2*, becomes the carrier of another image that is present as an object in the space.'

Conceptually, this approach is bringing the work almost back to where it began. Performance/experimentation is married with some sculptural elements to make the visitor experience something that cannot be seen – in ways shaped specifically by this particular artist. This then is what really distinguishes *Current Studies* from a scientific experiment: ultimately, what we are made to admire and enjoy here is not the flow of air and its physical dynamics. We admire instead the specific ways the flow can be experienced, as well as the specific mind-set used to create this world. In the sciences these days one's task is to make oneself disappear. In the arts, however, it is to assert your presence, and to make people see things that they couldn't see themselves. Consequently, the logic we are made to see is as much the artist's as the materials'.

All images from the series *Current Studies* © Sjoerd Knibbeler, courtesy of the artist and LhGWR, the Hague

SJOERD KNIBBELER (b. 1981, the Netherlands) produces work that focuses on visualising invisible natural phenomena such as the wind, air movement and climatological conditions. Inspired by subjects such as flying, aeroplanes, aerodynamics and climatology, he creates a world that follows his own logic, where associative relationships and imagination play a key part. He studied at the Royal Academy of Art, the Hague, and is represented by LhGWR, the Hague, who presented his work during the Unseen Photo Fair in 2014. This year he won the prestigious Grand Prix du Jury Photographie at the 30th International Festival of Fashion and Photography in Hyères and held a solo exhibition at Foam.
www.sjoerdknibbeler.com

JÖRG COLBERG (b. 1968, Germany) is a writer, photographer, and educator. Since its inception in 2002, his website Conscientious has become one of the most widely read and influential blogs dedicated to contemporary fine-art photography. In addition to publishing writing online, his articles/essays have been published in photography and design magazines and in photographers' monographs. He is also a Professor for Photography at Hartford Art School.

The surreal photo collages by the Japanese artist Naohiro Utagawa create psychological landscapes that are as fascinating and surreal, as much as they appear daunting and even violent at times. The primary source material for Utagawa are photographs which he cuts, tears, bends, crumbles and folds. In so doing, Utagawa does not only subvert the traditional application of photography, but he also reinterprets it: here photographs are not just created through the click of a button, but they are assembled, put together or installed much like a sculpture artist uses clay for instance. The effect that he creates by using or even abusing photographs in such a manner is that he defamiliarizes the photographic print as a material object.

Utagawa's method of assemblage evokes the intricacy of micro installations by the American artist Joseph Cornell. While Cornell used the rectangular shape of a soapbox as a physical boundary for his works, Utagawa frames his collages through photographs. Photography is therefore used twice: as a primary source material for the sculptural installations and as a method of recording these very installations. One of the many tensions alluded to in Utagawa's series is that he abuses photographs by tearing into them, thus subverting their traditional

Naohiro Utagawa
p. 169

purpose, yet he uses photography to document these collages in all their intricate detail. Utagawa thus sets out a visual and conceptual contradiction which navigates in-between a document and an anti-document.

Utagawa's highly unorthodox approach to photography is partially related to his training, or lack thereof, in this area. Born in 1981 in Kanagawa, on the outskirts of Tokyo, Utagawa completed a four-year law degree in

2004. In his own estimation, by the time he commenced his third year at Chuo University, he knew law was not for him and he focused instead on a career in the arts. An autodidact in photography ever since his break from law, Utagawa climbed the echelons of the photographic establishment in Japan to be shortlisted in 2013 for the New Cosmos of Photography award – one of the most prestigious awards for up-and-coming photographers in Japan.

Utagawa's idiosyncratic approach to photography is mirrored in the way he creates his collages: working from a small studio space in Tokyo, and with blackout curtains drawn to prevent natural light from entering the room, he works in near darkness. Utagawa seems to need darkness more than he needs the light to create his work. His studio becomes quite literally, a *camera obscura*. Photography traditionally tends to depict elements that are somewhere out in the real world, beyond the darkened room; here the artist uses photography as a primary source material to make collages that depict a deeply introspective portrait of the artist.

Utagawa describes the process of making his artworks as a form of searching, whereas the searching itself becomes a

Psychological Landscapes

by Marco Bohr

means to an end to create his works. Looking into Utagawa's world from the outside it is difficult to tell when an artwork can be considered complete. Or perhaps these works are never complete and all the viewer gets to see is a glimpse into the process of art production. This is yet another tension in Utagawa's project: by using photography's capacity to document the artwork, the viewer makes the assumption that the collages are completed artworks and thus worthy of being re-photographed, whereas in reality we become privy to a process of assemblage that might, in fact, be never-ending.

The multiple contradictions in Utagawa's work are best signified through an image that depicts two hands, one of a man and one of a woman, held in mid-air. At first sight it looks as if they are tenderly touching each other,

yet on closer inspection both hands are wounded, alluding to a sense of violence. Utagawa recalls that while working on a shoot, one of his colleagues broke a finger and the model incurred a scratch. The violence must not be read in the literal sense, but rather as a metaphor for what Utagawa does to the photographs. He treats the photographs, all of which are from his own archive, like very few photographers would ever treat their own work. Utagawa's treatment of photographs can be referenced with the Greek roots of the word *iconoclast*: breaking a likeness or an image.

Utagawa's work purposefully goes against the grain of photography. He treats his own photographs like throwaway objects, allowing him to compose works long after the photograph has been taken. The resulting artworks are far less about the subjects depicted in the photographs than they are a depiction of Utagawa's complicated, self-reflexive relationship with photography.

All images from the series *Images* © Naohiro Utagawa, courtesy of the artist

NAOHIRO UTAGAWA (b. 1981, Japan) graduated from the law department of Chuo University before establishing himself as a photographer. In 2013 he was shortlisted for the New Cosmos of Photography award, receiving an honourable mention from Masafumi Sanai. In the same year his project *Daily* was published by Space Cadet. He has exhibited extensively in Tokyo, including at Guardian Garden, IMA Gallery and the Tokyo Metropolitan Museum of Photography. He also featured in the *New Japanese Photography exhibition* at Doomed Gallery, London, in 2015. www.naohiroutagawa.com

MARCO BOHR (b. 1978, Germany) is a photographer, academic and writer on visual culture. Born and raised in Germany, studying photography in Canada, living in Japan, and continuing postgraduate studies in the UK, he hopes to bring an international perspective to the study of photography. He completed a Visiting Fellowship at the Australian National University before his appointment as lecturer in Visual Communication at Loughborough University. His writings appear regularly on visualculture-blog.com, a platform for photography and visual culture.

Sense / Sensō

by Aaron Schuman

David Favrod
p. 175

In David Favrod's *Fuji VS Catogne* (2012), the sharp-toothed edge of a craggy mountain peak — solid, heavy, roughly hewn by harsh tectonic shifts, and dusted with brilliant, white snow — is elegantly tamed; softened by cloud, mist, and a subtle, golden, sepia tone. Visually, it's as if the imposing clarity and awe-inspiring sublimity of German Romanticism has been delicately wrapped in the finest of Japanese papers, subdued by different histories, distant memories, and alternative forms of both art and transcendentalism. And in a sense it has, for Favrod's himself — born in Kobe, Japan, to a Japanese mother and a Swiss father, and raised in a small village in the lower Valais since the age of six months – has spent the last decade using the photographic medium to negotiate between the two distinct aspects of his own heritage. As he explained in the statement that accompanied his earlier series, *Gaijin* (2009), 'When I was eighteen, I asked for dual nationality at the Japanese embassy, but they refused. It is from this feeling of rejection, and also from a desire to prove that I am as Japanese as I am Swiss, that this work was created. [Its aim] is to create my own Japan, in Switzerland, from memories of journeys when I was small, my mother's stories, popular and traditional culture, and my grandparents war recitals.'

Favrod's latest series, *Hikari* (2012-15), stems directly from *Gaijin* in that it continues to engage with his own Japanese background within a Swiss context. But here Favrod focuses more precisely on notions of memories — specifically those of his grandparents during the Second World War — and how they can be absorbed, interpreted, commemorated and transformed. 'When you first look at *Fuji VS Catogne,'* he explains, 'you immediately think of Mt. Fuji. But in reality, it's Le Catogne – a Swiss mountain. Like memory, it's easily malleable, and I like walking along this thin line, which separates the fiction from the reality.'

Like many of the works found in the series *Gaijin*, images such as *Fuji VS Catogne* walk this line and generally address where such boundaries blur, yet within *Hikari*, Favrod has also boldly experimented with, and expanded on, his creative approach, employing a variety of unconventional visual strategies that help him to hint at more detailed and precise aspects of his grandparents' wartime memories. 'Many of their memories were sounds', he recalls. 'During the bombings they went to underground shelters — it was

dark, and their only memories were of the sounds of planes, explosions, people crying. I wanted to introduce these sounds into my pictures, so I decided to use onomatopoeias — like those found in manga — and to paint them directly onto the prints with acrylic.'

In *Baoummm* (2013), a fallow field in winter – bathed in a sickly yellow light, with grey clouds descending and a menacing plume of smoke on the horizon – is interrupted by the Japanese characters *doka* (the Japanese comic-book equivalent of 'Bam!' or 'Boom!'), falling sharply and rapidly, like a high-speed arrow that's about to pierce the frozen ground. Similar onomatopoeic tactics are used in *Tatatatata* (2013), *Arrgh* (2013), and *Viuuu* (2013) with the acrylic white words painted over richly saturated black prints, intended to mimic the darkness of bomb shelters as they echo with the din of war. In other works, such as *Pour Sadako* (2012), Favrod incorporates longstanding Japanese arts and traditions, and merges them with more contemporary forms of constructed, allegorical and mix-mediated forms of photographic practice. A flock of red, yellow, and orange origami cranes, in various states of completion, hover over a tranquil stream, blending in with the with the fallen, autumnal leaves that lie on its edges and float on its shallow surface. 'Sadako was a young girl living in Hiroshima when the atomic bomb was dropped,' Favrod elaborates. 'Years later, she developed leukemia, and died in 1955, at the age of twelve. An old Japanese story says that whoever folds one thousand origami cranes will be granted a wish. Sadako didn't manage to fold a thousand cranes whilst alive, but her friends folded the remaining ones, and buried them with her.'

Throughout *Hikari*, there are many similar allusions — cultural, historical, familial, and personal (incorporating direct references to air raids, anime, ancient castles, atomic flashes, kamikaze pilots, dead siblings, poisonous rain, Favrod's grandmother, self-portraits of Favrod himself, and more), and the series certainly serves as a poignant testament to both the ravages of the war within Japan, and his grandparents own, painful experiences of it. But ultimately, Favrod's ambitions for the project also stretch well beyond such particulars. 'My grandparents witnessed the war', he notes. 'They were survivors, they have now passed away, and their memories will soon be a part of history that nobody will remember. In twenty or thirty years, the only memories that we will have from the Second World War will be collective memories. And the mystery of that is just as important. It's really important to me that the viewer brings their own history to the work, and creates their own stories through the images. Because really, *Hikari* is about two things: memory and commemoration.'

All images from the series *Hikari* © David Favrod, courtesy of the artist

DAVID FAVROD (b. 1982, Japan) received an MA in Art Direction and a BA in Photography from ECAL. He is the recipient of the 2014 Talents C/O Berlin, 2013 Lens Culture Exposure Award, and won the Swiss Design Award in 2010. He has had solo and group exhibitions around the globe, including at the Aperture Foundation in New York, the Center for Contemporary Arts in Santa Fe, the Houston Center for Photography, Museum of Contemporary Canadian Art in Toronto, Benaki Museum in Athens and the Daegu photo Biennale in South Korea. He lives and works between Switzerland and Spain. www.davidfavrod.com

AARON SCHUMAN (b. 1977, United States) is an artist, writer, editor and curator. He regularly writes for a number of art and photography publications, and has contributed essays to several recent books, including *The Photographer's Playbook* (Aperture, 2014), *Storyteller: The Photographs of Duane Michals* (Carnegie/Prestel, 2014), *C-Photo: Observed* (IvoryPress, 2013), *Pieter Hugo: This Must Be the Place* (Prestel, 2012), and the forthcoming *Alec Soth: Gathered Leaves* (MACK, 2015). In 2014, he served as chief curator of Krakow Photomonth's main programme, Re:Search, featuring exhibitions by Taryn Simon, Jason Fulford, and more. He is also a senior lecturer at the University of Brighton and the Arts University Bournemouth, and is the founder and editor of *SeeSaw Magazine*.

From the Point of View of Images

by Taco Hidde Bakker

Alessandro Calabrese
p. 187

At the basis of Alessandro Calabrese's series *A Failed Entertainment* lie analogue photographs he took over the past three years on strolls through Milan, the city he's based in and where he teaches photography; focussing on a variety of topics, including the city's outskirts, construction sites, abandoned buildings, street scenes and people whom he cares about; images that to a large extent were inspired by classical Italian photographic realism.

Despite a fascination for illustrious Italian sources of inspiration, Calabrese developed an ambiguous relationship with the notion of the singular, authored photograph. His interest in the internet, algorithms and Google, made him discover the artistic potential of a powerful tool by Google, called Reverse Image Search, to

which he uploaded his Milanese photographs, which then would generate images, sometimes up to several dozens, that the application *thinks* are 'visually similar', as defined by its pre-programmed algorithms. In a promotion film for the application a statement is made that perfectly describes what Calabrese had in mind for what his new project could lead to: 'Now, every

image is a jumping off point to explore, examine, and discover.'

From the results for each of the photographs Calabrese processed through the Reverse Image Search, he randomly selected a handful which he then printed in their original sizes on separate acetate sheets. By overlapping the sheets and including his own made source image in the centre, Calabrese arrived at colourful collages for which his photographs were but the starting point; merged into a new vision, as he calls it, calculated by the algorithm, at once close to his photographs yet completely different.

Calabrese sees his process for *A Failed Entertainment* as a form of self-criticism with regards to authorship in photography: why do you take a

picture, when and where? What are a photographer's options when there is so much to choose from? Google's image-matching algorithm was supposed to cancel out authorship, but it slipped back in when Calabrese had to make choices regarding his selection, the style of overlapping and deciding at what point to stop: 'What we see is the end of a process, a performative action so to say, in which all the images are merged together. It proved impossible not to stop, so in the end I was forced to make a choice.'

What fascinates Calabrese are photography's basics, in this case his own straightforward registrations of things and situations that strike him, but combined with the concept of infinite reproduction, represented through the theory of the fractal: an object that is built up from an infinite number of constituents similar to it in shape. David Foster Wallace's complex, dystopian novel *Infinite Jest* of interwoven plots starts from the fractal theory and was originally to be called A Failed Entertainment. It is with this project that Calabrese pays homage to a writer that inspired his thinking on and dealing with photography in the networked age.

Within each of the images of *A Failed Entertainment* the source image is supposed to hide inside the black hole occupying the centre. 'It might just be an idea, though I'm not very fond of ideas in photography, as my images could as well be absent altogether, but they are there, hidden inside the gravitational black centre.' The whole project alludes to the overwhelming amount of images available to us nowadays, and for Calabrese the black hole is a representation of the frustration of being confronted with the unsettling idea of not being able to follow the ongoing stream of pictures and words anymore. At the same time, the black hole seems to stand for a kind of catharsis too, a blind spot and a garbage can for our image-overload, into which now ironically Calabrese's own, carefully crafted photographs have disappeared from sight.

'My ambition was to show something more objective. With an apparently simple tool I called up pictures starting from my pictures. I want to show something about the world using other people's photographs, not so much from a point of view of singular authorship, but from the point of view of images.' And Calabrese added that his is also a reflection on the archive, his own archive filled with real photographs, as well as the boundless archive of images circulating the world wide web: 'Perhaps they're gone already, deleted from the web, when I wish to revisit them. So in a way I freeze the moment wherein my images generated these supposedly similar images.' Every new input may yield completely different results, which Calabrese thinks to be an equally frightening as satisfying thought, as it has led to some sort of new *decisive moment*, in its technological sense, but it worries him too, because it might go on infinitely: 'I do need to know the line that I cannot cross. When should I stop?'

All images from the series *A Failed Entertainment* © Alessandro Calabrese, courtesy of the artist

ALESSANDRO CALABRESE (b. 1983, Italy) graduated in Landscape Architecture from IUAV and attended the Master in Photography and Visual Design at NABA, Milan, in 2012. He worked as an assistant to Hans van der Meer and carried out research for the platform *Paradox*. An artist residency in the Aosta Valley gave rise to his first publication *Thoreau* (Skinnerboox, 2012). Returning to Milan in 2013, where he continues to live, he started teaching photography at NABA. His latest project A Drop in the *Ocean—Sergio Romagnoli* (in collaboration with Milo Montelli; Editions du Lic, 2014), was first exhibited at Fotografia Europea 2015. He participated in Plat(t)form at Fotomuseum Winterthur and was shortlisted for the Prix Levallois in 2015. www.alessandrocalabrese.info

TACO HIDDE BAKKER (b. 1978, the Netherlands) is a writer, translator and researcher based in Amsterdam. In 2007 he graduated in MA Photographic Studies at Leiden University and since publishes on photography and visual arts for a variety of magazines, art venues and artists. Additionally he is editor at *EXTRA*, a Dutch-language biannual magazine on photography published by FotoMuseum Antwerp and Fw:Books.

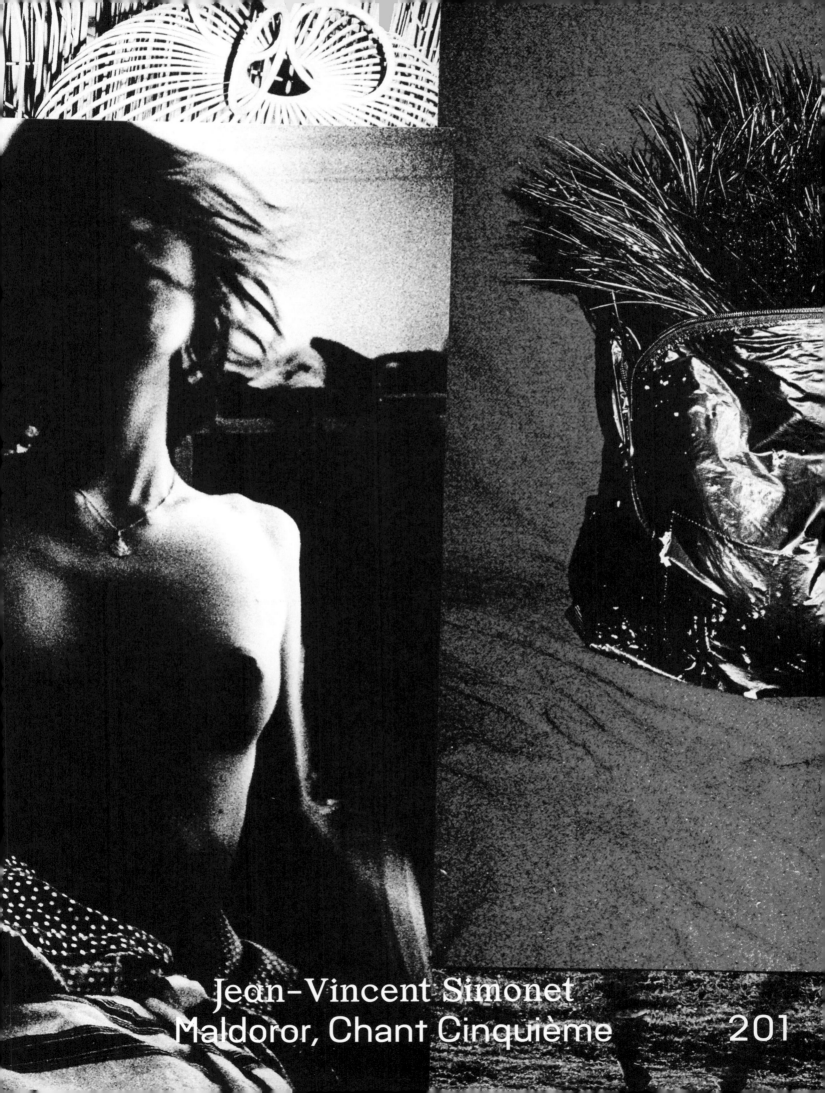

Jean-Vincent Simonet
Maldoror, Chant Cinquième

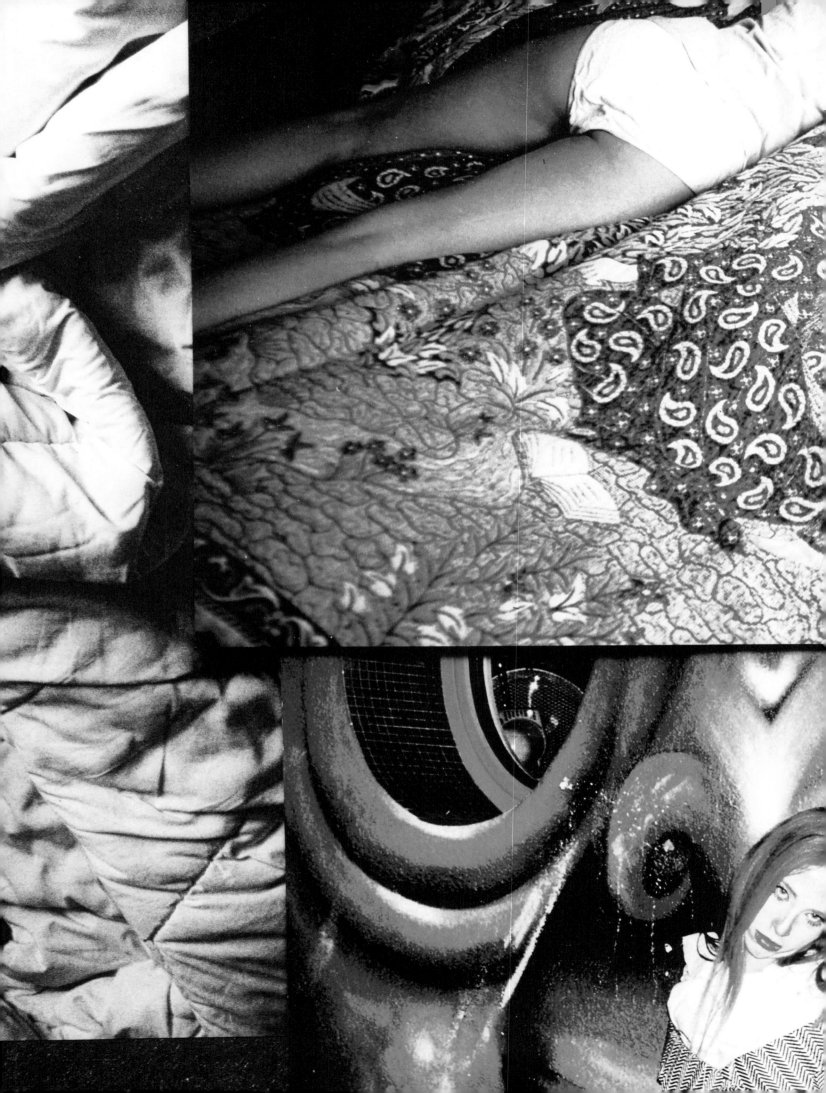

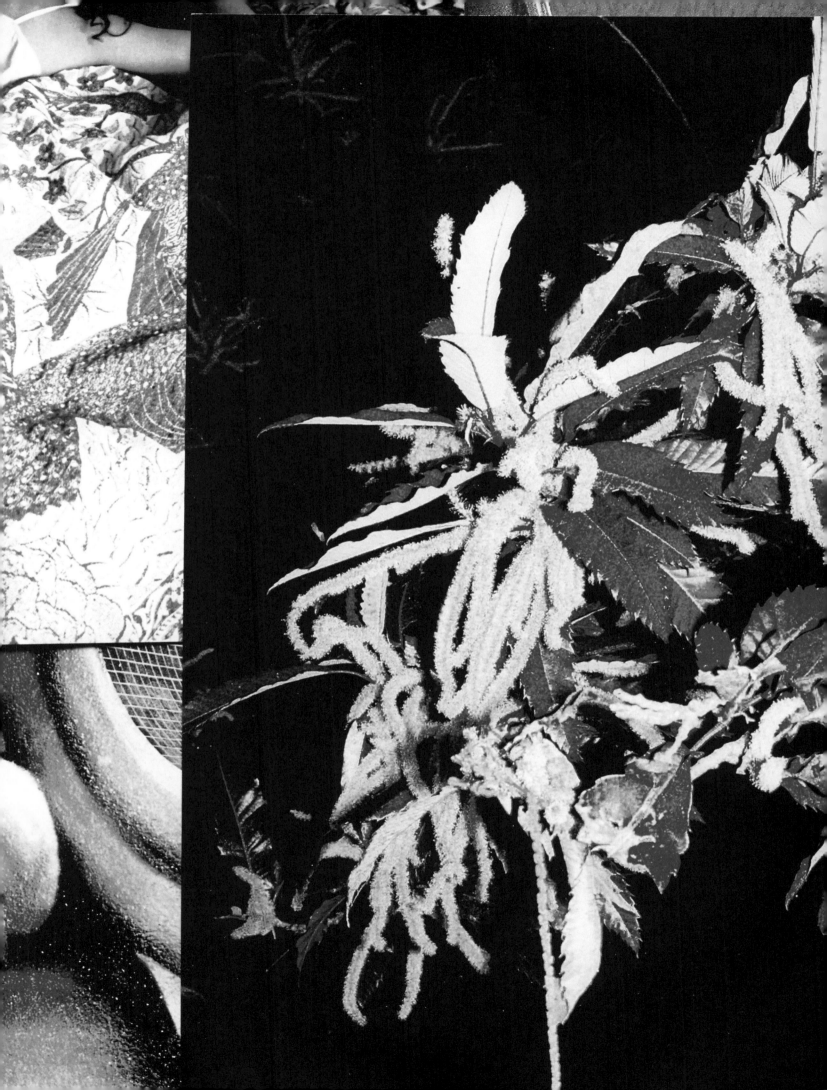

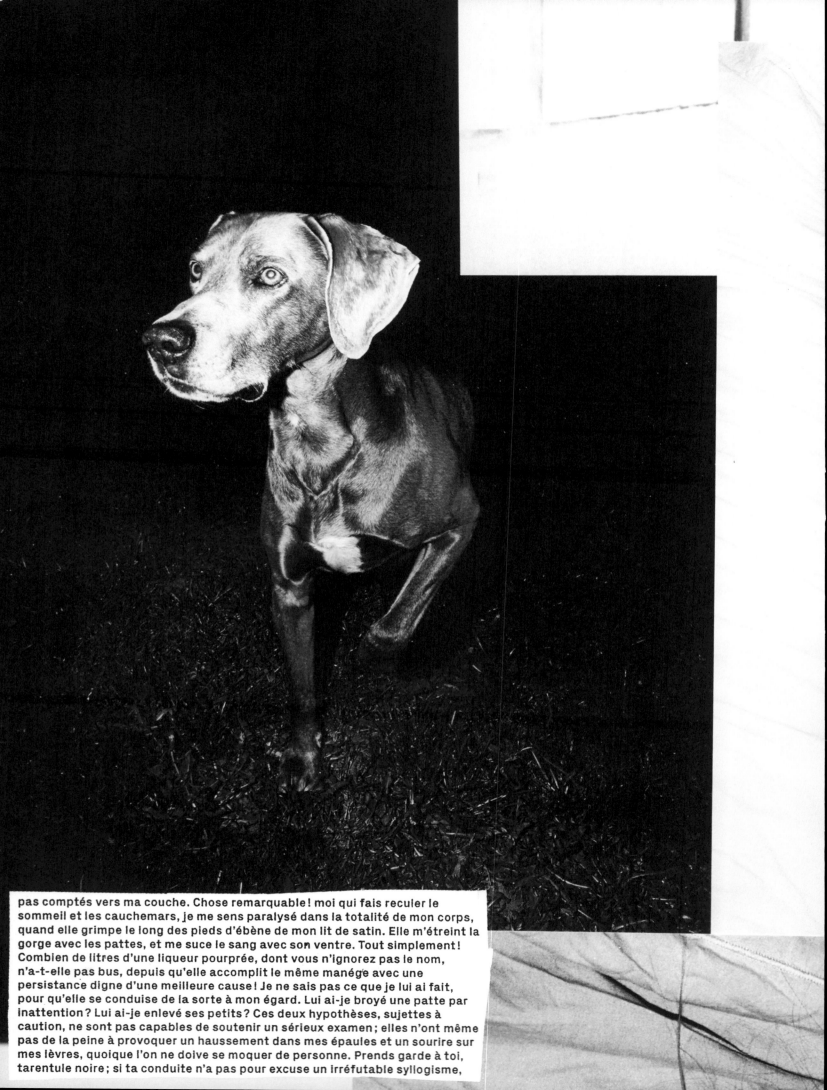

pas comptés vers ma couche. Chose remarquable! moi qui fais reculer le sommeil et les cauchemars, je me sens paralysé dans la totalité de mon corps, quand elle grimpe le long des pieds d'ébène de mon lit de satin. Elle m'étreint la gorge avec les pattes, et me suce le sang avec son ventre. Tout simplement! Combien de litres d'une liqueur pourprée, dont vous n'ignorez pas le nom, n'a-t-elle pas bus, depuis qu'elle accomplit le même manège avec une persistance digne d'une meilleure cause! Je ne sais pas ce que je lui ai fait, pour qu'elle se conduise de la sorte à mon égard. Lui ai-je broyé une patte par inattention? Lui ai-je enlevé ses petits? Ces deux hypothèses, sujettes à caution, ne sont pas capables de soutenir un sérieux examen; elles n'ont même pas de la peine à provoquer un haussement dans mes épaules et un sourire sur mes lèvres, quoique l'on ne doive se moquer de personne. Prends garde à toi, tarentule noire; si ta conduite n'a pas pour excuse un irréfutable syllogisme,

emploie, pour atteindre à ses fins, les moye
êtes témoin vous-même qu'il ne m'est plus
que la bise sifflait dans les sapins, le Créat
chant 5, strophe 6
Silence ! il passe un cortége funéraire à côt
une simple forme impérative, que comme u
extrêmement l'âme du mort, qui va se repo
point être contraire à la mienne ; mais, ce q
principe qui commande de faire à autrui ce
signe de la paix, et de l'autre un emblème d
faite de toute métaphore, des instruments
au lieu d'engendrer une opportune réactio
cheval, aux crins épais, qui balaie la pouss
après la tunique flottante du consolateur.
majesté, comme un vaisseau qui fend la pl

ui paraîtraient d'abord y porter un invincible obstacle. Toujours mon intelligence s'élève vers cette imposante question, et vous
rester dans le sujet modeste qu'au commencement j'avais le dessein de traiter. Un dernier mot… c'était une nuit d'hiver. Pendant
a porte au milieu des ténèbres et fit entrer un pédéraste.

clinez la binarité de vos rotules vers la terre et entonnez un chant d'outre-tombe. (Si vous considérez mes paroles plutôt comme
el qui n'est pas à sa place, vous montrerez de l'esprit et du meilleur.) Il est possible que vous parveniez de la sorte à réjouir
dans une fosse. Même le fait est, pour moi, certain. Remarquez que je ne dis pas que votre opinion ne puisse jusqu'à un certain
avant tout, c'est de posséder des notions justes sur les bases de la morale, de telle manière que chacun doive se pénétrer du
drait peut-être qui fût fait à soi-même. Le prêtre des religions ouvre le premier la marche, en tenant à la main un drapeau blanc,
sente les parties de l'homme et de la femme, comme pour indiquer que ces membres charnels sont la plupart du temps, abstraction
eux entre les mains de ceux qui s'en servent, quand ils les manipulent aveuglément pour des buts divers qui se querellent entre eux,
assion connue qui cause presque tous nos maux. Au bas de son dos est attachée (artificiellement, bien entendu) une queue de
lle signifie de prendre garde de ne pas nous ravaler par notre conduite au rang des animaux. Le cercueil connaît sa route et marche
et les amis du défunt, par la manifestation de leur position, ont résolu de fermer la marche du cortége. Celui-ci s'avance avec
ne craint pas le phénomène de l'enfoncement; car, au moment actuel, les tempêtes et les écueils ne se font pas remarquer par

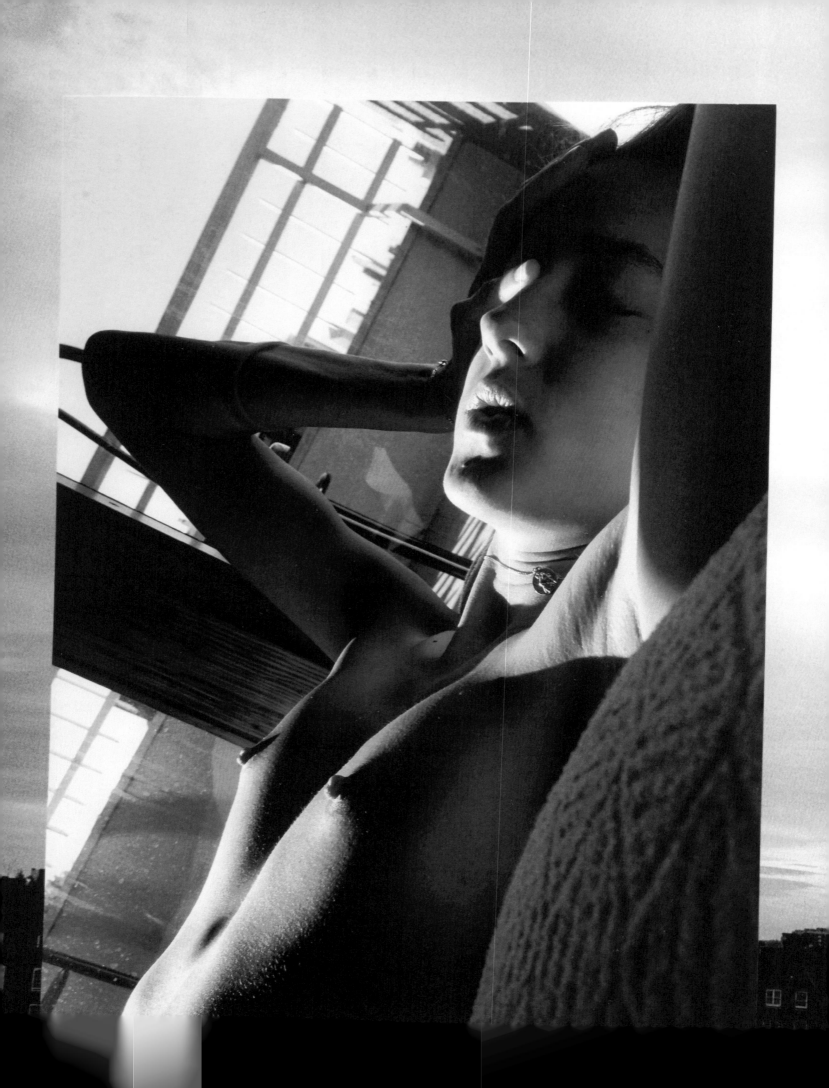

PLEASE NOTE
This ATM is operated by
Bank Machine Ltd.
To contact us tel: 0800 025 6923
The staff in this store do not
have access to this machine

This machine
will charge you for
debit and cash card
cash withdrawals

A CONTEMPORARY MALDOROR

on Jean-Vincent Simonet p.201

by Kim Knoppers

I no longer know what I saw first, the photograph or the object. I do remember that it caused a great deal of irritation. My annoyance didn't motivate me sufficiently to figure out exactly what I was looking at, but I was intrigued enough by *L'Enigme d'Isidore Ducasse* by American photographer Man Ray for it to go on floating about in the back rooms of my brain. What was underneath that piece of fabric carelessly held together with a bit of string? And why was it interesting to look at? Who was Isidore Ducasse anyhow? The mysteriously packaged thin— made specially to be photographed, yet an object that would live a life of its own and feature in the collections of Tate Modern in London and the Boijmans Van Beuningen Museum in Rotterdam – remained for me, until recently, *L'Enigme de Man Ray*.

Last January, during Plat(t)form, the international portfolio viewing at Museum Winterthur, I met the young French photographer Jean-Vincent Simonet. He told me he felt hugely attracted to the dark, theatrical and transgressive character of *Les Chants de Maldoror* (The Songs of Maldoror) by nineteenth-century writer and poet Comte de Lautréamont: 'I'm not really a literary guy. I don't read thousands of books like some do, but this one blew me away.'

In the book, which consists of six songs, a total of sixty verses of various lengths, Comte de Lautréamont crosses all the boundaries of decency. His central character, the pessimistic and blasphemous Maldoror, has dispensed with God and completely rejected all religion and morality. He is the personification of evil and he abandons himself to his perverse and sadistic instincts. In vividly written passages he leaps from glow worms as big as houses to an ode to the calm of the ocean to a pact with prostitution to four masked men who attack a hermaphrodite. There is nothing resembling a linear narrative and the perspective is fluid. Sometimes Maldoror speaks to us directly, sometimes we are addressed in the third person by a narrator. Fortunately Lautréamont does feel some compassion for the reader, whom he warns at the start of his intense book: 'May it please heaven that the reader, emboldened and having for the time being become as fierce as what he is reading, should, without being led

astray, find his rugged and treacherous way across the desolate swamps of these sombre and poison-filled pages; for, unless he brings to his reading a rigorous logic and a tautness of mind equal at least to his wariness, the deadly emanations of this book will dissolve his soul as water does sugar. It is not right that everyone should savour this bitter fruit with impunity.'

Comte de Lautréamont was the pseudonym of a diplomat's son, born in Montevideo, called Isidore Lucien Ducasse. All kinds of mysteries surrounded Ducasse when he died at the age of twenty-four, but life granted him enough time for *Les Chants de Maldoror* to establish his reputation. Nevertheless, he might easily have been completely forgotten after his death. The book was banned immediately because of its blasphemous character. We have the enthusiasm of the surrealist André Breton to thank for the fact that Lautréamont became a cult hero and a source of inspiration for contemporaries including Man Ray. *L'Enigme d'Isidore Ducasse* was inspired by a passage from Lautréamont: 'Beautiful as the accidental encounter, on a dissecting table, of a sewing machine and an umbrella.' Aha, so that's what Man Ray hid under a piece of fabric. When the photograph was used in 1924 to illustrate a statement in the periodical *La Revolution Surréaliste*, it seemed as if the photo was intended to portray the surrealist vision of what lay behind the rational world

Attrac

the

theatri

transgres

char

ted to

dark,

cal and

sive

cter.

and the conventions of everyday reality. The famous surrealists Luis Buñuel and Salvador Dalí are also known to have been inspired by Lautréamont. Whereas in the famous scene from their film *Un Chien Andalou* a man holds open a woman's left eye and takes a razor blade to it, in the passage from *Les Chants de Maldoror* there is no blade: 'By sewing your eyelids together with a needle, I would be able to deprive you of your view of the world and thereby make it impossible for you to find your way; and I won't guide you.' It takes little effort to sense the terrifying ghost of Lautréamont walking abroad.

By the time Simonet began his dialogue with Lautréamont, a hundred and forty-five years had passed and he was the same age as the French misanthropist. Simonet is obviously no shy soul but an adventurous spirit. 'I discovered the book and I was really shocked by the power of the text. It immediately created a lot of mental pictures. I decided to make a rendition of the original book. I took the six cantos as a starting point for six booklets. Each of the six booklets offers a thematic approach related to the universe of *Les Chants de Maldoror*: Romanticism, Chaos, Bestiality, Science, Intimacy and Literacy.'

Lautréamont writes in his first song about the red of the inside of nostrils, while in Simonet we see a lonely figure in a red haze. Thick shrubbery is portrayed by the photographer in pictures of arid-looking overgrown landscapes without a central focus, in which dead branches merge into pink and blue shapes that look like hairs. Those glow worms of the past become in Simonet a black-and-white photograph of a covered flashbulb. That intriguing recurring figure with his tattoos of different phases of the moon – might he be the personification of Maldoror? Of course it's not an exercise in filling the blanks,

that's not the point. Simonet's photos don't literally follow the text, they are loosely based on the atmosphere it evokes. Like Lautréamont, Simonet does not shrink from theatricality. His photos of gothic angels are provided with dramatic blue photoshopped skies full of stars. Parts of the text have been laid out in gothic-looking calligraphed letters. Sometimes the letters run through the photos. Other times the images are placed right across the text.

'The structure of the six chapters of *Les Chants de Maldoror* and Lautréamont's eclectic style gave me the opportunity to use a diversity of photographic techniques and layouts. Until a few years ago I was really a nerd in photography. I learnt all about cameras. In *Maldoror* I combined all my experience.' Simonet used iPhone pictures, 20 x 25 and large format. He works in both analogue and digital, in black-and-white and in colour. Many of the photographs are 35 mm. In Chant Troisième we find many multiple exposures, magnification experiments and photograms made in the darkroom. 'I like playing with digital as well. I don't know a lot about it, but I'm interested in glitching. It's really simple software and if you combine it with other stuff and don't overdo it, the effect is really interesting. Even with simple software you can get a long way without knowing a lot about coding or data-processing. I'm now starting some experiments with 3D printing.

'All this experimentation and trickery with the medium of photography is for me linked to surrealism. Of course I don't use the same technique, but the experimental and open character is similar. I'm in love with the black-and-white drawings of Hans Bellmer in which distortion is important. I don't do this in drawings but instead in my computer. So I get visual inspiration from the surrealist movement. I don't really relate to their manifestos.

'The photographs in Chant Cinquième are actually taken from my visual diary and are not derived from Lautréamont's book in particular. He's always making references in the book to his own life and to the romantic and gothic era he lived in, so I

thought it was legitimate to make references to my life as well. My lifestyle is connected to contemporary gothicism and I'm trying to explore that in my work. I'm interested in this contemporary, urban fashion movement called Health Goth[1] in which gothic references are mixed in a techno way and the body is treated as a sculpture. Of course you don't feel this in *Les Chants de Maldoror* but it's a contemporary means of dealing with romanticism and gothicism that I feel is interesting.

'Fashion is the field in which I'd like to play. Maybe this interests me more than making fine-art photography prints and exhibitions. I like applied photography. For me it's inspiring to work within limitations. There are these styles to show and you must find a way to do it. I feel more free in these conditions than when working without any given framework. It allows me to focus on the visual part instead of thinking about a concept.' Over the past year Simonet has cautiously begun studying the work of the Marquis de Sade, that other unique figure in the history of literature. It will undoubtedly provide an inspiring framework for an ode to the imagination within which Simonet can parade his image-fetishism without the slightest constraint.

1 For more information on Health Goth: Weinstock, Tish. 'Health goth is the latest trend to be spat out by the internet, so what's the deal?' i-D. 10 November. 2014. Web

All images from the series *Maldoror, Chant Cinquième* © Jean-Vincent Simonet, courtesy of the artist

JEAN-VINCENT SIMONET (b. 1991, France) graduated with high honours from ECAL in 2014 before starting his career of mixing editorial, fashion and experimental photography. His personal work was exhibited at Pla(t)form 2015 in Fotomuseum Winterthur and he was the recipient of the Swiss Design Award 2015 for his project *Maldoror*. He lives and works in Lausanne where he juggles between commissioned photography and personal explorations. www.jeanvincentsimonet.com

KIM KNOPPERS (b. 1976, the Netherlands) has been a curator at Foam Museum since 2011. She studied art history at the University of Amsterdam. She was previously curator at De Beyerd Center of Contemporary Art and has also worked as a freelance curator. She has curated group exhibitions including *Remind* (2003), *Exotics* (2008) *Snow is White* (2010, together with Joris Jansen) and *Re-Search* (2012), and solo exhibitions by WassinkLundgren, Onorato & Krebs, Jan Hoek, Lorenzo Vitturi, Jan Rosseel, JH Engström, Geert Goiris and Broomberg & Chanarin amongst others.

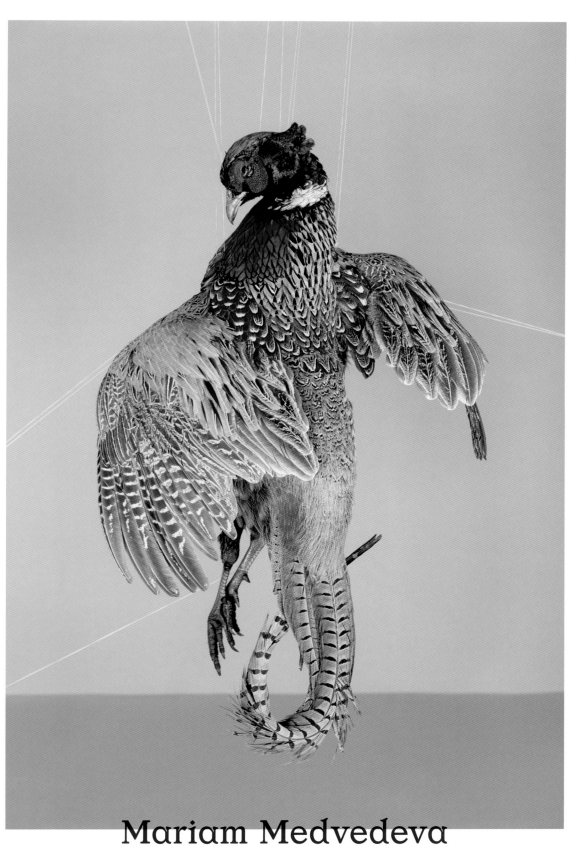

Mariam Medvedeva
When You are Dead, the Pose You
Take Doesn't Matter Anymore

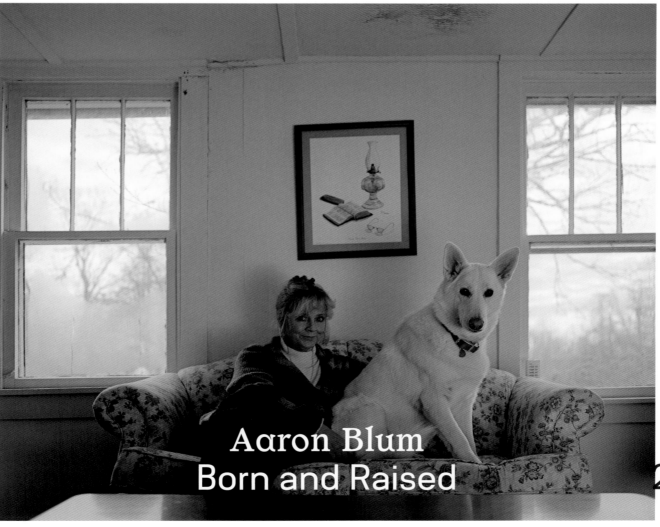

Aaron Blum
Born and Raised

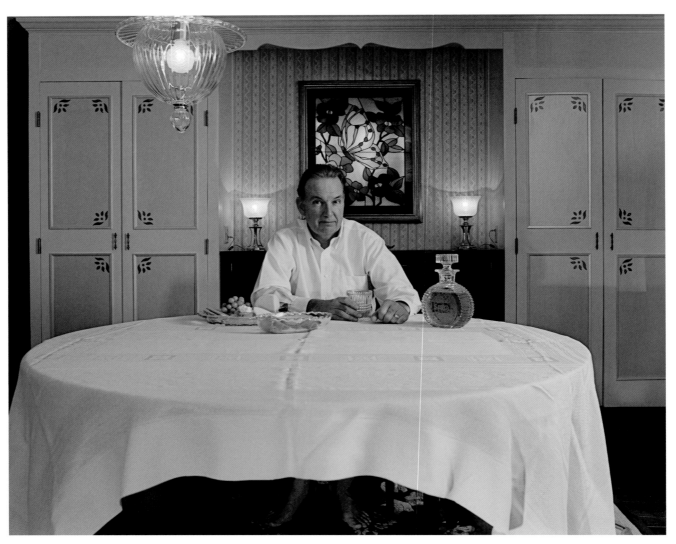
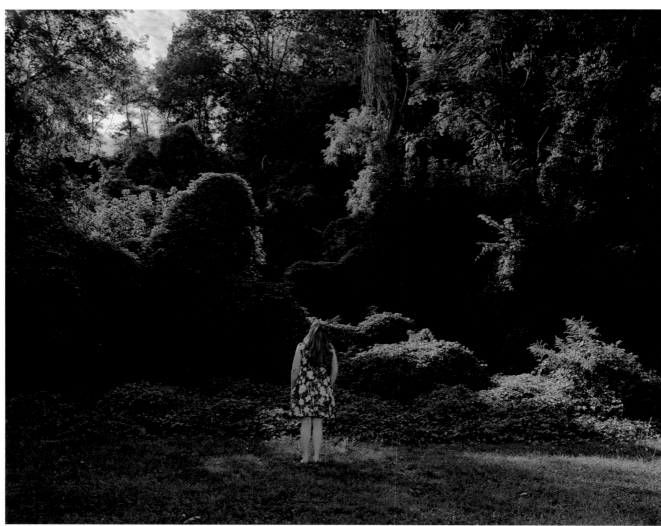

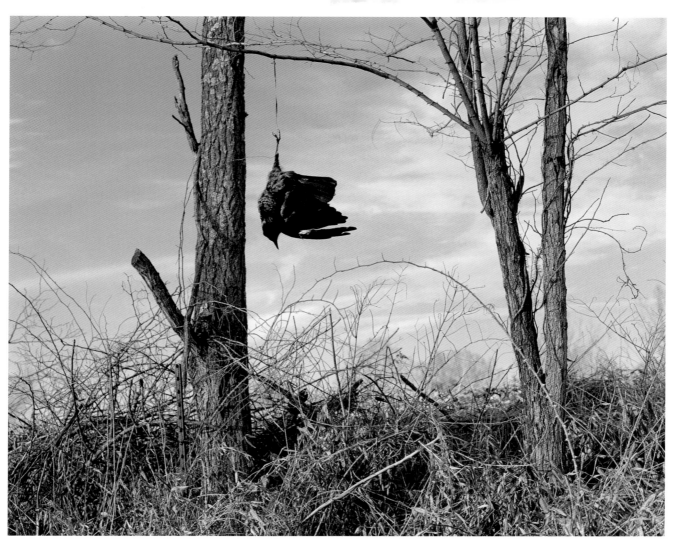

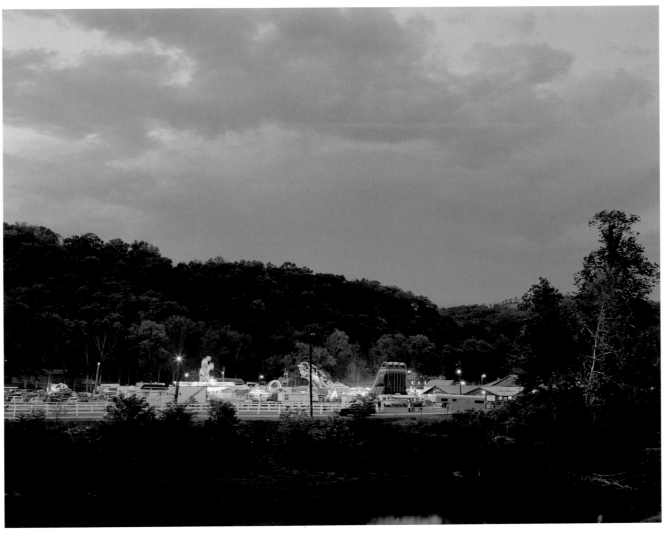

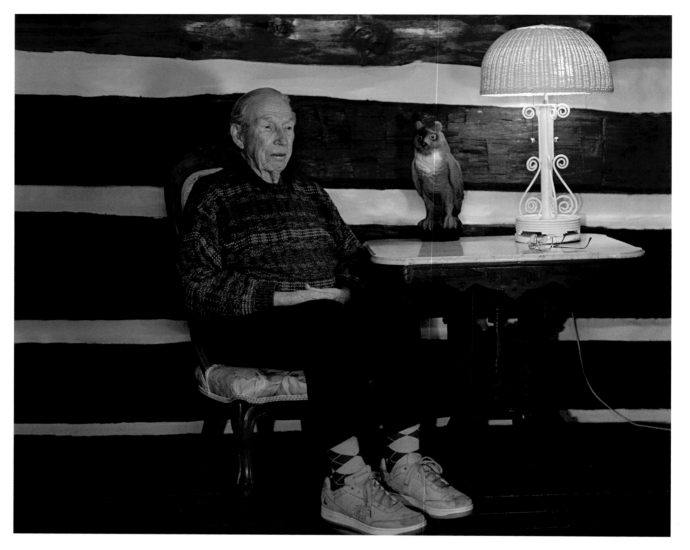
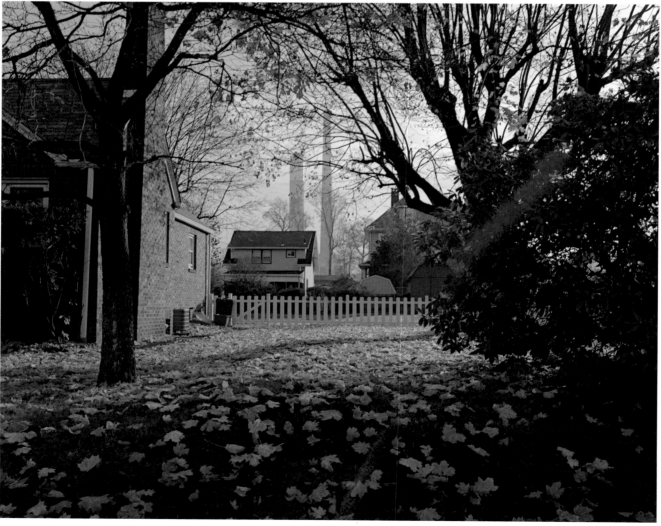

Abel Minnée
I Studied Photography,
I Studied Photography

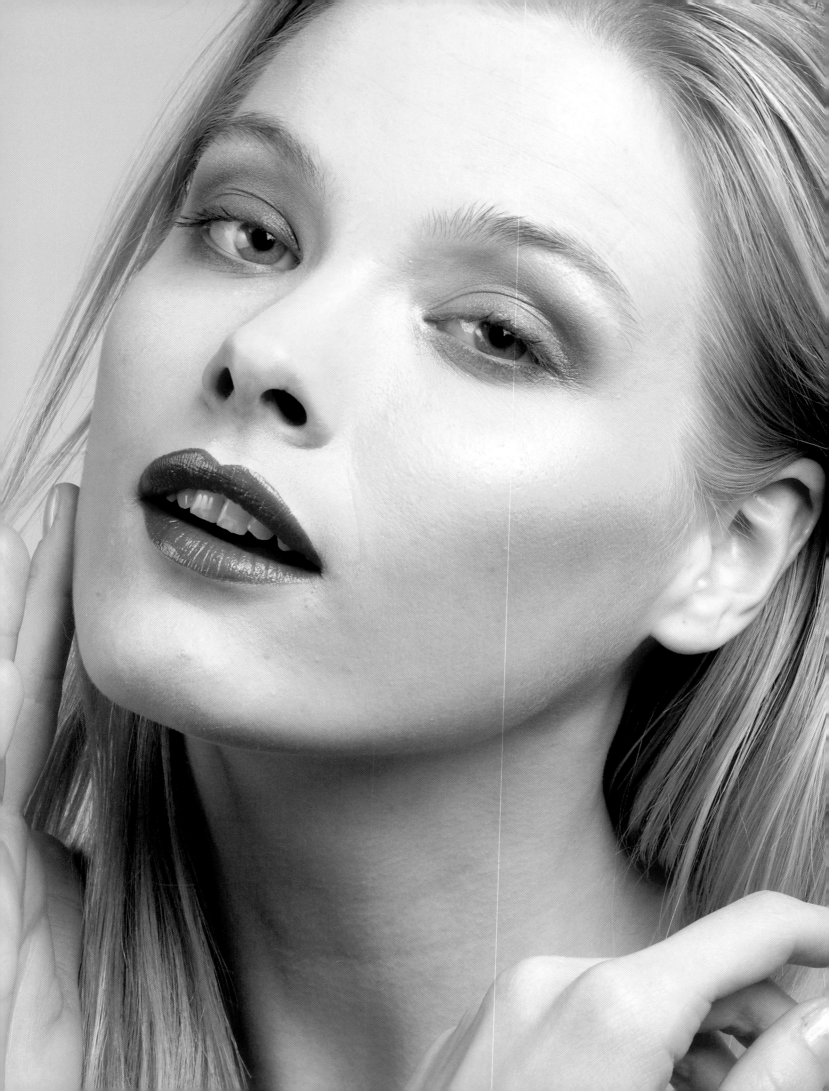

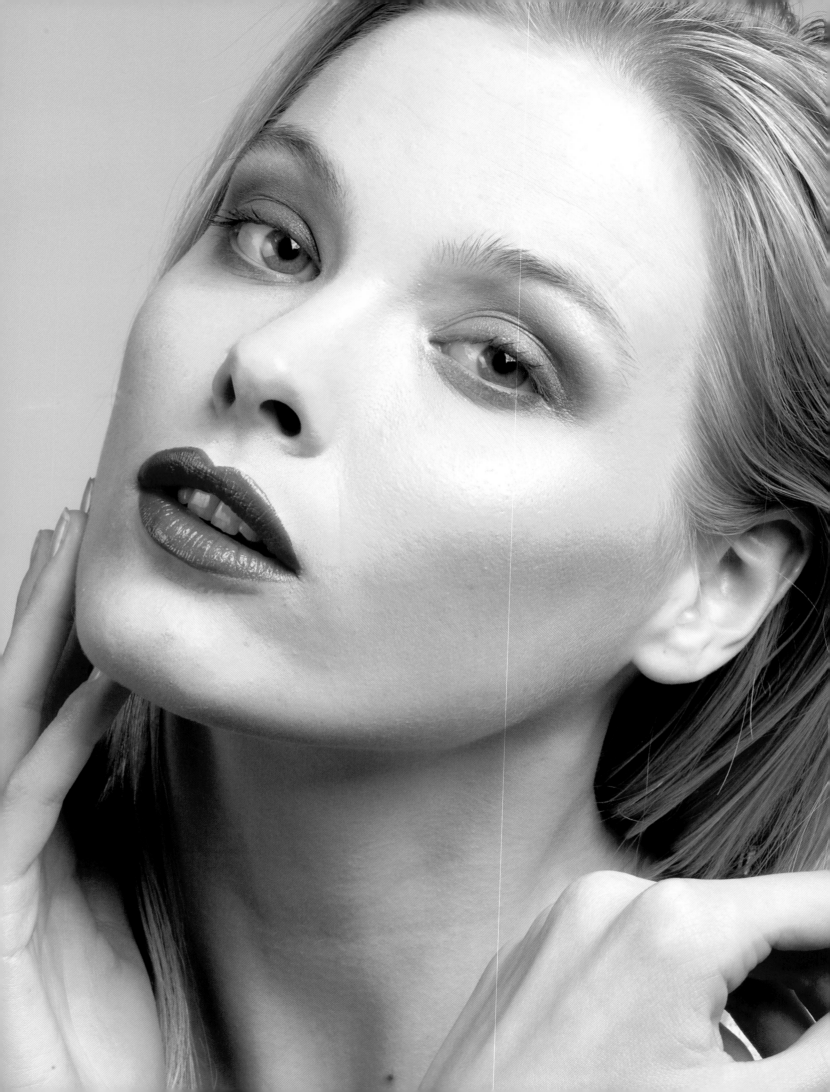

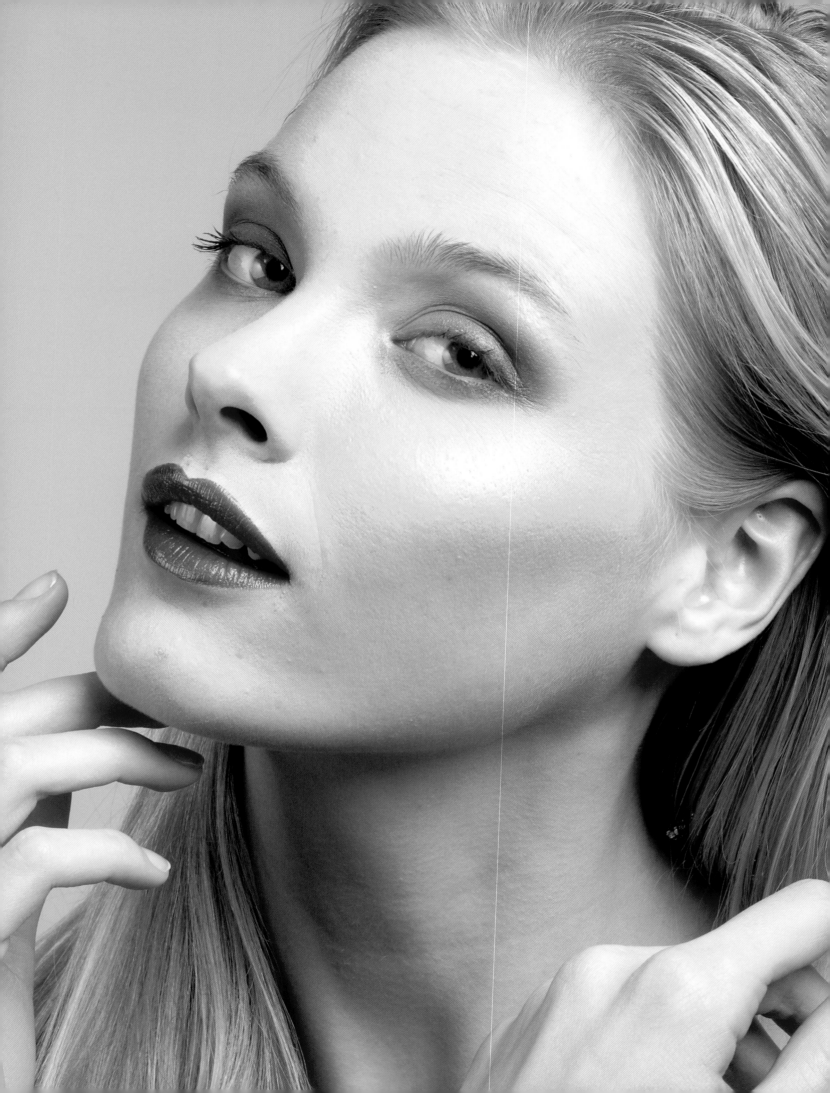

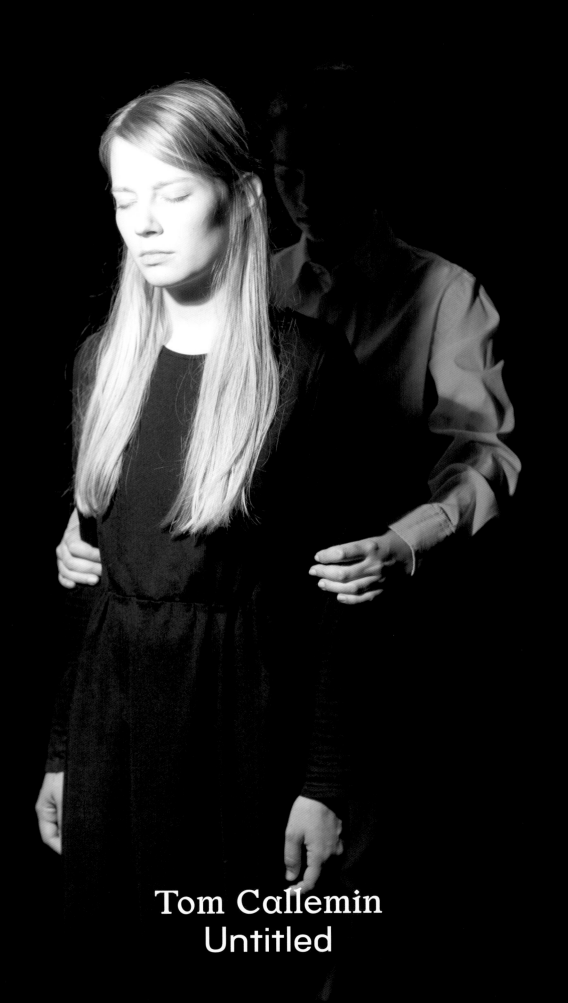

Tom Callemin
Untitled

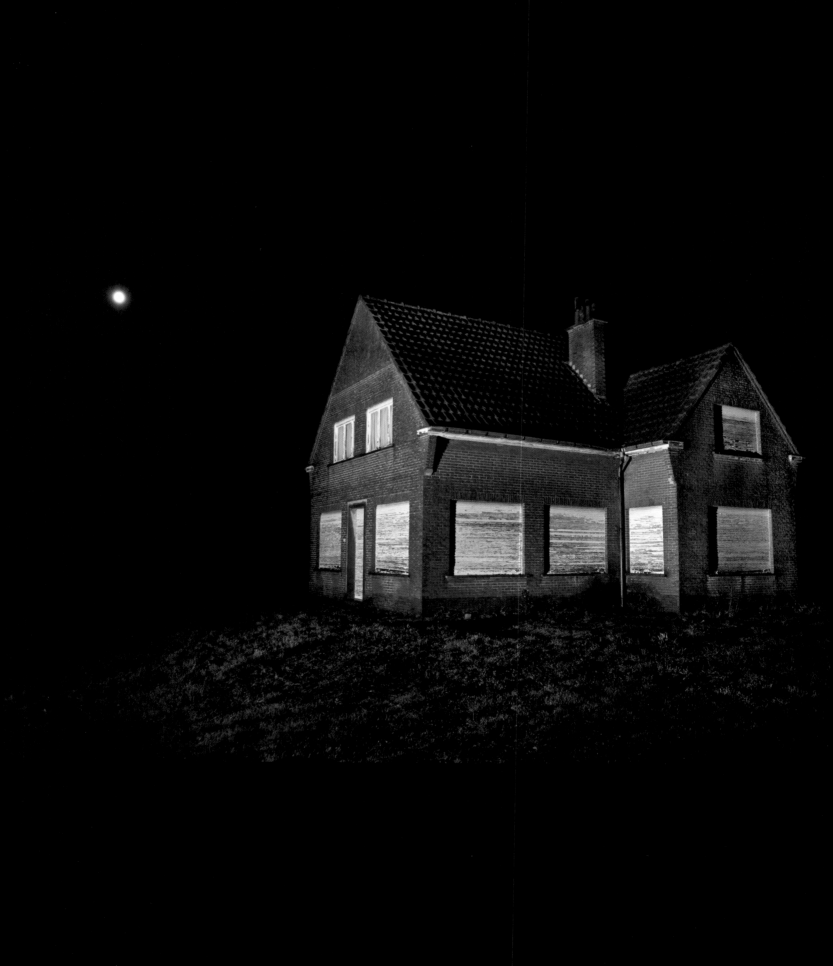

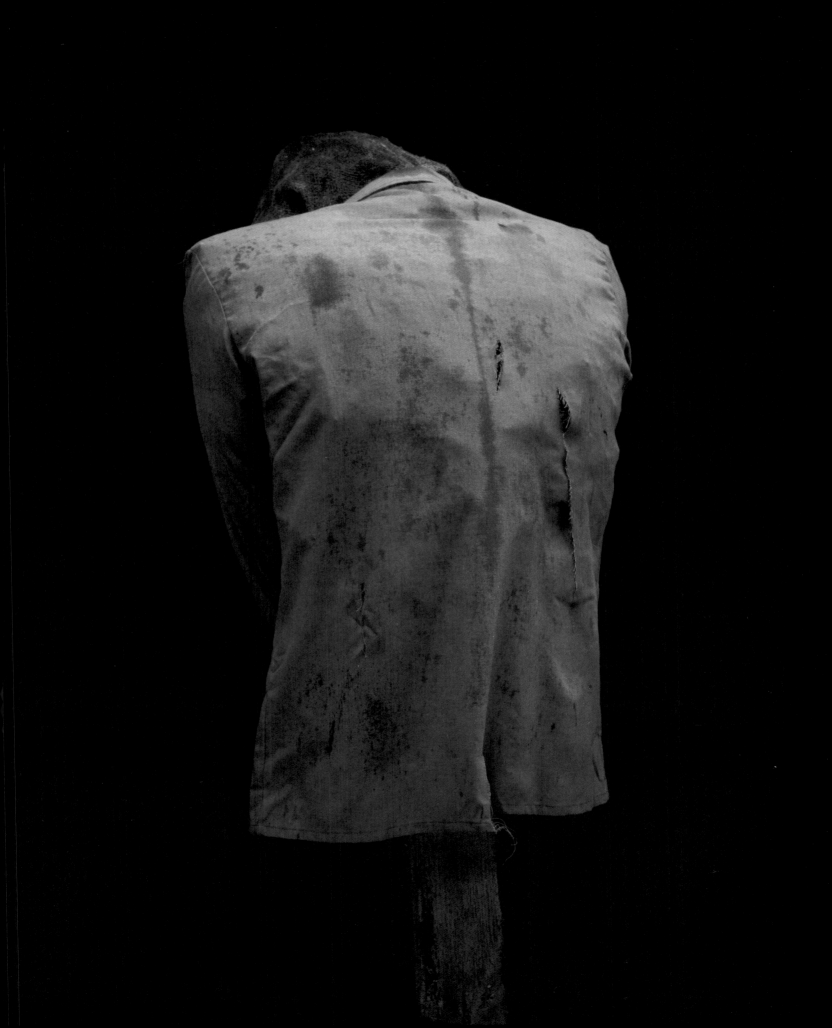

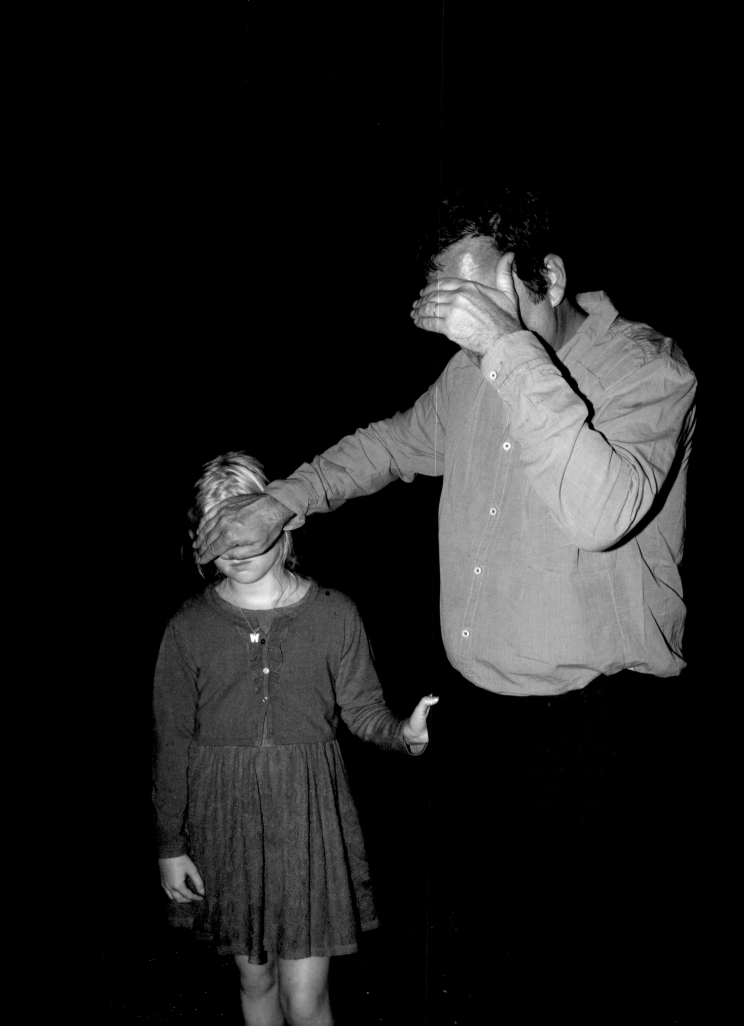

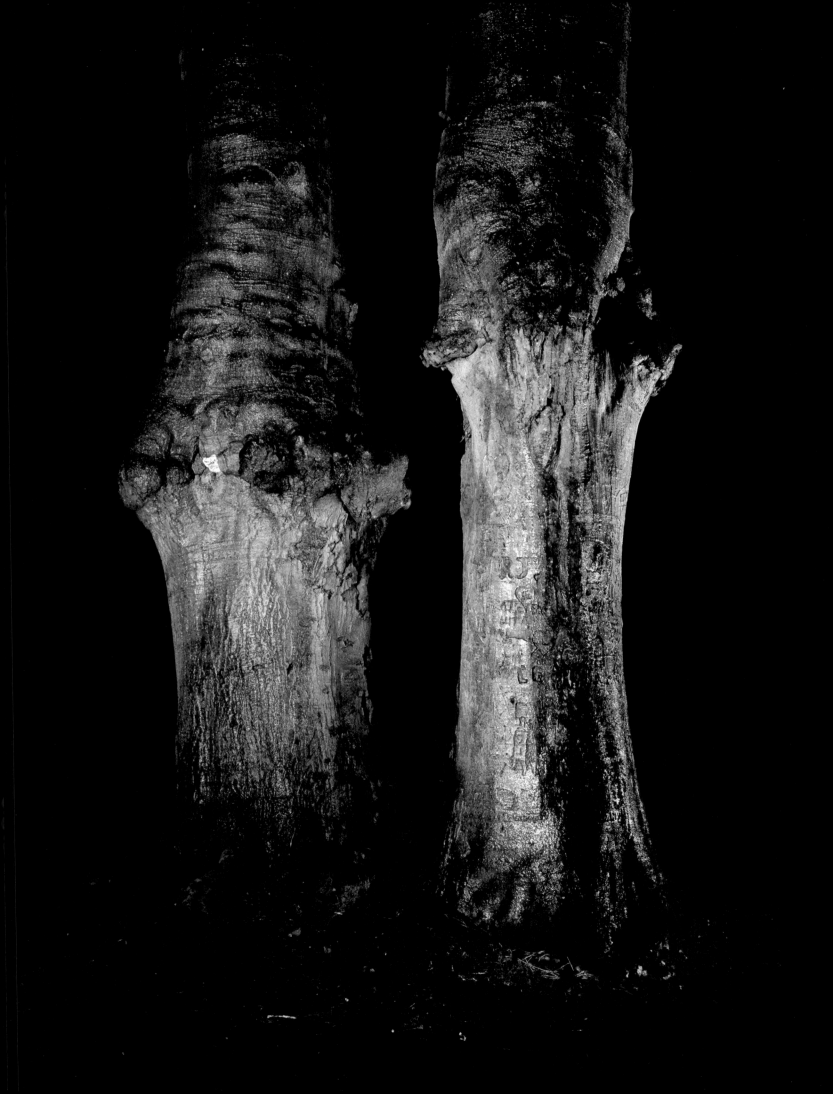

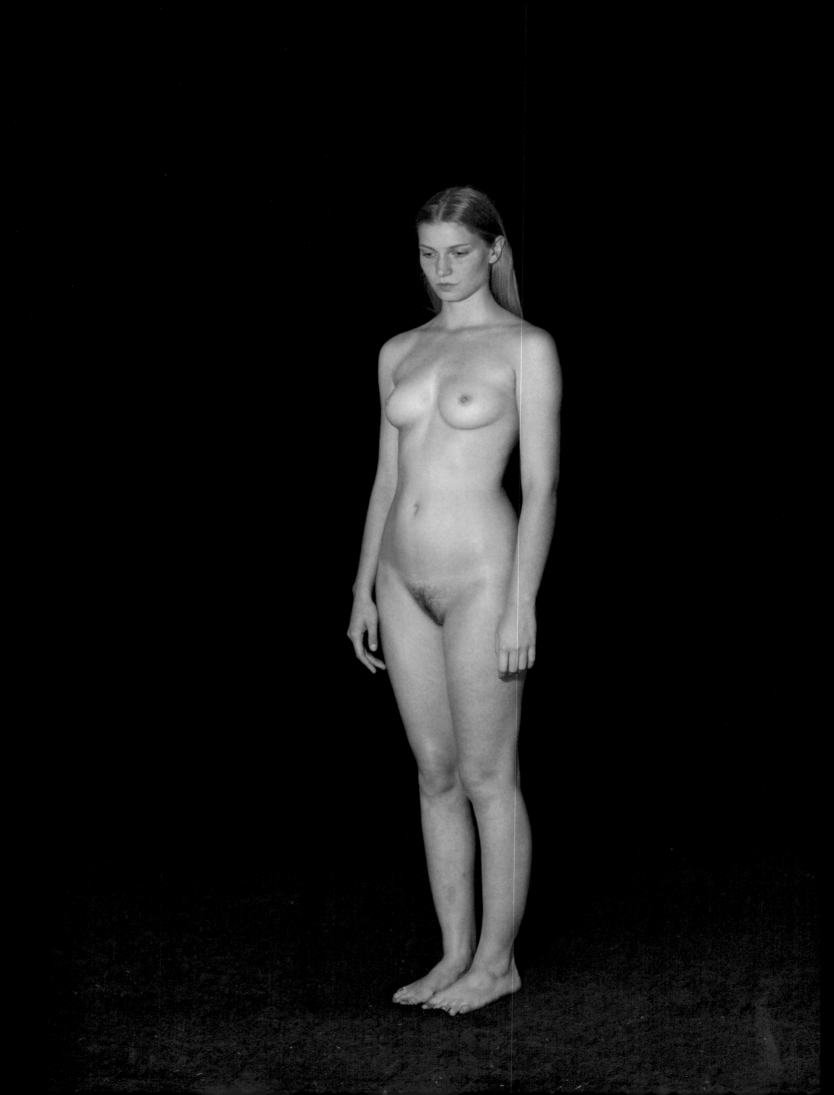

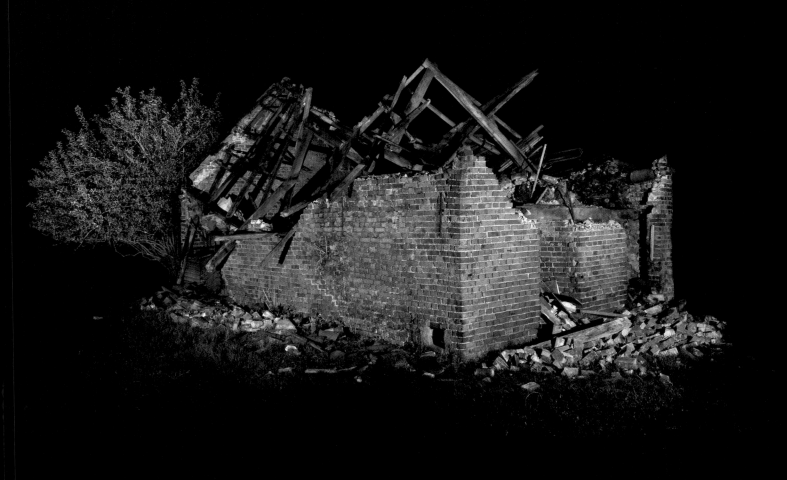

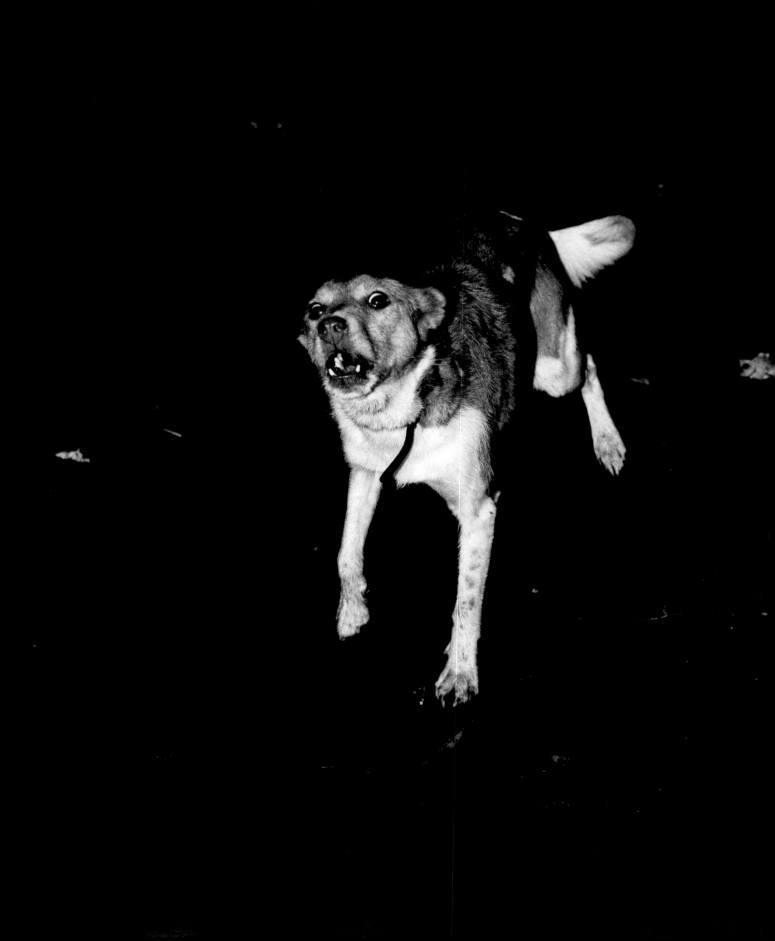

The Theatre of Indifference

by Federica Chiocchetti

'With our decaying sensitivity and the lack of self-consciousness,' wonders Russian artist Mariam Medvedeva, 'aren't we, in a certain sense, already dead?' In her latest series, wittily titled *When you are dead, the pose you take doesn't matter anymore*, Medvedeva explores notions of death and indifference, playing with the theatricality of still life and post-mortem photography. Elegantly arranged and meticulously hung and tied to thin threads, reminiscent of the thread of life manoeuvred by the dreadful female personifications of destiny (the ancient myth of the Parcae or Fates), her dead animals are displayed and photographed with human poses. 'I wanted to show dead animals in human poses, a little theatre where characters play in a paradoxical direction: they are actually dead but act as if they were alive; a sort of caricature of humanity.'

Her imagery is imbued with myth and symbols, signs and premonitions: 'Mythology is a primordial form of thinking from which stem all the other, more evolved, ones — religion, art, philosophy, science.' She is fascinated by the idea that for centuries, humans thought through symbols and images, explaining the world by means of faith rather than logic or science. 'Regardless of their nationality and religion, humans are able to create and read symbols and photography is very "fluent in talking" the symbolic language.' Following up her previous project where she worked on the old monogram of Jesus, *Ichthys*, which visually resemble the profile of a fish, she developed an interest in hiding meanings within visual art through animal symbolism, particularly birds, as traditionally believed to be messengers between the earth and the sky.

The process she had to go through to find the subjects for her series was anything but soothing. If one needs dead animals that are not stuffed and come from a legal source, hunting is the only answer. She had to get in touch with traditional hunters in France, where she lives. It was a completely unknown world to her. At the beginning she was somewhat perplexed about the ethical side of the project. Hunting in itself is already an extremely controversial practice that most of the time provokes mixed feelings and reactions among people who are not involved in it and are against the principle of killing animals as a hobby. But also, she was not entirely

Mariam Medvedeva
p. 225

On Mariam Medvedeva

comfortable with sourcing dead animals from French hunters for the sake of her artistic aspirations. 'I decided to be present during the hunting of the animals I was then going to photograph; it felt more appropriate for me to witness their death than just borrowing their body for my photographs.'

For two hunting seasons she saw all the stages of the shooting and the animals' metamorphoses from alive to dead before she took them with her. She describes the experience as 'almost philosophical'. Following, yet also subverting, the usual 'procedures' of post-mortem photography of the past, where the subjects were normally humans on their deathbed, she then took care of the animals' bodies, cleaning them and preparing them to be photographed, a process that took as many hours as the making of the images itself. 'Working with big animals such as foxes, rabbits and nutrias was very tough, because of their smell and infections. I didn't have the possibility and time to bring them to the studio (which was at least 5/7 hours driving from the locations), so I would go with the hunters fully equipped and ready to photograph the animals in garages, but also prepared in the event of an unsuccessful shoot.'

Perhaps it was during this solitary and meditative time spent watching these creatures being deprived of life and dedicating herself to offer them a different, vicarious presence that only lives in her images, that she developed her interest in man's decaying sensitivity and indifference. Audrey Linkman, in her seminal book *Photography and Death*, studies the practice

and meaning of post-mortem photography, which in Victorian times was normally commissioned out of love to mourn the accidental loss of a beloved relative. Intriguingly, Medvedeva somewhat subverts post-mortem photography, introducing killed animals as subjects, posing like human beings in all their motionless incontrovertibility, to denounce human indifference. 'We are surrounded by apathetic "dead" men but, surprisingly, that only leads us to think about death even less — to the point of total indifference. We are bombarded by news, almost every day, about catastrophes, wars, conflicts and other events where death plays a constant role. We can hear that hundreds of thousands died, but are we really sure we can actually grasp that information? In our hectic routines these news stories do not seem to receive the attention they deserve.' In her uncomfortable photo works, the ominous presence of multiple threads, to which her dead beasts are hung and tied, refers to the different types of death an individual can happen to

encounter: physical, spiritual, moral. Medvedeva wonders to which extent we are still alive if we have become so indifferent: 'Aren't we all already spiritually or morally dead?'

All images from the series *When you are dead, the pose you take doesn't matter anymore* © Mariam Medvedeva, courtesy of the artist

MARIAM MEDVEDEVA (b. 1985, Russia) began her artistic career in music. Feeling a natural progression towards photography she moved to New York in 2010 to work on her new creative language. In 2012, she moved to Paris, graduating from a master program at the Speos Photographic Institute. Following exhibitions in Moscow and Paris, she received an award for young photographers at the 2013 Bièvres International Photo Fair, and was the recipient of two IPA Honorable Mentions for her projects *Ichthys* and *Anticipation*. She lives and works in Paris. www.mariammedvedeva.com

FEDERICA CHIOCCHETTI (b. 1983, Italy) is a London-based writer, photography critic, editor and curator. She is the founding director of the photo-literary platform Photocaptionist. Currently working on her PhD in photography and fictions at the University of Westminster, she is the 2015 Art Fund Curatorial Fellow (Photographs) at the V&A, working on the exhibition *P.H. Emerson: Presented by the Author*. Recent projects include the exhibition and book *Amore e Piombo*, co-edited with Roger Hargreaves for AMC books, and winner of the Kraszna Krausz 2015 Best Photography Book Award. She curates the end-frame of the *British Journal of Photography* and has been appointed curator of the next Photo50 exhibition within the London Art Fair.

Since it first began to be recognised as a distinctive region, Appalachia has been understood as essentially American and yet distinct and apart. The region was America's first wild west. Its mountainous spine that runs diagonally across the country, from New York State in the north to Mississippi in the south, and its Native American inhabitants both proved to be barriers to early European expansion. The poet Washington Irving went so far as to propose in 1839 that his country rename itself after the region, which he saw as better representing the unique character of the young nation than the more generic name which endures to this day. A century later those rugged mountains produced two thirds of America's coal, fuelling the rise of the United States into an industrial superpower.

Aaron Blum
p. 229

Despite its central place in the story and geography of the United States, Appalachia has long been prone to distortion by outsiders. Its rugged landscape often romanticised and its inhabitants have been portrayed as backward and uncultured. Even the region's name stems from something of a misunderstanding on the part of the early Spanish explorers who christened it after the Apalachee, a Native American tribe in fact resident in distant Florida. The advent of photography did not change the tendency for the region to be depicted inaccurately, it only altered the means by which these inaccuracies were generated. Dozens of photographers have made work about Appalachia and its people, often playing up to its reputation for natural and human wildness. Even those few photographers like Stacy Kranitz or Roger May who have sought a more nuanced vision of the area have often found that vision misunderstood by viewers who may have come to their work looking to have old preconceptions reconfirmed.

The photographer Aaron Blum has more justification than most in his attempts to document Appalachia. He writes that 'as a resident of West Virginia I have always been aware of the views others hold of my home, and they have guided me to create my own version of life in the hills.' Rather though than attempt to encapsulate a definitive vision of the region as others have, Blum instead focuses in on his own small corner of it, mixing posed photographs of his family and friends with more familiar images of the strange Appalachian mixture

Another Appalachia

by Lewis Bush

of modern industry and primordial beauty. Blum's *Born and Raised* reveals an upper-middle-class community notably absent from other documentary accounts that have tended to focus on the poor and the marginalised in a way that has perpetuated images of destitution. Blum's photographs instead reveal palatial homes and ornately decorated living spaces occupied by refined, if sometimes eccentric denizens. At times there's a feeling of William Eggleston's photographs in these affluent interiors and their sometimes awkwardly posed inhabitants, and Blum's still-life photographs resonate with a similar intensity and humour.

The characters in Blum's photographs form a strangely eccentric cast. A white-haired man sits gazing at the floor, alongside a stark-eyed plastic owl, in another a woman sits on a floral sofa alongside a huge white dog almost twice her size. Blum is not entirely iconoclastic, for scattered amongst his posed portraits are many photographs which might at first be taken for Appalachian clichés. He photographs the verdant countryside and forested hills, punctuated by piles of trash, smoking power stations and industrial decay. There are tattooed, barefoot friends, dilapidated wood-panelled houses, and a dead crow swinging ominously from a tree. Blum's photographs feel like a knowing nod to past misrepresentations of the region, and perhaps a small acknowledgement that stereotypes are sometimes rooted in a degree of truth. *Born and Raised* is a neat example of the increasingly prevalent rejection of the old documentary tradition that calls on photographers to search for a definitive and objective vision of their subjects, as much as it is a comment on what happens when highly subjective visions of a place and people are repeatedly passed off as an unassailable truth. Far better to do as Blum has done, to accept the narrowness of our own experiences, and to speak of that instead.

All images from the series *Born and Raised* © Aaron Blum, courtesy of the artist

AARON BLUM (b. 1983, United States) is a proud eighth-generation Scots-Irish Appalachian from the mountains of West Virginia. After graduating with degrees in photography from West Virginia University and Syracuse University. He immediately began receiving recognition for his work including the Juror's Choice Award at Center: Santa Fe, Critical Mass Top 50, Flash Forward Award from Magenta, and a Leopold Godowsky Jr. Color Photography Award. His work has been featured by *Fraction Magazine*, CNN, BBC and *Next Level* among others and is in the permanent collection at both the Haggerty Museum of Art and the Houston Museum of Fine Art. www.aaronblumphoto.com

LEWIS BUSH (b. 1988, London) studied history at the University of Warwick, and worked in public health before gaining a master's degree in documentary photography from the London College of Communication. He has since gone on to teach photography there and at other institutions in the United Kingdom. At the same time he develops his own personal photography practice which is concerned with the ways that power is created and exercised in society. He also writes extensively on the medium's history and its contemporary use for a range of print and web titles, and on his blog, Disphotic.

Clear Observations

by Zippora Elders

If there is any single word brought to mind by the photos of Abel Minnée, then it is clarity. Clarity of image, clarity of technique, clarity of composition. But the content is clear too. The face of a model is perfect in its imperfection; it is her fine features that first demand attention, which then switches to the photographer's decision not to smoothen her skin in post-production. The flat surface is given depth, the print gains in materiality, and a photo that seemed unmistakably digital, turns out to have been shot with an analogue camera.

Anyone acquainted with the photographer knows that the abovementioned model is one of his best friends. Another model is recognizable as his former lover, in a photo that is very slightly blurred, rendering the girl just out of reach. Although Minnée often presents his photographs distantly and theoretically, it is interesting that a personal aspect is often couched within them too. This says a great deal about Minnée's work, whose roots lie to a great extent in his direct environment and his Amsterdam network.

Minnée first picked up a camera in his teens, during a holiday, and continued photographing when he returned home to

Abel Minnée
p. 235

Amsterdam. He went out a lot and took his camera with him, to the parties at Paradiso with DJ Mr. Wix, for example. That got the ball rolling. He was asked to make flyers, to do fashion shoots and adverts, and subsequently enrolled at the Royal Academy of Art in The Hague.

But the straightforward approach of the photography lessons didn't appeal to him. And neither did the Hague. Whenever he was there he felt an urge to get back to the capital city as quickly as possible. He transferred his attention to gaining work experience, by assisting with fashion and advertising shoots, and eventually abandoned his studies.

Almost ten years later, Minnée still has one foot in the commercial world. He's a hybrid, a chameleon, switching with ease from the stance of a participant to that of a spectator, and back again. But he is always observing. In fact that's perhaps the most accurate description of his autonomous works: they are clear observations.

Not entirely unexpectedly, American photographer Christopher Williams emerges as an important reference point for Minnée. Williams' work has its origins in the 1970s, a time of academic self-reflection and the demise of modernism. His photography is critical and political, but it is also fairly academic, accessible mainly for an informed audience. Williams' work also demands a sharp eye; he dissects everyday objects and creates polished photographs that look commercial yet, on closer inspection, have something 'off' with them.

A second source of inspiration is from a very different quarter, namely the Dutch Fluxus artist Willem de Ridder. Fluxus is a movement originating in the 1960s that concerns itself with anti-art and anti-commercialism. De Ridder is a multifaceted personality whose activities reach far beyond the conventional boundaries of the arts sector. He's a radio producer, storyteller and magazine publisher. Moreover, he was one of the founders of Paradiso, that pop podium where Minnée's career began. Like Williams, De Ridder probes (the dominant) reality, often by turning it on its head by absurdist and populist means.

Minnée unites these approaches in his own practice, which is marked by a convergence of objectifying theory and everyday astonishment—but undoubtedly also by a keen sense of the mechanisms of our image-dominated consumer society.

It's no surprise to find that the more conceptually oriented Rietveld Academy in Amsterdam, which Minnée attended from 2010 to 2013, proved a more appropriate choice. There he learned to contemplate life, to ask questions rather than expecting answers, to remain open to what is unknown or impossible to understand.

The need to initiate 'clear' images and research projects remained. Minnée hardly ever produces series and rarely manipulates images. He produces few photographs, and those he does make are always accompanied by profound research. Or rather, he does in fact make long series of photos, but generally only one of them gets through his tough selection process. From beginning to end he works with great attention to detail, almost obsessively.

A work by Minnée begins with something he has noticed in everyday life. It becomes a subject to contemplate. Only later does he ask: is it worthwhile to approach this subject photographically? If so, then the most simple and childlike questions follow. He picks away at the subject, dissecting and deconstructing it. As a result he quite often captures the 'rear' of a subject, the back story, to show and experience what frequently remains invisible.

Currently Minnée is studying for his Master's degree at the Academy of Visual Arts in Leipzig. He felt a need for seclusion. Once every two months he's in Amsterdam for commercial work or for creative projects with friends. The photographer Bram Spaan is one of those friends, and several of the photographs presented came about thanks to Spaan's technical insights and resources.

All images from the series *I Studied Photography/I Studied Photography* © Abel Minnée, courtesy of the artist (with some images made in collaboration with Bram Spaan)

ABEL MINNÉE (b. 1988, the Netherlands) is currently studying for an MA in Photography at Academy of Visual Arts, Leipzig, and holds a BFA in Photography from the Gerrit Rietveld Academy, Amsterdam. He has exhibited extensively throughout Amsterdam, has interned for Paul Kooiker, and his work has been commissioned by *VICE Magazine*, Nike and Tommy Hilfiger, amongst others. www.abelminnee.com

ZIPPORA ELDERS (b. 1986, the Netherlands) has been a curator at Foam Museum since 2014. She studied art history and museum curating at the University of Amsterdam and the VU University, where she specialized in visual art of the 20th and 21st centuries. She is particularly interested in time-based media art, new media art and network society. She has worked and written for various Dutch art institutions, including the Stedelijk Museum Amsterdam, the Sandberg Instituut, the Rijksakademie van Beeldende Kunsten and Nieuw Dakota.

The Uneasy Realisation of a Model

by Taco Hidde Bakker

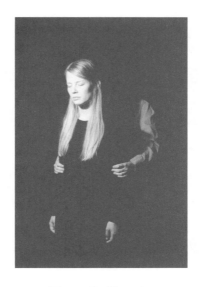

Tom Callemin
p. 241

In 2014 Tom Callemin published a book with Art Paper Editions, its cover plainly listing the titles of the twelve photographs it contains. All twelve are dark images, literally; with pitch-black backgrounds from which emerge people and objects, such as a man and a child, two trees, a cage, a chapel, a room and a house. The final title *The performance* is descriptive on a less tautological level: a blond-haired girl with her eyes closed, her elbows being grabbed by the hands of a girl in the penumbra behind her. Everybody and everything in Callemin's powerful photographs is enclosed, *à huis clos* in that beautiful French expression, by a darkness that is as inviting as it is disquieting in its theatrical isolation. Callemin says he 'creates meaning by omission, by letting go of a detailed background.' A theatrical setting and an 'empty' background is of crucial importance, as 'it opens a reservoir of meaning.'

All the portraits Callemin makes, whether in photography or video, are made inside, in a measured setting. Events underlying images don't interest him so much, but rather the iconicity that certain images obtain by living on in our minds and memories. 'When I'm fascinated by a photograph, I often encounter multiple images of similar situations shortly after. These images melt into one, for which I make sketches as a model of an image I want to make.' Such an image may have the suggestion of the iconic, but 'tiny changes in how I photograph result in enormous changes in how such an image will be read. These are the balancing acts I perform. It's about how much you, as photographer, want to show.'

The act of photography is performance in the work of Callemin, whether he works with people, animals or objects. Callemin's own role is also brought into play, to an extent that the viewer of his work will be confronted with his own role vis-à-vis the model, but also the artist in whose place he has come to stand. 'In photography a viewer always comes to replace the apparatus.' Callemin hopes that his careful and attractive compositions will create an experience within the viewer, but within that experience also a capsizing towards something more unsettling, perhaps through identification with the unease of the models, who usually are put to the test when collaborating with Callemin on the realisation of a photograph.

'I like to throw my models off balance,' says Callemin, 'and search for something that otherwise wouldn't come to the fore. A modelling session should be an intense experience demanding the utmost concentration from model and photographer alike.' How filmmakers like Carl Theodor Dreyer and Robert Bresson

use of text, Callemin wants to be as neutral as possible, avoiding the addition of new layers to the work. 'I want to do a minimal suggestion, but I'm also interested in the hidden symbolism of the titles, for example *House* also comes to symbolise the generic notion of a house. It gains wider meaning through such dry naming, offering the viewer a screen for projection.'

The few photographs finally shown result from meticulous preparations and dozens, sometimes even hundreds of failed takes. 'I attach so many conditions that it becomes almost impossible to realise a photograph as I had imagined it beforehand. It's incredibly important that an image comes into being exactly as it should be and I sometimes go to great lengths, including meticulous replicas of situations built in my studio, to arrive at that precise image. But finally each image proves to be a failure.'

worked with actors served as example. For what later became his influential silent movie *The Passion of Joan of Arc* (1928), Dreyer treated his lead actress harshly, pushing her to her knees so to arrive at a more credible performance. 'How far may I go as a director of my photographs?' Callemin wonders and immediately he responds: 'Quite far, I think.' This may lead a viewer to being in disagreement with the photographer's position, but 'because I took that standpoint as the photographer, the viewer of that image sees exactly what I saw and thus has to agree with that exact standpoint.' But Callemin's own role isn't just a well-defined role either, it's as insecure as the roles of the models and the audience. 'One makes one's own character, like the photographer who wants to show something different than the obvious. Therefore one needs to push through limits sometimes.'

Callemin says 'to seek credibility through aesthetics'. What kind of lighting must he use to find that zone in which fiction enters the stage? 'It all has to do with the nuances of careful lighting and I find it really exciting to create ambiguity that way.' How then do the plain titles relate to that ambiguity? When it comes to the

All images from the series *Untitled* © Tom Callemin, courtesy of the artist

TOM CALLEMIN (b. 1991, Belgium) graduated with an MA in Visual Arts (Photography) from Ghent School of Arts in 2015. He has exhibited extensively in Belgium and, amongst others, has also shown work at Unseen, Amsterdam, in 2014 and Tokyo Wonder Site in 2015. He was the recipient of the Prix Levallois Laureate award in 2015, which will lead to an exhibition at Galerie de L'Escale, Levallois, later this year. www.tomcallemin.com

TACO HIDDE BAKKER (b. 1978, the Netherlands) is a writer, translator and researcher based in Amsterdam. In 2007 he graduated in MA Photographic Studies at Leiden University and since publishes on photography and visual arts for a variety of magazines, art venues and artists. Additionally he is editor at *EXTRA*, a Dutch-language biannual magazine on photography published by FotoMuseum Antwerp and Fw:Books.

Dominic Hawgood
Under the Influence

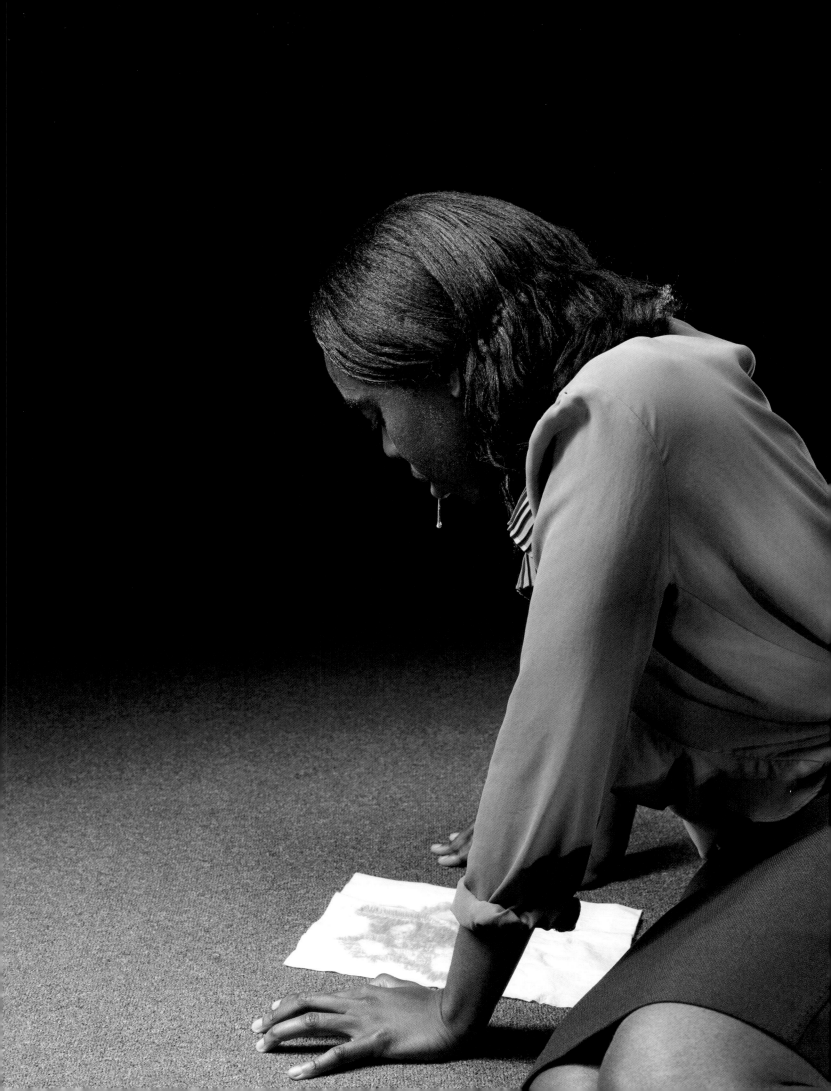

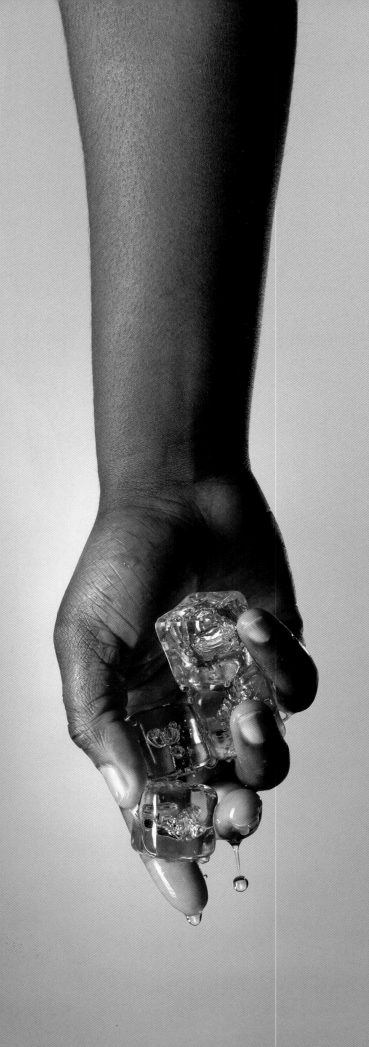

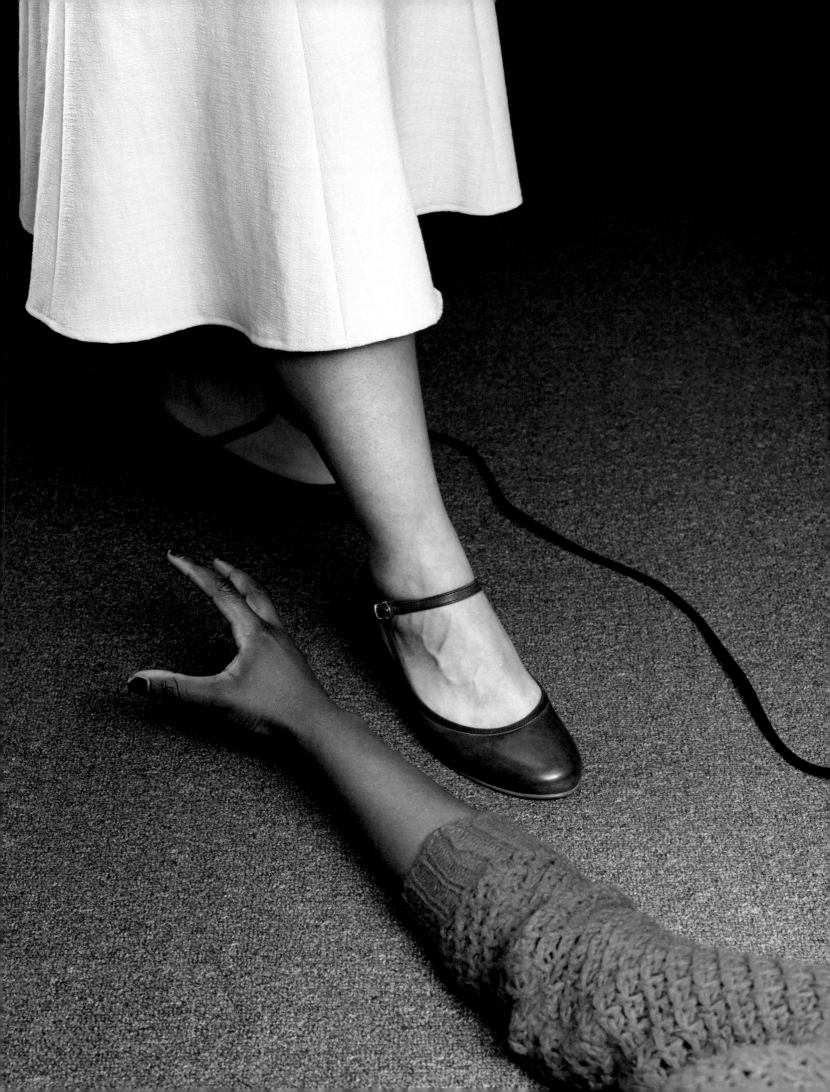

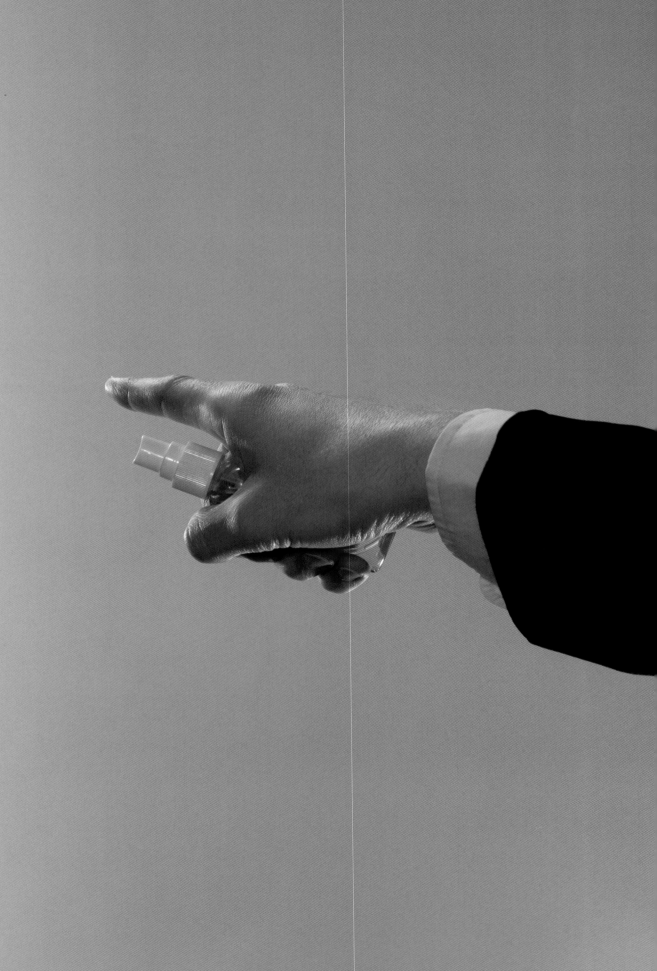

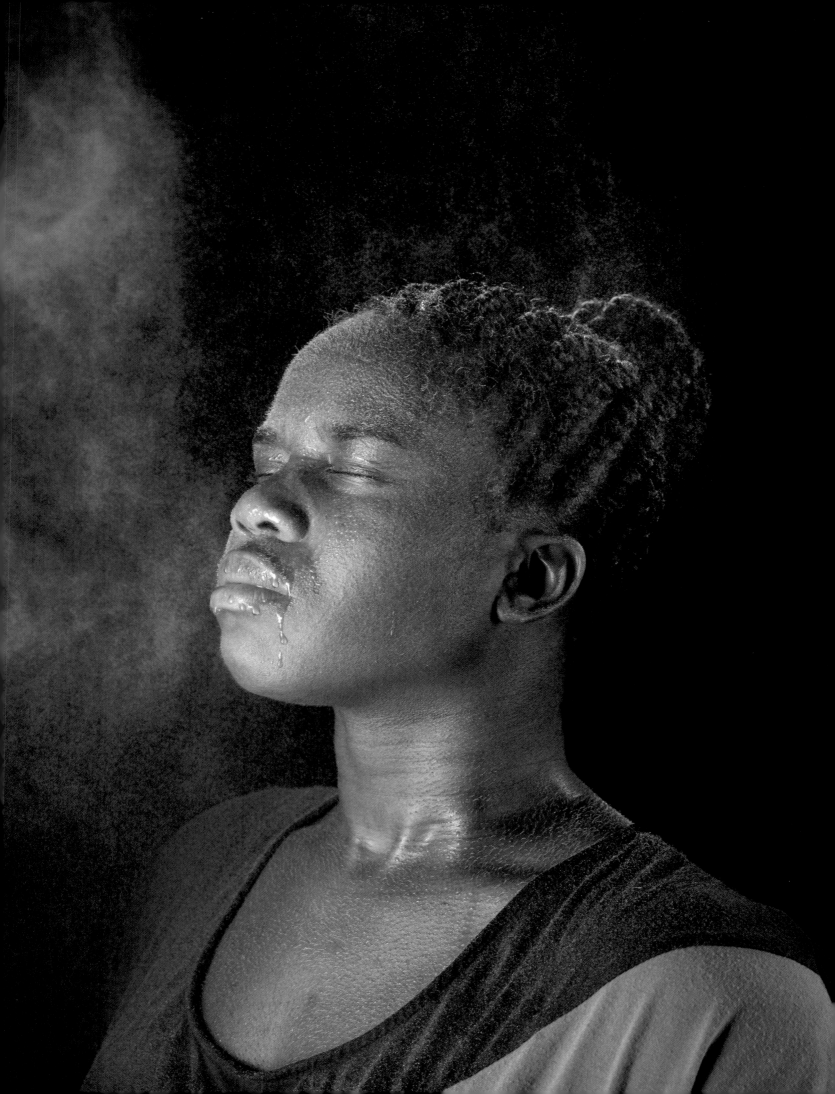

SPEAKING
IN TONGUES

on Dominic Hawgood p.257

by Liz Sales

Photography's complex relationship with the idea of the real is further complicated in the work of London-based artist Dominic Hawgood. He skilfully uses photography, Computer Generated Imagery (CGI), lighting design, and installation to reveal the artifice of image-making, while somehow still legitimizing the authenticity of his subjects' experiences—as well as his own. His imagery points to the possibility of realism expressed through fabrication.

Hawgood created *The Conversation* during his artist residency at Central-trak Artists' Residency at the University of Texas at Dallas in 2012. While living and working in Texas, he placed an advertisement in a local newspaper searching for self-identified glossolalists, people who have the ability to speak in tongues—an incomprehensible speech considered by Charismatic Christians to be the sacred language of angels.

Hawgood worked to build trust with his respondents, who became comfortable sharing their experiences of religious ecstasy on camera. The artist explains, 'It was an interesting dynamic, coming as an outsider into a scenario that was personal and private. To make the project work required an element of trust, and I thought it was interesting that we all had a desire to communicate a story on some level. I was looking to create imagery, and as I understand it both participants understood it as an opportunity to communicate their faith to an audience, to spread the word. We still keep in contact.'

Instead of appropriating the language of documentary photography, Hawgood avoids the genre's authoritative implications by carefully producing these images in sparse urban exteriors. Despite the manufacture that is apparent in these images, the authenticity of experience expressed on the faces of their subjects is palpable. This tension challenges the viewer's

assumptions about staged imagery and points to the possibility of authenticity expressed through artifice.

Hawgood's more recent work, *Under the Influence*, also deals with religious ecstasy. Here he examines the practice of healings and exorcisms in African churches in London. 'These are places I walked past all the time, and it was easy to do just that. I was interested in how they structured their services and also how they used merchandising. After much calling, speaking to people and doing online research I found one church in particular that really captured my imagination.' His resulting imagery does not serve as a documentation of what he witnessed in the church so much as it acts as a vehicle for conveying aspects of his experience. *Under the Influence* offers interrelated pieces of Hawgood's experience and relies on the viewer to help construct his or her own narrative.

One of these pieces is Pascale Cumming-Benson's essay 'Angel-Water: An Exorcism,' which appears alongside *Under the Influence* on Hawgood's website and in *Ends Meet*,

a publication available through Royal College of Art, where both Cumming-Benson and Hawgood studied. This text is another means of conveying an outsider's experience of religious ecstasy. A portion reads:

In the auditorium (a university lecture theatre) where the exorcism will take place, the mood is tightly controlled. When singing, this mood manages to be both foreboding and uplifting—the kind of full, spirited atmosphere that produces the need to move and dance along with everyone else. Hands are lifted up, stretched and exposed. But I am unsure what to do with my hands, only lifting them up, palms (half-) displayed, when encouraged to do so by the band member leading the hymns; and although I am swaying and singing, most of the time my hands are clasped in front of me, or resting, palms down, on my thighs. The ministers standing in the aisles are an unsettling presence: they seem like actors in an abstracted process that I don't understand. (Pascale Cumming-Benson, 2014)

This text serves to situate the work as the artist's reconstruction of his own experience, rather than the findings of a detached observer— a thread that runs clearly through all aspects of Hawgood's practice.

This project's production process is less clear. Hawgood does not clarify whether or not the source material for these images was photographed on site, restaged in the studio,

His image
serve
docume
of what he v
so m
as a veh

y does not

as a

ntation

itnessed

ch as it acts

cle of his

ence.

evidence and fabrication. He will not explain how these images were made and the images themselves do not give him away.

By leaving the particulars of his process unclear, Hawgood has incited viewers' imaginations and prompted outside narratives to freely form around the work. He explains, 'I was looking for new ways to create narrative, and what better way than to let everyone create it for me, through their own assumptions and readings of inaccurate reviews on my work. I think I was particularly interested when someone challenged me about the project as being exploitative in my documentation and handling of a minority, the conclusion never factored in the possibility of fiction.' This response to the work exposes the complexity of viewers' relationships to photography and realism; in a postcolonial and postmodern context, the politics of representation are no different in documentary photography than they are in staged imagery.

Under the Influence is as readily interpreted as a consciously staged re-enactment as highly produced documentation. Hawgood continues,

digitally reconstructed, or some combination of the three. The artist states, 'I've never said anything about the production (of these images). All I have ever released is three lines of text: "*Under the Influence* examines the practice of exorcism in African churches based around London, and considers the role of merchandising of these modern belief systems. The enigmatic experience of seeing deliverance first hand becomes the inspiration for a series that engages with topics about authenticity, desire, and the real."' This refusal to discuss the source of the images is possible because of the artist's superior technical skills, which are well suited to both the hyper-real situations he depicts and his desire to situate his work in the nebulous space between photographic

'I felt [the images] sometimes appeared fake due to the theatricality of the performance, so I set about creating that experience for the viewer. This ambiguity was placed on loop, it was never clear how something was produced and so you're continually confronted by questions about realism.' Regardless of how these images were created, without narrative support from the artist, the ambiguity he experienced when witnessing healings and exorcisms is transferred to the viewer. This ambiguity conveys the experiences an outsider might have within these churches better than conventional documentary photography could.

Hawgood's portrayal of religious ecstasy exists alongside the church's own. In the church of his focus, exorcisms and healings are heavily documented and circulated by the church itself. The artist explains, 'There were film crews recording all the time, with products being sold constantly. I was transfixed by the way faith was being packaged. The website and its content, the merchandising, the services, social media… it was a complex web of commodification, obsession and transmission of ideas. I also liked the pace at which the church evolved, you could literally see it growing, watch marketing strategies take effect, and see from where they were visually sourcing inspiration.'

Hawgood's keen eye for commercial image strategies and how they help to shape our reality likely developed during his time working in advertising.

He states, 'I experienced advertising from a very specific viewpoint in which I was actively involved but at the same time distanced. Working as a lighting tech on stills productions, I was part of a cog in the corporate machine, but it allows you to understand fully the creative process. You see how ideas are born, made, and executed and the decisions being made that shape each concept. I took away an understanding of how to craft and overproduce an image, the desirable lighting characteristics in various situations and an approach to producing strong narrative.' This is apparent in *Under the Influence*, which employs the visual rhetoric of advertising, including skilful lighting, digital post-production manipulation, and CGI. Hawgood's depictions of a microphone raised toward the heavens, a face bathed in a mist of holy water, and a crutch being cast aside are marketable symbols of Pentecostalism, just as their accompanying titles— *Who are you?*, *This Body is Not Your Temple*, and *I Command You Get Out*, respectively—are drawn from its compelling lexicon.

Hawgood's interest in high-end production extends to the gallery space. His solo show last spring at TJ Boulting in London was based on a high-resolution three-dimensional architectural rendering. The work was set against pristine white walls and a spotless white floor. His complex lighting scheme cause the black and white images, printed on vinyl, to appear as if floating off the walls. The colour images, seated in sculptural

light boxes and lit from behind with coloured LEDs, were equally uncanny. The highly conceived and executed exhibition brought the viewer closer to the disorienting experience of the phenomena depicted.

While Hawgood continues to make new work, he has not put *Under the Influence* to bed. '*Under the Influence* seems to continually evolve. I'm being resourceful with ideas, reworking them, pushing them to their limits. The process is liberating and fun. For my next solo show during PhotoIreland I'm using one of my 3D renders as the starting point, and reworking it as a light installation; the (holy water spray) bottle model had been 3D printed and floats in a seemingly 2D space. I'm looking to expand away from photography, to consider new ways to make art. It's a natural progression that creates new opportunities and collaborations, and keeps things both interesting and challenging.'

All images from the series *Under the Influence* © Dominic Hawgood, courtesy of the artist

DOMINIC HAWGOOD (b. 1980, United Kingdom) is a digital artist combining photography, CGI, lighting design, performance and installation. Since graduating from the Royal College of Art in 2014 he has won the *British Journal of Photography*'s International Photography Award, and been selected for The London Open (Whitechapel Gallery), Fresh Faced Wild Eyed (Photographers Gallery) and 20/20vision (nominated by Louise Clements of FORMAT Festival). He has been awarded residencies with Planches Contact, France, RedMansion, China, and also commissioned to produce new work by the European Photo Exhibition Award. This year *Under the Influence* has been reimagined as a solo show at both TJ Boulting, London, and Oonagh Young Gallery, Dublin. www.dominichawgood.com

LIZ SALES (b. 1978, United States) is an artist, art-writer, and educator with a Master in Fine Arts from the ICP-Bard program in Advanced Photographic Studies. Her work deals primarily with the relationship between technology and perception. She is an editor at *Conveyor Magazine* as well as a faculty member at the International Center of Photography, who teaches in the General Studies, Continuing Education and Teen Academy programs. She lives and works in New York City.

Eva Stenram, *Drape (Cavalcade VII),* 2013 StandardHotels.com

10TH
ANNUAL
EDITION

PRINTED MATTER'S
NY ART BOOK FAIR
at MoMA PS1

SEPTEMBER
18–20, 2015
PREVIEW
9/17

nyartbookfair.com

PARIS PHOTO

SAVE THE DATE
12.15 NOV 2015
GRAND PALAIS

Organized by

 Reed Expositions WWW.PARISPHOTO.COM BMW J.P.Morgan

Momo Okabe
Limited edition print now available at Foam Editions

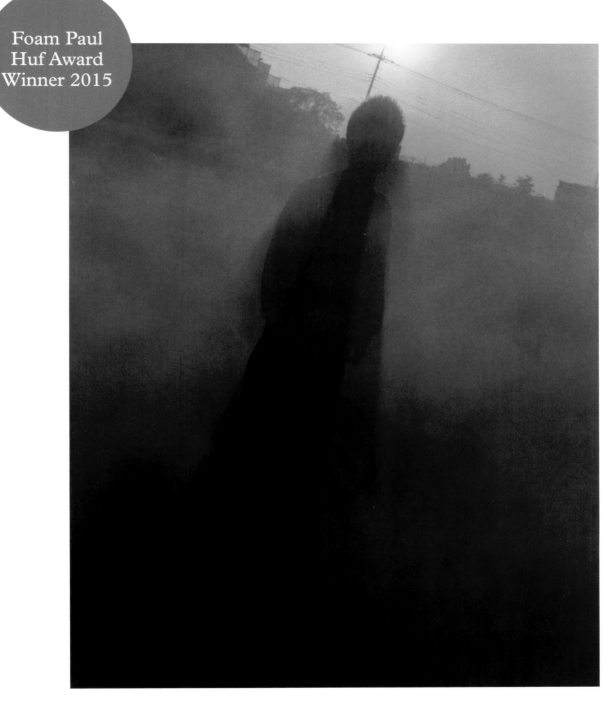

Untitled from the series Bible, 2013
C-print, 40 x 60 cm, edition of 20, € 530

For more information
please contact:
Foam Editions
Floor Haverkamp
floor@foam.org
shop.foam.org

SUB-SCRIBE

The world's leading photography magazine

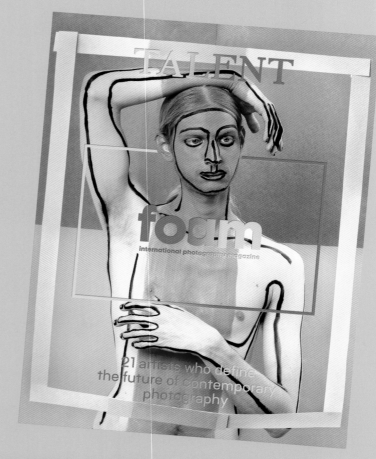

NOW

See <u>frameweb.com/foam</u> for the latest subscription offer

FOAM MAGAZINE'S CHOICE OF PAPER

The following paper was used in this issue,
supplied by paper merchant Igepa:

Starline Creamback, 300g/m^2 (front and back cover)
Maxi Offset, 80g/m^2 (all texts)
EOS vol 2.0, 90g/m^2 (p.9 & p.137)
wood –free white bulky design
paper vol 1.1, 110g/m^2 (p.33)
heaven42 Softmatt, 135g/m^2 (p.49)
heaven42 Softmatt, 115g/m^2 (p.49 & p.97 & p.225 & p.281)
Circle Gloss, 115g/m^2 (p.73)
Maxi Gloss, 115g/m^2 (p.161 & p.257)
Z Offset Rough, 120g/m^2 (p.201)

For more information please call +31 344 578 100
or email skirschner@igepa.nl

 IGEPA

Issue #42, Talent

Editor-in-Chief
Marloes Krijnen

Creative Director
Pjotr de Jong (Vandejong)

Editors
George Allen, Marcel Feil,
Pjotr de Jong, Marloes Krijnen

Managing Editor
Elisa Medde

Acting Managing Editor
George Allen

Magazine Management
Anne Colenbrander,
Judith van Werkhoven
(Vandejong)

Art Director
Hamid Sallali (Vandejong)

Design & Layout
Floris van Driel (Vandejong)

Typefaces
Lemmen Antiqua, ortype.is
Rather, ortype.is

Contributing Photographers
and Artists
Aaron Blum, Alessandro
Calabrese, Tom Callemin,
Sara Cwynar, David Favrod,
Peng Guo, Dominic Hawgood,
Heikki Kaski, Sjoerd Knibbeler,
Mariam Medvedeva, Abel
Minnée, Márton Perlaki, Justin
James Reed, Johan Rosenmunthe,
Constantin Schlachter, Jean-
Vincent Simonet, Matthew
Leifheit and Cynthia Talmadge,
Danila Tkachenko, Christian
Vium, Manon Wertenbroek

Cover Photographs
Front cover: image from
the series *Tandem* © Manon
Wertenbroek, courtesy
of the artist

Back cover:
Current Study #3, from the
series *Current Studies* ©
Sjoerd Knibbeler, courtesy of the
artist and LhGWR, the Hague

Inside:
Contemporary *Floral
Arrangement 5* (A Compact
Mass), from the series *FLAT
DEATH* © Sara Cwynar, courtesy
of the artist and Foxy Production,
New York, and Cooper Cole
Gallery, Toronto

Inside (spread):
All images from the series
Tranquillity © Heikki Kaski,
courtesy of the artist

Contributing Writers
Taco Hidde Bakker, Karin
Bareman, Marco Bohr, Lewis
Bush, Federica Chiocchetti,
Tim Clark, Jörg Colberg,
Zippora Elders, Marcel Feil,
Brad Feuerhelm, Kim Knoppers,
Claudia Küssel, Russet
Lederman, Gemma Padley, Liz
Sales, Aaron Schuman

Copy Editor
Pittwater Literary Services:
Rowan Hewison

Translations
Liz Waters

Printing
Grafisch Bedrijf Tuijtel
Industriestraat 10
3371 XD Hardinxveld-
Giessendam NL

Paper
Igepa Nederland B.V.
Biezenwei 16
4004 MB Tiel – NL

Editorial Address
Foam Magazine
Keizersgracht 609
1017 DS Amsterdam – NL
T +31 20 551 65 00
F +31 20 551 65 01
editors@foam.org

Publishing

Frame Publishers BV
Laan der Hesperiden 68
1076 DX Amsterdam
The Netherlands
foam@frameweb.com

Directors
Robert Thiemann
Rudolf van Wezel

Marketing & Sales Director
Margreet Nanning
margreet@frameweb.com

Brand Manager
Benjamin Verheijden
benjamin@frameweb.com

Distribution & Logistics
Nick van Oppenraaij
nick@frameweb.com

Sales Manager
Sarah Maisey
sarahmaisey@frameweb.com

Sales International Galleries
Molly Taylor
molly@frameweb.com

How to Subscribe:
€59 for 1 year – 3 issues

Students
€49 for 1 year
Visit www.frameweb.com/foam
for more offers

Distribution:
Foam is available at sales points
world wide.
Visit frameweb.com/foam/
wheretobuy

ISSN 1570-4874
ISBN 9789491727818

The production of Foam
Magazine has been made
possible thanks to the
generous support of paper
supplier Igepa Netherlands B.V.